tear here

Typical Shutter Speeds and Apertures that Work Well Together at Various Film Speeds

Film Speed: ASA 100

Shutter Speed	Aperture Setting
500	2.8
250	4
125	5.6
60	8
30	11
15	16
8	22

Film Speed: ASA 200

Shutter Speed	Aperture Setting
500	4
250	5.6
125	8
60	11
30	16
15	22
8	32

Film Speed: ASA 400

Shutter Speed	Aperture Setting
500	5.6
250	8
125	11
60	16
30	22
15	32
8	45

alpha books

Filters for Black-and-White Photography

Filter Color	Filter Number	Effect of Filter
Yellow	8	Natural sky
		Natural sunset
		Natural haze
		Natural flowers & foliage
		Lighter reds & oranges
		Lighter green tones
		Very light yellow tones
Yellow-Green	11	Natural flowers & foliage
		Natural skin tones
		Dark blues and purples
		Light green tones
		Light yellow tones
Orange	16	Increased contrast in sky
		Dramatic sunsets
		Reduced haze
		Increased texture
		Lighter reds & oranges
		Dark blues and purples
		Light yellow tones
Red	25	Strong contrast in sky
		Strong haze reduction
		Lighter reds and oranges
		Dark blues and purples
		Dark green tones
		Light yellow tones
Deep Red	29	Dramatic sky contrast
		Simulated moonlight
Blue	47	Dark reds and oranges
		Dark blues and purples
		Dark yellow tones
Green	58	Enhanced haze effect
		Light foliage
		Natural skin tones (tungsten lighting)
		Dark reds and oranges
		Dark blues and purples
		Light yellows

Filters for Color Film

Filter Number	Effect	Film Type	Conditions to Use Under
80A	Cooling	Daylight	Tungsten lighting
80B	Cooling	Daylight	Photo lamps/Tungsten lighting
85B	Warming	Tungsten	Daylight/Flash
85C	Warming	Tungsten	Daylight/Flash
81 series	Warming	Daylight	Reduces blue cast in strong sunlight
82 series	Cooling	Daylight	Cools down red tones in daylight
86B	Warming	Daylight	Reduces blue light in heavy shade

Gray Card

Point your light meter at this card to obtain an accurate meter reading when shooting areas that have bright reflections or heavy shadows.

The COMPLETE IDIOT'S GUIDE TO Photography

by Roger Woodson

alpha books

A Division of Macmillan General Reference
A Simon & Schuster Macmillan Company
1633 Broadway, New York, NY 10019

International Standard Book Number: 0-02-861092-X
Library of Congress Catalog Card Number: 96-084594

98 97 8 7 6 5 4 3

Interpretation of the printing code: the rightmost number of the first series of numbers is the year of the book's printing; the rightmost number of the second series of numbers is the number of the book's printing. For example, a printing code of 96-1 shows that the first printing occurred in 1996.

Printed in the United States of America

Publisher
Theresa Murtha

Development Editor
Faithe Wempen

Editor
Nancy Mikhail

Copy/Production Editor
Laura Yockey

Cover Designer
Mike Freeland

Illustrator
Judd Winick

Designer
Kim Scott

Indexer
Becky Hornyak

Production Team
Heather Butler
Angela Calvert
Kim Cofer
Tricia Flodder
Scott Tullis

Contents at a Glance

Contents

Foreword

There are three main reasons for you to be scanning these pages (which proves, after all, that you are not an idiot!):

1. You've treated yourself or someone in the family to a new camera. (Can this guide really cut through the photographic mumble-jumble and point you and your camera toward great photos from the very first roll? Yes.)

2. You've been taunted for too long by pictures that somehow don't come out! (You don't have to be helpless/hopeless anymore. Author Roger Woodson will be with you.)

3. You've been shopping around, but are (wisely) afraid to ask questions from a clerk who is only there to ring up the sale. You also don't know the How and the Who of Camera Mail-Order Buying. In fact, you haven't a clue as to how to pick the right camera from a shelf-load of look-alikes, all priced differently (see Chapter 2). (Just admitting that proves again that you are not an idiot!)

Roger knows that you and a thousand others have the same hesitancies: What camera do I need? What film should I buy? Will my pictures come out next time?

Roger has talked to the park ranger at the Grand Canyon who has given up on telling the Nice Folks that they will be disappointed taking flash pictures of the entire canyon after dark. Nice Folks point to the built-in flash and just go ahead with their point 'n' shoot cameras. When park rangers tell Canyon stories and show slides, Nice Folks are also certain to take flash pictures of the screen. When all they get are pictures of a white screen, they blame the camera.

Roger has those Nice Folks as neighbors. They visit to complain of bad cameras and bring an endless assortment of red-eyed photos of the baby or the cat.

The Complete Idiot's Guide to Photography is an oasis in the photographic desert—fresh, cool, clear drinking water for the eyes and the brain of these Nice Folks, and perhaps for you. This guide is the only technologically up-to-date book to incorporate all the things from before and after the 1970s: the cameras, the films…everything that changes yesterday's bad snapshots into today's prizewinners. This innovative and keenly aware guide drills home cautions, suggestions, and photo folklore, mostly for the neophyte, but also for those en route to exploring savvy sensitometry sophistication. Not since 1974–75, when the Eastman Kodak Company reached out to enlist experienced experts, has anyone tried to come to grips with down-to-earth basics for the camera-owning public with the now long-gone "Here's How" booklets.

Roger's practicality in sharing worldly-wise tips means that your camera won't be swiped when you turn your back (see Chapter 7). He'll show you how to add a stuffed sack to your kit to assure sharper photos (see Chapter 6). He has idiot-proofed some of photography's long-term baffling dilemmas: Should an exposed roll of film be left with its leader extended? Should film be wound before or after the next exposure? (See Chapter 14.) Roger is up for a medal for his ingenious way of slitting duct tape—certain to save a vacation's memories, or a $50 or $100 camera repair!

"Making Memories Without Making a Mess" (see Chapter 15) talks picture sense—not film, not shutter speeds. This guide is for someone who wants lovable family pictures, not driver's license portraits. With a few suggestions, there's an end to dull-as-dishwater photo keepsakes.

The guide introduces and explains numerous words only heard at repair shop counters where photographers let down their hair: macro, medium format, hot shoes, thyristors, solarization, and more puzzling expressions.

Indubitably, *The Complete Idiot's Guide to Photography* is more than a Kameraland Kindergarten for Kapable Kamera Kids. Teacher Woodson jump-starts the more ambitious beginners in the first 20 how-to mini-chapters, like a step from the family car into a Maserati. *The Complete Idiot's Guide to Photography* stresses the visual components sensibly for Kamera Kids. Shut off the TV; absorb the Woodson curriculum in these pages. Put on a cap and gown. Award yourself Kameraland's Home Study Course Art-Shuttery Certificate for Composition and Color Control. It's the end of sending Junior to stand still "over by that tree" with a guaranteed halt to the album-page hilarity with that tree forever growing out of Junior's head! After Chapter 20, there are guidelines for the serious hobbyist, one expert speaking to another.

The Complete Idiot's Guide to Photography is more than words. It's chock-full of the everyday know-how of the expert, is easy to read, and is even easier to understand.

Thanks, Roger, for making sure this seasoned photographer will never again pick up a camera to finish a roll of images—before the film has even been loaded. The Woodson Method assures 100% prevention of photography with an empty camera! (See Chapter 14.)

George Gilbert, author, lecturer, historian; Founding president of the American Photographic Historical Society

George Gilbert (photo-columnist for the *New York Post*, *Cue Magazine*, and *Art Photography*) has carried his camera over the years from the depths of a Colorado uranium mine, on cattle roundups, and to the backstages of Broadway nightclubs. He is the author of 14 books on photography. Prof. (U. of W. Conn.) Gilbert's photographs are in the Metropolitan Museum of Art, the Art Institute of Chicago, the Houston Fine Arts Museum, the Brooklyn Museum, and other institutions.

Introduction

So you want to take photographs, eh? Welcome to my world! I started taking pictures before I was tall enough to see out of the windows in my room. This is no joke. Several decades later, I'm still clicking the shutter. Photography is a passion of mine and a hobby that anyone can enjoy and grow with.

In its early days, photography was a mysterious craft, full of strange controls, black capes, and smoking flashes. But happily, those days are gone forever. Today, any child can pick up a point-and-shoot camera and take relatively good photos. Many of the cameras sold today have auto-exposure, auto-wind, auto-focus—auto-everything! As this book's title implies, any idiot can take pictures. But, we both know that you are no idiot. In fact, you must be pretty smart to have chosen this guide to the fabulous hobby of photography.

Although anyone can take photos, not everyone can take *good* ones. If you want to get past the old, wrinkled-ear snapshots that are stuck in your boxes and albums, you have to venture beyond the auto-control world. Moving up to the more professional equipment and technique can be intimidating at first! But with this book, you can relax, because each chapter will help you move up the ladder of photographic skills.

What You'll Find in this Book

In this modern age, one of the toughest parts of getting into photography is deciding what to buy and where to buy it. There is so much to choose from that it is easy to become confused. If you are not already knowledgeable of photography, you can make costly mistakes buying the wrong equipment. You'll find time-tested answers to this dilemma in the first few chapters.

When you move into the second part of this pro-in-your-pocket book, you will learn about professional techniques that will make all of your photographs more enjoyable. We will explore all of the controls found on average cameras, examine composition, and talk about using light right. This is where you will acquire your shutterbug basics.

Part 3 spotlights specialties. Whether you want to concentrate on capturing your kids or wildlife at the zoo on film, you'll find answers to your questions. Some of the specialties discussed include indoor photography, portraits, landscapes, and insect photography. Each chapter is dedicated to a certain specialty, and you are sure to find a few that capture your attention. We will cover lighting, close-ups, nature photography, and much more. There's even a chapter for artistic types.

The red-light district leads off Part 4. This is where you will get an introduction into the wonderful world of processing and printing your own film. You will learn how to

evaluate and choose darkroom equipment. Tips will tell you where you can set up a darkroom in your home. Black-and-white processing is easy and inexpensive. You'll see, step-by-step, what's involved in developing your own film and making your own prints. If you get hooked on the hobby, a darkroom is likely to be in your future. Find out how much fun one can be on rainy days.

Will this book make you the next Ansel Adams or Leonard Lee Rue III? Probably not, but it can make you a very good photographer. The ideas and instructions in this text are easy to understand and use. You can put them to work right away and see results quickly. Take a moment to thumb through these pages. Scan the table of contents. I feel certain that you will agree that this is your one-stop guide to the full range of photography.

Bonus Beacons

You'll notice the following sidebars throughout the book. They mark some special points I want you to be sure to catch.

Bet You Didn't Know

"Bet You Didn't Know" boxes will give you information or little-known facts about photography.

Jargon Alert

This sidebar provides the meaning of technical terms and words used in the field of photography.

Insider Tip

These boxes offer inside advice and great suggestions on how you can excel in your hobby.

Watch Out

These sidebars help you avoid trouble.

Dedication

This book is dedicated to Afton, Adam, and Kimberley—the people in my life that make it all worthwhile.

Acknowledgments

I would like to acknowledge and thank my parents, Maralou and Woody, for helping me buy my first camera and for being supportive parents.

My thanks to Dean Newell, Adam Woodson, Afton Woodson, and Kimberley Woodson for serving as the photogenic models in this book. Thanks also to my agent, Jake Elwell of Wieser & Wieser, Inc., and to the folks at Macmillan.

Special Thanks from the Publisher to the Technical Reviewer

The Complete Idiot's Guide to Photography was reviewed by an expert in the field who not only checked the technical accuracy of what you'll learn here, but also provided insight to help us ensure that this book tells you everything you need to know to take fantastic photos. Our special thanks are extended to Jane Washburne.

Jane Washburne is the owner of Washburne Photography in Indianapolis and has over 20 years of special event photo experience, including weddings, parties, charity events, and portraits. She also has over 10 years of hands-on and managerial experience in photo processing labs.

Part 1
Help with Hardware

John Madden doesn't do commercials for this type of hardware, but you can consider this section the nuts and bolts of photography equipment. This is where you will learn how to assess your equipment needs.

Sorting through all the equipment options available to you may be one of the most confusing things you will ever do in photography. Fortunately for you, I've already paid the price for mistakes and have experience that you can learn from. I'm about to give you a complete course in the selection and acquisition of photo gear.

You are going to learn about simple, point-and-shoot cameras, professional-type component systems, lenses, and artificial lighting options. Then we will talk about tripods, monopods, and other supports. If you like buying gadgets and gizmos, you'll love Chapter 7. It shows you everything you never knew you needed, and more. Chapter 8 rounds out this section with advice on how to get the best buys on your cameras and accessories.

Assessing Your Equipment Needs

In This Chapter

➤ Knowing what type of camera to buy

➤ Getting the most for your money

➤ Casual snapshots

➤ Keeping it simple

➤ High-quality photographs

➤ Putting your needs into perspective

There is a wealth of photography equipment available to you. It comes in all shapes and sizes, and for all skill levels. You can opt for a disposable camera or a lens that costs more than your car. Sorting through all the hardware options can be frustrating and confusing. Before you buy anything, be clear on what your needs are.

Having the right camera is to a photographer what having the right hammer is to a carpenter. Few carpenters would attempt to frame a house with a little tack hammer. If your goal is to take superior snapshots, you need to buy your camera from somewhere other than the cash-register rack in your local grocery store. There is no substitute for good gear when it comes to taking great pictures. This chapter will give you the nitty-gritty on the best equipment to suit your needs.

Take the Gamble Out of Buying Your Photo Gear

Choosing camera equipment shouldn't be done by pasting pictures of cameras on a roulette wheel and spinning it for an answer. Research is needed to make wise buying decisions. People who purchase photo gear without investing the time to evaluate their needs are frequently disappointed. You don't have to read every technical report written on cameras and camera lenses before making a decision, but you do have to ask yourself some questions.

What do you want to take pictures of? A camera outfit that works well for taking pictures of your pets or kids may not perform well when aimed at wildlife or race cars. Knowing what you want to photograph is the first step in identifying the type of equipment you should buy.

How important will flash photography be to you? If most of your photography will rely on an electronic flash, you have to pay attention to the options in this category.

Will your subjects be moving at high speeds or will they be stationary objects? Fast-moving subjects can be captured sharply on film with a camera that has a high shutter speed. With slow shutter speeds, the image will be a blur.

Do you need a camera with a zoom lens? Many inexpensive, point-and-shoot cameras are available with built-in zoom lenses. This type of lens opens a door of opportunity for you to explore different compositions in your pictures. A zoom lens can also enable you to crop unwanted items out of a photo before a picture is taken. Give serious consideration to buying a camera that is, or can be, equipped with a zoom lens.

How idiot-proof do you want your camera to be? It's possible to buy a camera that does almost all the work for you. Some cameras will wind your film when it is loaded, advance the film after each shot, and rewind it when the roll is finished. Many cameras will automatically set the proper film speed for you. Flash exposures are frequently auto-mated, and you can even get auto-focus lenses. While some professionals turn up their noses at full-auto cameras, this type of system is not a bad bet for a beginner.

Sit down and make a list of what you want out of a camera. You can use the list as you move through this book to define the perfect system for you.

So Much to Choose From—What Do I Do Now?

You can buy a decent camera for less than $50 if your needs are not too technical. Spending $100 will get you more features. However, until you are willing to spend a few hundred dollars, you are going to be working with a simple system. This is not all bad. Sometimes simple is best.

When you begin shopping for photography equipment you may be overwhelmed by the tremendous options available to you. It is senseless to invest thousands of dollars in a system that will be used only for occasional snapshots. This is where your personal research pays off. You can eliminate a vast majority of the confusing factors when you know what you want and need.

Many people scan catalogs and shop department stores for cameras. This is sometimes the best way to find a low price, but it is not the best approach for a novice to take when seeking the perfect camera. Go to a camera store. Talk with experienced photographers and knowledgeable salespeople. The Flashing-Blue-Light special might not be such a bargain for your needs. Even if you don't buy from a dedicated camera shop, at least do your initial shopping in one.

There are two basic mechanisms that determine how a camera functions: direct-vision and single-lens reflex (SLR). Of the two, single-lens reflex is the more expensive—and more accurate. As you can see in the following diagrams, there are two sight lines on a direct-vision camera, one for the lens and one for your eye. What your eye sees and what the lens sees are slightly different things. On the single-lens reflex unit, the image that you see with your eye comes in through the lens and is bounced with mirrors up to the eyepiece. This ensures that your eye sees exactly what the lens sees.

Insider Tip
OOOH...
Use a notebook to record the features you want in a camera. Write down the types of pictures you want to take. Carry the notebook with you as you visit camera stores and take notes about various types of equipment. Your journal will help you make a buying decision when the time comes.

Jargon Alert
Single-Lens Reflex Camera: This is a camera in which the image entering the lens is reflected into the viewfinder. Basically, what you see is what you get with this type of camera. It is the choice of pros who shoot in the 35mm format.

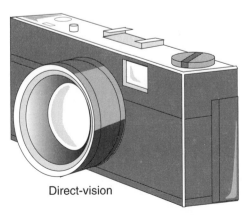

Direct-vision

Direct-vision cameras use a simpler, less accurate system for viewing the image through the eyepiece.

5

A single-lens reflex unit uses mirrors to offer a precise view of what the lens "sees."

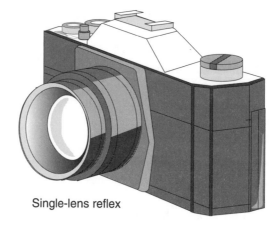

Single-lens reflex

A 35mm camera that uses direct-vision can be acquired inexpensively almost anywhere and works fine for most purposes. Individuals interested in taking up photography as a serious hobby, however, will want a single-lens reflex unit. If you are not sure which viewing system the camera you are looking at has, ask a salesperson or look in the instruction manual that comes with the camera.

Keep It Simple and Get More Good Shots

Family snapshots are always one reason for buying a camera. It can be the only opportunity you get to "shoot" your in-laws legally. The best pictures are often taken on short notice and with minimal preparation. If you have to search for just the right lens, check lighting with a light meter, and set up strobe lights before you take a family photo, you may miss the golden moment. Wouldn't it be easier to grab your trusty point-and-shoot camera and capture the moment?

I have thousands of dollars invested in my photo arsenal. My wife has about $150 tied up in hers. The equipment I have is capable of much more than that of my wife's, but she's usually the one who gets all the great shots of our kids. Why? Her system consists of one handheld unit with a built-in flash. It's fast and easy to use. Unless my gear is already deployed, it's just too much trouble to take a quick picture. This is something to give some serious consideration to.

If your goal is to take clear, dependable pictures of your family, a mid-range, point-and-shoot camera is probably all you need. Depending on how much you want to spend, you can get features like automatic loading and rewinding. The camera may have a built-in telephoto lens. You can count on it having a built-in electronic flash. This type of camera is small enough to fit in a jacket pocket and fast enough to use on short notice. There's a lot to be said for this type of camera. They are said to be idiot-proof.

Auto-focus cameras and point-and-shoot cameras are very popular. Auto-focus lenses actually focus on a subject from various distances. Point-and-shoot cameras can employ auto-focus lenses, but many of them are made to focus on a range of distances. Anything within the given range will be in acceptable focus. Some professional photographers shun the automated machines, but most people love them. You don't need a sophisticated camera to capture your family on film. Simple, inexpensive cameras can give you plenty of good pictures. Spend your money on film instead of fancy hardware and enjoy more photo sessions.

Simplicity and convenience are key elements to look for in a casual camera. Some instruction manuals are so thick that you could stand on them to get eye-level shots of giraffes. This is probably not what you want. Find a user-friendly camera that you can have in action within minutes of unpacking it.

If you shop at a store where the sales staff is knowledgeable about their products, you can get a hands-on demonstration of various types of cameras. This is often the most effective way to evaluate different cameras. It is also a good way to get a head start on the instruction manual. Allow someone in a camera store to demonstrate all of the functions a camera has to offer. Don't just hold the camera, look at it, and agree to buy it. Make the staff of the store earn their keep by showing you all the details of the camera.

Having someone show you, step by step, what every button is and why it is needed can be very helpful. Far too few people take the time to get complete demonstrations before making a camera purchase. Invest your time before you spend your money. You might find that the camera that looks so good is not easy to use. After handling a few cameras, you may find that one is much lighter than the rest. The more cameras you handle and investigate, the better your chances are of finding just the right one.

Cameras have reached a level of development where young children can take top-notch pictures. Having an eight-year-old show you the procedures for using your new gear can be embarrassing, but it might happen. The fact that a camera is simple doesn't mean that it's not packed with features. You can find an easy-to-use camera that will fit most basic needs. Self-timers, auto-load features, auto-rewind controls, auto-focus, fill-flash units, and other time-saving features can all be had with small cameras. Heck, things are so automated now that cameras can almost take quality pictures without the help of a photographer. Chapter 2 will give you a complete rundown on most of these features. You will find additional details on photo flashes in Chapter 5.

People who grow to love photography sometimes keep their first camera, but they usually move on to bigger and better equipment. Buying a complicated, expensive camera for your first experience in photography is not a good idea. You should stick with a simple camera until you gain experience and find your way through the maze of photography methods that you want to master. It is not until you have gained field experience that you can know what your real needs are.

Cameras with Interchangeable Lenses Offer Versatility

Once you get beyond the capabilities of a one-lens camera, you are stepping up into component systems. These systems are not cheap to build, but they offer unlimited photo opportunities. If you are planning to buy components to create the perfect camera system, move slowly.

There are several big-name camera manufacturers that offer extensive component systems. Other manufacturers sell cameras and interchangeable lenses, but don't offer the depth of choice that the big-name manufacturers do. Buying a no-name camera body will severely hamper your ability to compile a professional-quality system. Stick with the big names that offer a wide variety of accessories and lenses. You will pay more for the camera body, but your growth in the hobby will not be stunted by a lack of compatible products.

Watch Out
Once you buy into a specific brand, you should stick with it. This is when buying a cheap camera body and starter lens can be a big mistake. It's sort of like building a rental-car business with a fleet of Yugos.

Buying used equipment can be very tempting. The prices are usually a fraction of what new products sell for. A beginner can benefit from buying used equipment. This is a chance for you to experiment with serious gear without mortgaging your home to pay for it. Consider buying a used system to determine if you really understand your needs. You may find that the 35mm camera you bought isn't ideal for your portrait and studio work. Finding out that you need a medium-format system will not be nearly as traumatic as it would if you had already invested thousands of dollars in a new 35mm system.

Insider Tip
A 35mm, single-lens reflex camera is an excellent choice for breaking into the field of photography. (For more information, see Chapter 3.)

Serious photography can require some serious cash. When you're just getting started, keep your investment low. Don't spend the big bucks until you are sure of what you want and need. You probably won't be able to determine your true needs until after you have spent dozens of hours clicking a shutter.

Your Needs: When, Where, Why, Who, and What?

Profiling your photo needs is a task that should be taken seriously. It would be wonderful if you could do this before you bought your first camera, but most people can't. You will probably buy one or two cameras before you begin to understand fully what your photo

profile is. There are five aspects of your personality and photography tastes that should be considered when creating a description of your needs. Until you can answer all five of the questions comfortably, you will not know for sure what you want from a camera or photography system.

When

When will you be taking pictures? Are you going to be exposing film in low-light conditions, such as early morning or late evening? Wildlife and nature photographers often work with these dark conditions. Will you be using your camera during special events, such as school plays, ball games, or similar situations? If you will, you must assess needs that are specific to your uses. For example, a built-in flash on a point-and-shoot camera may not be powerful enough to illuminate your subject at a distance. Are you dedicated enough to be out in the rain or snow with your camera? If so, you must look for equipment that is made to withstand the rigors of inclement weather.

When you use your camera has an impact on the type of camera you should buy. If you are a grab-and-go photographer who responds to photo opportunities on short notice, you need a system that is lightweight and easy to use. This could apply to parents who wish to record magic moments with their children at the most unexpected times. On the other hand, if you will be staging your shots in a studio, you can opt for more extensive equipment.

Where

Where will most of your photography be done? The simple answers are either indoors or outdoors. But, this is not enough of a breakdown. Let's start with indoor photography. Is your home the primary location for your photography sessions? If so, you will be dealing with incandescent lighting that will require the use of an electronic flash or a filter to retain true colors on color film. If the camera you buy can't accept filters, this may prove to be a problem for you. Most simple cameras don't allow the use of filters, but they overcome this obstacle by making a built-in flash available.

Indoor photography in large buildings can be too demanding for small flash equipment and short focal-length lenses. While a pocket-size, point-and-shoot camera can do fine on a museum tour, it will not produce satisfactory results at a sports arena. The key to success with short lenses and small flashes is getting close to your subject.

Jargon Alert
Focal Length: The focal length of a lens is the distance between the center of the lens and its focal point. The focal point is a point on either side of a lens where light rays entering parallel to the axis converge. We will talk more about this in Chapter 4.

Many people like to photograph flowers and other setups in make-shift studios. If your interests run along this line, consider buying a component system that will allow you full flexibility. A fixed, on-camera flash is seldom a good choice for any type of studio photography.

Outdoor photography can be very demanding on both the photographer and the camera. There are many situations when using your camera outside will result in disappointing images. How many times have you seen people taking pictures at the beach? Would you believe that most of these pictures will have poor and irregular exposures? They will. The bright background fools an in-camera light meter and causes subjects to be darker than they should be. Light reflecting off of white sand or snow will fool the best in-camera meter unless a spot-metering system is employed.

A photographer who is standing in the sun and photographing a subject in the shade will get poor exposures. People feel that electronic flash is rarely needed when taking pictures with good sunlight available. Not so. Natural light often creates shadows on a subject. If the subject happens to be a person, this can result in one side of the person's face being too dark. Fill flash should be used to light a subject evenly when shadows are present. This low-powered flash removes shadows from a picture that is otherwise well-lighted. A full flash will be overpowering and create a harsh effect. If you expect to do much work outdoors, you should consider getting a flash system where you can adjust the power of the flash.

Why

Why are you taking pictures? Most people take pictures to memorialize trips and family members. If you want to go to a zoo and come back with a selection of pictures that will remind you of the animals you saw, almost any camera will get the job done. But, if you have aspirations of seeing your zoo shots on the cover of a magazine someday, you will have to invest in some serious component equipment. Getting a close-up shot of Uncle Fred and the big trout he just caught is easy. Framing the eye of a grizzly bear in your viewfinder is not so simple.

When you ask yourself why you want to take pictures, you open the door to more questions. Is your goal to have a camera around the house for when the kids do something cute, or are you looking for a hobby that you can grow with? A point-and-shoot rig is all you need for fast family photos. If you want to build a serious hobby around your passion for photography, a component system is in your future.

Who

Who will you be taking pictures of? Are your subjects going to be fast-moving children or relaxed adults? Will you be taking group photos at family reunions and similar meetings? Are you going to pin on your press pass and go in search of celebrity photos? Define who your subjects will be before you commit heavily to any type of camera system.

Fast-moving subjects require fast shutter speeds to avoid blurring. A 35mm, single-lens reflex camera is the best choice for this type of subject. (See Chapter 3 to learn more about this camera type.) Group photos often require a wider-than-average lens coverage. A lens with a rating of 24mm to 35mm is a good, all-round choice. Zoom lenses that offer a range of focal lengths are also good options. Pictures that must be taken from a distance should be done with a camera that has, or can accept, a telephoto lens. Telephoto lenses that range from 100mm to 300mm are good choices, and you can buy this type of lens in a zoom configuration. (Lenses are covered in more detail in Chapter 4.)

What

What will you take pictures of? People are a frequent subject for photographers. Any decent camera can handle the requirements of people photography. Landscapes are a popular subject with outdoor photographers. If you are into this type of work, you will need a component system with a variety of lenses. Maybe your idea of fun is crawling around in the woods in search of rare insects to photograph. If this is the case, you will want a component system that can handle macro lenses and bellows. See Chapter 4 for more information on macro lenses and bellows.

The subject matter that you will seek with your camera often dictates your needs. It's not reasonable to think that you can take quality pictures of wildlife with a pocket-size camera and lens. Neither is it rational to consider using a large-format camera to record the movements of butterflies. While a view camera works well in photographing the Grand Canyon, it's a bit clumsy to set up for home photos.

It is difficult to find one camera that works well for all needs. However, few people experience a desire to do all aspects of photography. Once you define what you want to achieve with your camera, deciding which camera to buy will be much easier.

Jargon Alert
View Camera:
This is a large camera that enables through-the-lens viewing directly onto a ground glass. The camera is focused with the use of a bellows and typically uses sheet film. A view camera is ideal for large landscape photography.

Question	Yes	No
Will I be taking pictures in low-light conditions?		
Will a small flash meet my needs?		
Are snapshots my primary photo interests?		
Is close-up photography important to me?		
Will I use fill flash in outdoor pictures?		
Do I want my photos to be of a professional quality?		
Is a point-and-shoot camera going to suit me?		
Should I consider a component system?		
Are group photos something I will do?		
Do I need a long telephoto lens?		
Are people my main subjects?		
Will I shoot mostly outdoors?		
Do I need a large range from a flash?		
Do I have a desire for serious photography?		
Will an auto winder be important to me?		

The Least You Need to Know

➤ Take your time when shopping for camera equipment. Read technical reports, talk to experts, and compare different types and brands of equipment.

➤ Keep a notebook in which to record your thoughts and findings as you are shopping for photo gear. List and analyze your needs before you purchase equipment.

➤ Sometimes simple is better. If you are looking for family snapshots and other types of casual pictures, don't bog yourself down with an expensive component system; go with a point-and-shoot camera.

➤ Before you build a component system, make sure that you are buying into a name-brand that will allow you to extend your hobby as far as you want.

Simple Cameras for All Occasions

In This Chapter

➤ Putting it on autopilot

➤ What can go wrong?

➤ How much money?

➤ Frustrating flashes

➤ Extending lenses

Do you want a camera that will do all the work for you? Are you looking to spend less than $200 on a camera? Have you been curious about pocket cameras that preach the point-and-shoot principle? If so, you're in the right chapter. The camera equipment discussed here is simple, inexpensive, easy to use, and can produce terrific photographs. As you read this chapter, you will learn all about point-and-shoot cameras and where they work best. You will also be introduced to on-board flash units and zoom lenses that are built right into cameras. In short, this chapter will tell you all you need to know to assess your interest in a simple camera.

Auto-Load, Auto-Wind, Auto-Everything

Modern cameras are being made to do everything on their own. With a self-timer, a camera can even decide when it's the right moment to freeze time on a frame of film. Today's cameras are incredibly smart. There has never been a time when getting into photography was so easy—that is, assuming you can figure out what all the buttons, knobs, and levers on a new auto-everything camera do.

In some ways, older cameras were less frustrating to work with. New automatic cameras can be a challenge for anyone to figure out. It's kind of like setting the clock on your VCR. If you take the time to learn the steps involved with the process, it's not difficult. Automatic cameras can be intimidating at first, but they are a joy to use once you have mastered the controls.

The amount of automation found in a pocket camera varies from manufacturer to manufacturer. Price is also a factor in the amount of automatic functions a camera performs. I think automatic cameras are like computers; they're fantastic when they work properly and a pain in the neck when they don't.

How simple are today's point-and-shoot rigs? Very simple. In fact, let me tell you a little about the controls on my daughter's camera. The camera is a focus-free, point-and-shoot model. It has a ridged bar that slides back and forth to turn the flash on and off. A similar bar slides back and forth to open or close the lens covering. A large, red button sits atop the camera to fire the shutter. A small button on the right side of the camera body is moved up to open the camera back in order to load film. Once a film leader is placed on the film spool and the camera back is closed, the film winds into place automatically. Each time a picture is taken, the film advances automatically. A trapdoor on the bottom of the camera conceals the two AA batteries needed to power the package. A final button is situated on the bottom of the camera. When an entire roll of film has been used, this button is moved slightly to the right to automatically rewind the exposed film.

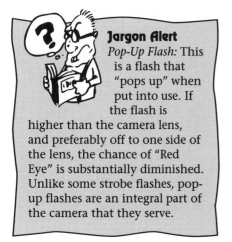

Jargon Alert
Pop-Up Flash: This is a flash that "pops up" when put into use. If the flash is higher than the camera lens, and preferably off to one side of the lens, the chance of "Red Eye" is substantially diminished. Unlike some strobe flashes, pop-up flashes are an integral part of the camera that they serve.

With my daughter's camera, photography can't get much simpler. After film is loaded, there are only two or three steps involved in recording an image. The shutter cover is opened and the shutter button is pushed. If flash is needed, the flash bar must be turned on. It doesn't get much easier than this.

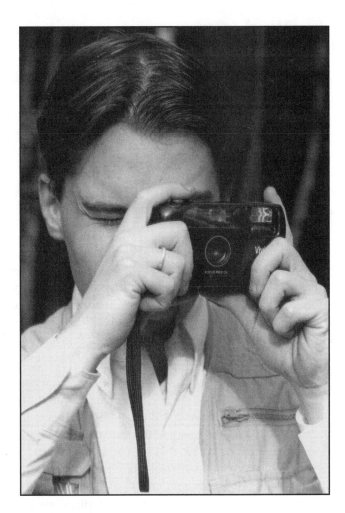

Here is an example of a very inexpensive direct-view camera.

Shop and Ye Shall Find

I recently browsed through a sales flyer from a major discount chain store. For less than $40 you can buy a 35mm point-and-shoot camera from a name-brand manufacturer. The camera has a built-in flash and sets film speed automatically. For $10 more you can get a different brand of 35mm camera that offers a pop-up flash (to reduce the red-eye effect in portraits), automatic film prewind, and film advance. This model happens to have a 35mm lens. For less than $100 you can buy a premier-brand pocket camera that offers built-in flash, a 38mm wide-angle lens, a 70mm telephoto lens, three shooting modes, and a 3-beam auto-focus system. As you can see, it's possible to get into decent cameras with minimal money.

Another camera featured in the flyer is also from a major name in photography products. This honey of a camera sells for less than $140 and does everything you could want a casual pocket camera to do. You have a 38mm to 70mm zoom lens, a 200-step auto-focus system, automatic film loading, advancing, and rewinding, an automatic flash with red-eye reduction, a self-timer, fill flash, and night-scene flash. Wow! That's a lot of punch in a little package.

If you move up the purchase-price ladder, you can find cameras with built-in zoom lenses with ranges in the neighborhood of 38mm to 140mm. Some models will imprint your photos with a date and time stamp. Not many professional photographers use pocket cameras as their primary tools, but I know many who use them for quick shots that would evade typical professional equipment. Don't be fooled by the Do-Little cameras, they can actually do quite a lot.

Many point-and-shoot cameras are equipped with a fixed-focal-length lens in the 35mm range. This is a fine choice. A 50mm lens is considered a standard lens. Basically, this means that a 50mm lens sees images with a likeness similar to what the human eye sees. A lens with a longer focal length, such as an 85mm lens, is a telephoto lens. A 35mm lens is a mild wide-angle lens. Using a 24mm lens is good for landscape photography, but not for portraits. A lens in the 35mm to 70mm range, especially if it is a zoom, should serve you well. Consult Chapter 4 for more details on lenses.

We've been talking about 35mm equipment up to this point. If you want to do much quality photography, a 35mm camera is an excellent choice. You might be tempted by the super low price of a 110 camera, but avoid this temptation. The quality of pictures taken with 110 and 126 cameras can't compare with those made from a 35mm camera. A camera with a 110 format produces negatives that are about one-quarter the size of a 35mm negative. This results in images that are not sharp and that will not enlarge well. Many flaws will be noticeable if 110 film is enlarged. Cameras with a 126 format use drop-in film cartridges, as do 110 cameras. The cartridges do not allow for proper film placement, so picture quality is often poor. It's not a bad idea to introduce a young child to photography with either a 110 or 126 camera, but that is about the only good reason I can think of for buying one. Even if you are looking for something at the bottom rung of the photography ladder as a starting point, don't go smaller than 35mm.

What Could Possibly Go Wrong?

If you think that nothing can go wrong with auto-everything cameras, you're wrong. A lot can go wrong with any automatic camera. While most pocket cameras are simple to operate, they can produce some annoying problems for the people who use them. Let me explain.

Is the Film Wound Correctly?

Imagine that you are on your dream vacation. Part of your fantasy is to amass photographs that will help your memories live forever. You load a 36-exposure roll of film in your auto-load camera, close the camera back, and hear the winder running. You begin your journey, snapping pictures of once-in-a-lifetime scenes as you go. It seems like you have taken a lot of pictures without reloading, so you check your camera. Oh no! The automatic film loader and advancer missed the end of your film and didn't wind it. You've been pushing the shutter button on a camera that isn't loaded properly. The result? You've got no pictures to maintain your memories. This can happen.

Watch Out
Many photographers using direct-vision cameras obstruct their lenses accidentally with a finger or strap without knowing it until their film is processed. Since the viewfinder on this type of camera is offset from the lens, you can't see if your camera strap or finger is in part of your picture.

Battery Failure Foils Your Fun

One of the most frequent problems with an automatic camera is not the camera's fault. It is a dead or dying battery. They're a bear to bury. Get a spare battery for your camera and, like the credit card company says, "Never leave home without it!" Low battery power can cause a number of difficulties with an automatic camera. A dead battery can put the camera completely out of commission. Rotate batteries frequently when using or storing your camera in cold temperatures. If your camera has a battery-check indicator, use it. When working with a camera that doesn't provide information on remaining battery life, always be prepared to replace old batteries on a moment's notice.

Red Eyes Ruin Flash Pictures

Even if you have never taken a single photograph, you've probably seen the handiwork of the red-eye monster in photos you have seen. This evil creature lives in the flash unit of many cameras. When an on-camera flash is used to take a portrait, it often taints the photography by turning the subject's eyes bright red. Some pocket cameras offer a red-eye reduction system. Others incorporate a pop-up flash that can help to keep the monster caged. Increasing the light in a room will also reduce red eye. However, unless

Jargon Alert
Red Eye: This is when the eyes of a subject are red in a photograph. The problem is caused by having a flash that is too close to your lens. It is a common problem with point-and-shoot cameras.

you move up to component systems where the flash you work with is offset to one side of the lens, you might meet the monster eye-to-eye, so to speak.

17

Understanding Your Field of Focus

Cameras may also have problems with focusing if they employ auto-focus. There is a difference between point-and-shoot cameras and auto-focus cameras. Point-and-shoot cameras have a set range in which objects appear to be in focus. Auto-focus lenses adjust their focus based on the location of a subject. As good as auto-focus lenses are, they can be fooled. As an example, if you were to take a family portrait using a self-timer, you might find that part of your family was soft in terms of focus. If you were all standing side by side, the auto-focus should work well. But, if some of the family is in front of the rest of the family, the auto-focus is likely to lock in on only some of the subjects. This results in a picture with some distortion in it.

Automatic Flashes Aren't Foolproof

Automatic, built-in flashes sound good on paper and in advertisements, but they can limit your creativity. They can also fail to meet their minimum requirements. The sensors that trigger an automatic flash can be fooled by light patterns. Let me give you an example.

Let's say that your children have just been chosen to star in a school play. You want to capture the moment on film. Hastily, before the mood changes, you pose your children in front of a window. There are no blinds or curtains, and natural light is flooding into the room, behind the kids. Quickly, you point and shoot on autopilot. The flash doesn't fire, but you assume this means it's not needed. After all, it's supposed to fire when light levels are low. The natural light behind your children has just fooled the camera. When you review the picture taken, you will find that you have a nice, dark, silhouette of your kids. Their cheerful faces will be hidden in the dark exposure. Creative options for built-in auto-flashes are limited. We'll talk more about the use of electronic flash before the end of this chapter.

The Risk of Malfunction

The more automated your camera is, the higher the risk is that something will malfunction. This should not scare you away from the versatile, easy-to-use pocket cameras. If you stick with a major brand of camera, you should not experience many problems that are not associated with the operator of the tool. Make sure your film loads and advances properly. Keep fresh batteries in your camera. Use common sense on exposures, and choose your film carefully. If you follow these simple instructions, your little black box should give you good pictures.

OOOH...

Insider Tip

Keep your film cool and your batteries warm. Cold robs the power from batteries, and heat shortens the life of film.

There is very little that is more frustrating to a photographer than to be pushing a shutter button that won't trigger the shutter. This is a common problem with pocket cameras when their batteries get low. Keep fresh batteries in your camera at all times.

Shade Your Lens in Bright Sunlight

Sun flare can be a nasty problem when using a pocket camera. You can overcome this by shielding the lens of your camera from the sun with your hand. But if you're not careful, your hand will wind up in the picture. Since lens shades won't work on flat-faced cameras, you have to protect the lens by some other means. The human hand is usually the most effective. If you don't prevent stray light from shining on your lens, you will see bright spots that resemble stars or doughnuts on your finished prints.

Should I Spend $50 or $150 for a Casual Camera?

How much should you spend for a pocket camera? There is no cut-and-dried answer to this question. Photographers who are willing to spend upwards of $100 will benefit from many good features and can be comforted in knowing that they are buying a major brand of camera. A casual user should budget between $100 and $200 for a good, dependable camera that can be used for snapshots. Cheaper cameras will produce acceptable images, but you will not gain the many automated features. More expensive models have bells and whistles that you probably don't need. If you target $150 as your budget figure, you should find a variety of quality pocket cameras within your budget.

You can certainly enjoy taking pictures with a camera that costs less than $100. However, if you get too stingy in your selection, you may become disappointed and frustrated with your results. This could lead to a lack of interest in the hobby. Don't set yourself up for failure by cutting too many corners on the equipment that you purchase.

The Flaws of Built-In Flashes

For the money you spend and the purposes intended, pocket cameras with built-in flashes are a good bargain, and they do a good job. Don't expect this type of camera to provide you with professional-grade photos on a consistent basis. It won't happen. You should expect some problems with these types of cameras, so shoot more than one shot of each scene. This is good advice for any photographer with any type of equipment. Switch positions and take several shots of special scenes. Leave as little as possible to chance. Built-in flashes are both practical and convenient. You don't have to worry about mounting brackets or dangling cords getting in your way. Since built-in flashes are with your camera at all times, you are always prepared for low-light shooting. There are, unfortunately, some flaws associated with integral flash units.

Most pocket cameras are made with built-in flash units. This does not mean, however, that the flash will be adequate under all circumstances. You can only expect so much from a tiny flash unit. I mean, would you use a toothpick as a bat in a Major League baseball game? I've known a number of rookie photographers who have been devastated that their flash pictures didn't turn out well when using small, onboard flash units. The types of problems vary, but they continue to turn up.

One of the most frustrating aspects of an on-camera flash is the red-eye look it can create in portraits. When you take a picture of someone, you hope to see them looking natural in your finished photograph. All too often, this is not the case when the picture is taken with a pocket camera that is equipped with a built-in flash. When a flash is mounted in close proximity to a camera lens, it is common for people pictures to be marred by bright red eyes. There is no good way to avoid this when the flash unit cannot be relocated. If you buy a pocket camera, look for a model that offers red-eye reduction or a pop-up flash. You will still suffer from some red-eye experiences, but they will occur less frequently.

Jargon Alert
Hotspot: This is a concentration of light in one particular area of an image.

Harsh lighting is another problem common with onboard flash units. Flashes that you do not have exposure control over, such as most of the flashes on inexpensive cameras, can produce hotspots. Since the power of the flash cannot be adjusted manually, you may experience overexposure in your flash pictures. Taking a picture of your child on Santa's knee may leave you with glaring reflections in Santa's glasses. Uncle Ed's balding forehead may bounce the flash right back at your lens, creating a hotspot. Again, if the flash cannot be moved or controlled, you are bound to deal with some problems. Convenience doesn't come without its cost.

The first time you take a pocket camera with a built-in flash to an event and attempt to take a picture at some distance, you will probably see just how inadequate the flash is. You have to be up close to get good results with tiny flash units. Professional flash units can reach out for 60 feet or more, but don't expect more than a few feet, say about 10 feet, of effectiveness from a built-in flash.

Depth is not the only concern with small flash units. The width of coverage with these little lighting devices can also lead to disappointment. While professional flash units can be fitted with accessories for normal, wide-angle, or telephoto use, integral flashes don't enjoy this flexibility. You may find that the edges of your pictures are too dark when you operate in a wide-angle mode. This is a problem known as vignetting.

Jargon Alert

Vignetting: This is a condition where the edges of a picture are dark. It is often caused by using a flash that emits a beam of light that is too narrow for the lens being used. It can also be caused by a lens hood on a wide-angle lens. This is usually not a problem with simple, point-and-shoot cameras. The flash units on these cameras are designed to work with the lens on the camera. However, when you are working with an interchangeable lens system, where you might go from standard to telephoto to wide-angle lenses, the problem can manifest.

When you buy a camera that has automatic film advancing, you expect to be able to shoot pictures as fast as you can pop the shutter. Well, you can, but don't count on your flash keeping up with you. The recycling times for flash units vary. This is true of even very expensive models. If you try to shoot flash pictures in rapid succession, you may find that your flash can't keep up with your auto winder. This, however, is something that you can test in a store before you buy a camera.

To test the recycling time of a flash, load batteries into the flash and camera it will be used with. Turn the flash on. When the ready-light glows, push the shutter button on the camera. If the flash doesn't fire every time that the shutter clicks, you know that the flash can't keep up with the auto winder. (By the way, film is not needed for this test.)

You can't angle or bounce light from a typical built-in flash unit. All of your lighting is coming at a subject head-on. This is rarely flattering in portraits. While a built-in flash can provide good lighting for a technical reproduction of a scene, it does not offer the creative options that other types of flash units do.

Integral Extending Lenses

When you buy a pocket camera, you have several options on the type of lens your unit will use. Inexpensive models will have one fixed-focal length. A 35mm lens is common on pocket cameras. This is a borderline wide-angle lens. It's good for getting a lot in a picture, but it's not suitable for taking shots of subjects that are some distance away.

A normal lens is generally considered to be a 50mm lens. This lens is supposed to see subjects in the same way that a human eye does. Anything smaller than a 50mm lens is heading into the wide-angle category. When the lens size gets very small, you're into fisheye lenses. Lenses with focal lengths greater than 50mm are working toward telephoto ratings. See Chapter 4 for more details on lenses.

Many pocket cameras offer zoom lenses of one sort or another. This type of lens is a good investment. It gives you much more control over your pictures. A good, all-round zoom lens is one that has a range of 35mm to 70mm. For average photography, you would not want a lens with a rating smaller than 35mm. Zoom lenses with wide ranges offer the most versatility.

Keep in mind that the built-in flash on a pocket camera may not offer enough power to light a subject properly when a telephoto setting is used on the lens. This is not always the case, but it is something that you should investigate. You can find details in most instruction manuals that will specify the limits of a flash unit.

If you buy a camera with a lens that can go from 35mm to over 100mm, you're in good shape. This range of focal lengths is adequate for most average photo situations. It is not suitable for wildlife work, but it will cover everything from people to landscapes, with some other subject matter thrown in for good measure. A 35mm lens gives you good landscape potential. Lenses that are rated at 85mm perform very well with people. Longer lenses can be used for subjects that are not as accessible. Getting a camera with zoom capabilities is in your best interest.

Announcing the New Tele-Hawk Point-and-Shoot Camera

Other cameras are now obsolete. The new Tele-Hawk is the only camera you need, and it comes with many accessories built into it. Leave your camera bag at home and carry only our lightweight pocket camera that packs a powerful punch. With a 35mm to 70mm zoom lens, you don't have to bother with other lenses. The larger, brighter viewfinder makes it easy for you to compose perfect pictures. The automatic flash offers four modes of operation. You have, at your fingertips, a setting for low light, a fill-in-flash mode, our patented slow-synchro flash for night work, and an off mode for natural-light conditions. Don't overlook the built-in macro mode for close-ups and the automatic back light compensation to save you from poor exposures. There is even a motorized, continuous shooting system on board this beauty. You will enjoy an electronic self-timer and multi-exposure capability. Film is loaded, advanced, and rewound automatically. If you have Tele-Hawk, the only other thing you need is film. See your nearest camera dealer for full details.

Descriptive Paragraphs

The above ad makes the camera sound like the biggest revolution in photography since the electronic flash. Is the camera really that great? Let's tear the ad apart and find out. Take notes on this, because you will find a lot of fluff in ads that doesn't mean much.

First of all, the ad claims that this camera is the only one you will need. I doubt it. Point-and-shoot cameras are basically limited to snapshot photography. If you want to photograph wildlife, extreme close-ups, or similar specialized subjects, a point-and-shoot is not the right choice.

The 35mm to 70mm lens on the camera is a good choice as a basic lens. However, you will be limited in landscape photography with a 35mm lens. A 24mm is much better. A 70mm lens is a small telephoto, but if you really want to reach out and touch someone with your film, you need at least a 200mm lens.

The part about a larger, brighter viewfinder is okay. If you notice, the company is really pitching its four-mode flash system. Well, one of the modes is off, how tough can that be? Almost any point-and-shoot camera has a standard, onboard flash. So, that leaves us with two modes to consider. The fill-in flash is a nice feature. But, I doubt if people using a pocket camera are going to have many occasions when they want to paint with light at night. It is also questionable that such a feature will perform well on this type of camera.

The ad refers to a macro mode for the lens. In my opinion, the ad should call it a close-focus feature. Macro lenses are very special in their design, and I seriously doubt that any camera like this has a true macro lens that is also a zoom and standard lens.

The back light compensation feature is okay, but there are times when back lighting is used to create special effects. Can you disable this feature for those kinds of shots? I doubt it. This sounds more like a sales hook to me.

The auto-loading, auto-winding, and auto-rewinding is pretty standard on most newer point-and-shoot cameras. If this camera is so sophisticated, I would think that the marketing team could come up with better features and benefits to throw into an ad.

Having a self-timer is good, and it is not a common feature on small cameras. The same is true of multiple-exposure capability. These seem like solid features to pitch. I don't doubt that this camera is good, but we don't know how much it costs. Does it have auto-focus capability? I didn't see anything about that. Is there a focus-memory button to allow you to take close-up readings and focus before you are ready to shoot? I didn't see anything about it. Obviously, you would have to go to a dealer for a full demonstration and review the camera manuals before you could make an informed buying decision. Ads like this one can be deceptive. While this one doesn't seem to be lying to you, it is leaving a lot of questions unanswered.

The Least You Need to Know

➤ Don't underestimate inexpensive, point-and-shoot cameras. With the right features, this type of camera can give you dependable, acceptable photographs on a steady basis.

➤ Avoid the temptation to buy 110 and 126 cameras. Set your sights on a 35mm camera.

➤ Look for a camera that offers a zoom lens. Ideally, the lens should have a low-end rating of around 35mm, and the stronger it is at the other end, the better off you are.

➤ Built-in flash systems generate a lot of red-eye pictures. Shop for a camera that offers a red-eye reduction system.

➤ Shoot test exposures to get to know your flash capabilities. Don't wait until your film comes back from the lab to find out that your subject was too far away to be illuminated by your flash.

Building Your Own Semi-Pro Camera System

In This Chapter

- ➤ Finding the right sized system
- ➤ Committing to one brand of camera
- ➤ Finding great equipment deals
- ➤ When smaller is better
- ➤ Big images—big bucks
- ➤ The lazy way to wind your film

You don't have to be a professional photographer to benefit from a component system. But, if you want to become a pro, or even a semi-pro, you have to go this route. What is a component system? It is a group of photography equipment that makes up a viable tool for handling a variety of photographic situations. At the least, it is a camera body and some interchangeable lenses. It can include independent light meters, filters, flash units, and much more. When you get into component systems, you are stepping up in price, but you can build these systems over time without breaking your bank account. If you are truly serious about wanting fantastic photos, this is the only way to go.

The first element of a component system is a camera body. This is the heart of a system. It is what holds your film and allows you to make many exposure settings. Lenses are the second important piece of the puzzle. There are lenses for all occasions, and you will learn more about them in the next chapter. As you continue to fill out a component system, you will probably want an electronic flash. See Chapter 5 for advice on these items. The more advanced you become, the more you will want. An independent light meter is sure to be on the wish list of a serious photographer. Chapter 7 will fill you in on various types of meters. The extent that you can go to in building a system is nearly unlimited. In this chapter, we are going to talk about format sizes, brand-name equipment you can depend on, used cameras, and automatic film-advancers.

Picking a Brand Name that You Can Stick With

When you choose a particular brand of camera to build a component system around, you must be judicious. Once you start with a brand, you should stick with it. There are many brands of cameras available that will give you professional-quality photos. Some brands offer more lenses and accessories than others do. This is important to a person who is building an extensive system.

When I think of professional 35mm equipment, two brand names come to mind, Nikon and Canon. Other manufacturers of 35mm equipment get some professional attention, but there are clearly two, or maybe three, leaders. In medium-format equipment, one name is king, while others are also respected. You don't have to buy into the best-known brands to get good service and quality, but it doesn't hurt. The important thing is to pick a brand that you can grow with.

How will you know what brand of camera to work with? Many factors may play a role in your decision. The amount of money you are willing to spend for various types of equipment is one consideration. Top-notch names command big prices. You can go with a lesser-known name and get good quality for a lower price. But make sure that your budget-minded purchase has enough lenses and accessories available to keep life interesting as your skills and interests grow.

My first 35mm camera was a Minolta. It was a good camera that gave me thousands of wonderful pictures. This brand is respected among professionals, and it offers a wide variety of options for building a component system. When I grew into a new level of photography, I switched to Canon equipment, which I still use today. I love it! Canon is a major contender in the professional market. Over the years, I've spent well over $10,000 to develop my system. Nikon is known for its reputation among professionals. The name is almost synonymous with professional. Any of these brands will provide you with more options than most people can afford to buy. And, there are other good brands, like Olympus, to choose high-quality products from.

Before you buy a camera body, do some research. Look at a listing of what accessories are available within the brand. Check prices on the various brands. If you can see that there is a depth of support accessories and that you are comfortable with the price ranges, you're well on your way to picking a brand. Handle various cameras and operate them in the camera store. Have someone at the store run through all of the controls with you. When you buy your first camera body, you set the tone for your entire system. Don't buy until you are sure that you like the brand.

Generic lenses can be used on most camera bodies, but this is somewhat self-defeating. Why pay a small fortune for a professional camera body and then attach a dime-store lens to it? This doesn't make sense. Your lenses have a tremendous impact on the quality of your photographs. Try to keep all of your purchases within the same brand. This will normally produce the best results. (We'll talk about lenses more in Chapter 4.)

Top-notch lenses made by camera manufacturers will usually fit only one brand of camera. For example, a Canon lens will not work on a Nikon camera. This being the case, you must venture into lesser-known names to get supplemental lenses that are not made by the manufacturer of your camera body. Many accessory lenses can produce good photos, but your best images will probably come from lenses made by your camera manufacturer.

If you're looking for a medium- or large-format camera, you can't go wrong with a Hasselblad. This name is well-known among professional photographers. Mamiya is a good brand to get into, and so is Bronica. To buy these types of cameras, you need deep pockets that are filled with money. Most casual photographers don't need to go to this expense to obtain fulfillment from their hobby. However, if you want to, any of these brands will serve you well, and brands like Pentax can also meet your needs. We'll be talking about medium-format and large-format cameras later in this chapter.

The durability and smooth functioning of big-name cameras is a primary reason why they are so expensive. Also, the lens elements (pieces of curved glass that refract light and funnel it to a destination) in lenses, as well as their coatings, contribute to higher prices. Professionals who run dozens of rolls of film through their cameras on a daily basis can't get by with a consumer-grade camera, but you can.

Buying a Used Camera is a Wise Way to Move into Photography

Buying used camera equipment makes a lot of sense when you are entering the hobby. Not only will your out-of-pocket expense be considerably less, you will also get to experiment with equipment that you can resell if you find you don't like it. Sure, you can sell

new stuff too, but you will lose a lot of money in the process. Camera gear depreciates rapidly in most cases, so buying used equipment allows you to take advantage of the price drop instead of being nailed by it.

There are three basic ways to acquire used photography equipment. You can consult one of the many mail-order advertisements, go to your local camera store, or watch classified ads where individuals are selling their old equipment. If you are dealing with a reputable company, you should gain some protection from cameras that are duds. Buying person-to-person doesn't afford this protection.

If you know enough about the type of gear that you are buying, you can test it before purchasing it. Since you may not yet have this type of knowledge, a reputable dealer who sells used equipment is probably your best bet. Dealers charge more than most individual sellers do, but you should be getting some peace of mind for the higher price you pay.

Regardless of who you are buying from, get a full demonstration of the equipment before you hand over your cash. Ask for all manuals and documentation that should accompany the camera and accessories. If no documentation is available, you might want to pass on the sale and continue your search. It may be possible to order new manuals from the original manufacturer, but don't count on this being the case. Used equipment provides an economical and sensible way to enter the field of photography, but make sure that what you are buying is in good working order.

When you inspect used equipment, always put the equipment through a full operation. In other words, cock the shutter and push the shutter button. Do you hear the shutter click? Watch to see the shutter move. If the camera has a removable lens, remove it. Depending on the type of equipment you are buying, the test methods will vary. Basically, do everything with the equipment that it is intended to do and see if it seems to work properly. Well-made photo gear can easily last for decades, so don't be frightened off by older stuff. A lot of my equipment is pushing twenty-years-old, and it all works flawlessly.

What Should I Buy?

Knowing what type of equipment to buy is something that comes naturally to some people. But, it can be difficult for others. There are various camera formats available to you. Each has its place. Some are more versatile than others. For general-purpose photography, a 35mm format is best. Medium-format cameras are good for taking pictures that will be enlarged. Large-format equipment is suited to landscapes. To get more specific on this subject, let's look at the various formats individually.

35mm, The Choice of Champions

The most versatile type of camera that you can buy is a 35mm format. You can do almost anything with this type of rig. Large- and medium-format cameras have certain advantages over 35mm units, but the handy 35mm is by far the more popular. This popularity is well-founded.

A quality 35mm camera can be outfitted with lenses that range from fisheye to super telephoto. You can install macro lenses, bellows, auto winders, high-powered electronic flashes, and other accessories. The next two chapters will help you to identify and understand lenses and flashes. With the camera set up properly, you can photograph any subject successfully. You can even mount a 35mm camera on a microscope or telescope for exciting and unusual pictures.

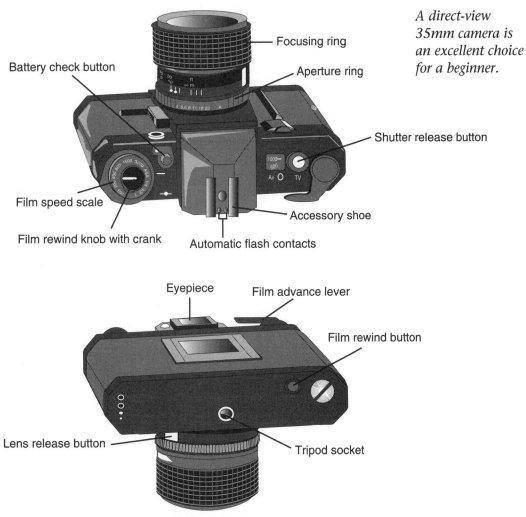

A direct-view 35mm camera is an excellent choice for a beginner.

Focusing ring

Battery check button

Aperture ring

Shutter release button

Film speed scale

Accessory shoe

Film rewind knob with crank

Automatic flash contacts

Eyepiece

Film advance lever

Film rewind button

Lens release button

Tripod socket

What makes the 35mm system so desirable? It is lightweight and easy to use. The cost of 35mm equipment is much less than that of larger formats. You can equip a 35mm camera body with a wide-range zoom lens and meet most of your photo needs without ever changing lenses. Many zoom lenses incorporate a close-up feature in the lens so that you can shoot anything from insects to airplanes with the same lens. Film for the 35mm format is readily available in all areas and is not too expensive. Processing for the film is also easy to arrange. All things considered, there is no wonder why the 35mm format is a favorite.

If you want to get serious about photography and build a component system, the 35mm format will most likely be the best choice. As long as you buy into a major brand name, you will find a seemingly endless supply of accessories to add to your collection. Gee, I wonder if manufacturers planned it this way? Here are some of the goodies you might buy:

Jargon Alert
Fisheye Lens: This is a lens where barrel distortion is sacrificed to obtain an angle of view of up to 220 degrees. In layman terms, it is a lens that gives you an almost round perspective of the world around you. Fisheye lenses are not very practical, but they can be fun to work with for special effects.

➤ A camera body

➤ Interchangeable, fixed-focal-length lenses

➤ Interchangeable zoom lenses

➤ Lens filters

➤ Electronic flash

➤ Independent light meter

➤ Tripod

➤ Monopod

➤ Macro lens

Of course, you don't have to buy everything at once, and you don't need everything on this list. A camera body and lens is all you need—except for film—to get started. Build your system slowly, as your interests and needs define themselves.

Insider Tip
Camera lenses are expensive, and they can be damaged easily. Purchase a UV-haze filter to install on each of your lenses. The filter is inexpensive and protects the valuable glass on your lens. This is cheap insurance against scratches and dings. See Chapter 7 for more filter options.

A name-brand setup, like the one mentioned above, will cost between $300 and $500, depending on the brand and features you buy. This is not a lot to pay for all the features and flexibility you will get. Remember, the camera body is the foundation of your system. The body you buy will play an important role in the development of your overall system. Once you know what you want to do and which brand you prefer, buy the best body you can. Cutting corners on the camera body will hamper your growth as a photographer.

Large-Format and Medium-Format Cameras Can Cost a Fortune

Don't even think about buying into a medium- or large-format system unless you have thousands of dollars to spend. You can expect to spend in the neighborhood of $2,500, at mail order discount prices, for a starter unit in a medium-format camera. One camera body that I checked pricing on in a medium-format was nearly $6,500, just for the body! Few photographers can afford this type of equipment unless they are making their livings with it.

What's the big deal about medium- and large-format cameras? Medium-format cameras are used extensively in studio photo sessions. They are also used by professionals for weddings, commercial photography, portraits, and similar types of shoots. One of their main advantages is the fact that they produce a larger negative than a 35mm system does. The larger negative enables darkroom technicians to perfect a picture so that it is nearly flawless. Since 35mm negatives are smaller, they are harder to work with in a darkroom. Enlargements lose some sharpness when they are made. This is less apparent with medium- and large-format negatives.

There is often some confusion over various photo formats. If you're feeling a little uneasy in your understanding of what all this format stuff means, relax. Let me put the facts into plain talk for you.

A medium-format camera is one where the photographer normally looks down into a viewfinder on the top of the camera. This type of camera is also called a roll-film camera. The film used in a medium-format camera produces a negative that is anywhere from three to five times larger than negatives made with a 35mm system. This larger negative allows for higher-quality enlargements and more creative darkroom work, such as airbrushing out blemishes or adding color.

Very few amateur photographers use medium- or large-format equipment. Film and processing is more expensive than it is for a 35mm format. The cost of equipment is considerably more, and an average person doesn't need the professional edge that larger negatives give.

Large-format cameras can produce negatives that are a full 8 × 10 in size. Think about this. The negative is the same size as many photo enlargements. As you might have guessed, this large negative can produce some impressive enlargements. Landscape work is the most common subject for large-format cameras, but they are also used in commercial advertising photography.

Jargon Alert
Covering Power: This is the maximum area of clear image that a lens can produce. To be effective, a lens must produce covering power that is greater than the image size and film format.

Large-format cameras are used by landscape photographers who are very serious about what they do. These cameras often sell for several thousand dollars. Unless you have money to burn and a dedicated interest in landscape and technical photography, you don't need a large-format camera. You can have more fun with a 35mm camera and save a lot of money in the process.

Auto Winders and Motor Drives

Many modern cameras are made with built-in film advancers. Depending upon the design, your film advancer may wind your film onto the spool reel automatically when the film leader is in place and the back of your camera is closed. Again, depending on the type of advancer you buy, it will probably advance spent film on a frame-by-frame basis or on a continuous basis. By continuous, I mean that as long as you hold down the shutter release, you will get rapid-fire pictures. Many newer cameras also rewind a roll of film when it is depleted. This was not the case a few years ago. If you buy an older camera, you may have to advance the film manually. How prehistoric! However, you can buy an auto winder or motor drive for most older 35mm cameras. Do you need one? No, but they are convenient, and they do let you take pictures at a faster rate.

Add-on auto winders and motor drives don't load your film automatically or rewind spent film. Their purpose is to advance film as you are taking pictures. Most of them will work in two modes. One is a frame-by-frame mode and the other is a continuous mode. I must warn you that a lot of film can be exposed in a hurry with a motor drive on a continuous setting.

Add-on auto winders are slower than motor drives; they are also much less expensive. While a typical auto winder may advance film at a rate of three frames per second, a motor drive might push the film through at five frames per second. Auto winders are sufficient for the needs of most photographers. If you're buying a new camera, there is a good chance that it will already be equipped with an auto winder.

There are a few advantages to having your film wound automatically. The most obvious is that it eliminates one step for you to remember. When you click your shutter, the film advances automatically and is ready for the next picture. This saves wear and tear on your thumb and it conserves time. It also prevents the embarrassment of pushing your shutter button only to find that you have not advanced the next frame of film to the shutter.

Auto winders and motor drives are very valuable to some types of photographers. If you are shooting frame after frame of a fast-moving model, having your film advanced automatically is a big advantage. A photographer who is documenting a bird in flight or a deer at a full run will capture many more usable images with an auto winder or motor drive than could be accomplished with manual film advancement.

Many winders can be set to wind either one frame at a time or continuously. If you have a winder set on the continuous mode, you can run through a roll of film very quickly. Until you get the feel for your camera, it will probably be wise to set your winder on a one-frame advancement. As you gain experience and feel for your equipment, the continuous setting will be more fun.

The Least You Need to Know

➤ Find a camera that fits you. Spend time handling various brands and types of cameras until you find one that feels like an extension of your hands and eyes.

➤ Choose the brand of camera system that you buy carefully. Once you make a commitment to one brand of equipment, it can be very costly to change brands.

➤ Whenever possible, try it before you buy it. If you belong to a camera club or have friends who own photography equipment, ask their advice on purchases you are considering.

➤ If you want affordable fun in photography, start with a 35mm camera. Even if you switch to a larger format in the future, you will always find good reasons to use your 35mm unit.

Lenses Are the Eyes of Your Camera

In This Chapter

➤ Landscape lenses

➤ Normal lenses

➤ Mirror lenses

➤ Long-shot lenses

➤ Close-up lenses

➤ Big-image bellows

➤ Specialty lenses

➤ Funny fisheyes

The lenses you use with your camera are critical components of your photography system. Cheap lenses are never a bargain. Inexpensive lenses produce inferior pictures. You don't have to pay thousands of dollars to get good pictures, but don't expect much from a $49.95 lens that you buy at some sale. Photography is not an inexpensive hobby. If you want to play, you have to pay.

In this chapter, you are going to be introduced to a variety of lenses. Some of them are essential, others are expensive toys that you won't often use. We will talk about wide-angle lenses, normal lenses, mirror lenses, anti-distortion lenses, zoom lenses, macro lenses, bellows, tilt-and-shift lenses, and fisheye lenses. Yes, I said fisheye, but don't worry, you won't need scuba gear.

Jargon Alert
Compound Lens:
This is a lens that contains several lens elements. The different elements work together to create sharp images that are free of distortion.

What exactly is a lens? Think of it as the eye of your camera. Even better, imagine it as a magnifying glass that allows you to make a variety of images on film. Lenses often contain several pieces of precision glass. This is necessary to correct visual distortion. When you focus a lens, you are making adjustments for distance. This is the key to a sharp picture. This distance is referred to as focal length. Depending on the focal length of a lens, you will get different images. As you move through this chapter, you should start to understand the meaning of focal length and lens selection better.

The lens converges light to a point of sharp focus. The distance from the lens to the focus point (focal plane) is the focal length.

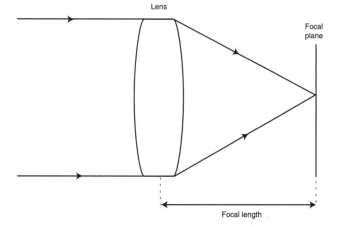

Lenses are rated by focal length. This is measured in millimeters. The smaller the rating is, the wider the view is through a lens. For example, a 16mm lens has a much broader view than a 50mm lens. When you drop down to fisheye status, your pictures are going to have a round perspective. They will no longer look like typical photos. You can use this creative aspect to your advantage.

Lens Types and Their Focal Lengths

Lens Type	Focal Lengths Available	Closest Focusing Distance (in feet)	Angles of View Available
Fisheye	7.5mm to 15mm	0.7	180°
Super Wide-Angle	14mm to 20mm	0.9	94° to 114°
Wide-Angle	24mm to 35mm	1 to 1.25	63° to 84°
Standard	50mm	1.75 to 2	46°
Telephoto	85mm to 300mm	3 to 10	8° to 28°
Super Telephoto	400mm to 800mm	15 to 45	3° to 6°

Wide-Angle Lenses

Wide-angle lenses are very useful for a number of photo situations. If you enjoy taking scenic pictures, a 24mm lens is an excellent choice. This lens will allow you to include a great deal of coverage in your pictures. Unlike a fisheye lens, a wide-angle lens produces pictures that are basically normal. Perspective can be lost in super wide-angle shots, but the general effect is pleasing.

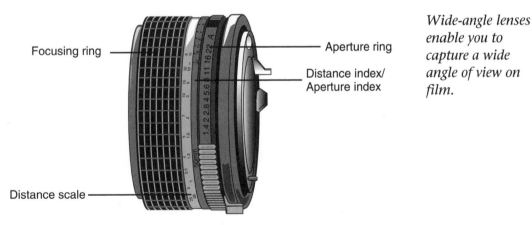

Focusing ring

Aperture ring

Distance index/ Aperture index

Distance scale

Wide-angle lenses enable you to capture a wide angle of view on film.

You don't have to chase after landscapes to gain benefits from a wide-angle lens. If you've ever wanted to get a large group of people in a single picture, a wide-angle lens can help you do it. Any time that you want to take pictures of an expansive subject, use a wide-angle lens.

A 24mm lens is about as much of a wide-angle lens as you can use without distracting distortion. It is my favorite wide-angle lens, but some people prefer a 28mm lens. You won't capture as much of a scene with a 28mm, but distortion will be less than what is experienced with a 24mm lens. Many photographers opt for a 35mm lens to meet their wide-angle needs. This is a useful lens, and it's not a bad compromise, but it can't include nearly what a 24mm lens can.

The best way for you to determine which type of wide-angle lens is right for you is to go to a camera store and try some out. With a single-lens reflex system, which is what we are talking about, what you see is what you get (see Chapter 1). Try different focal lengths to see which ones suit you best. There is no better way to compare lenses than to try them, one after another, on the same subject matter.

So-Called Normal Lenses that Are Rarely Used

A 50mm lens is considered normal. This lens is supposed to depict the world in the same perspective as the human eye sees it, photographically speaking. There are very few occasions when a 50mm lens is the ideal one to use. Its focal length is too long for wide-angle work and too short for telephoto work.

One good thing about a 50mm lens is that it's cheap when compared to other lenses. According to mail-order ads, you can buy an auto-focus, 50mm lens for a major brand of camera for less than $75. Getting any lens this cheap is rare, especially when it's brand-new and offers auto-focus capability.

If you are buying a 35mm camera that is being sold without a lens, you might want to buy a 50mm lens to keep your costs down while you are getting your feet wet in the photography hobby. Personally, I think you should invest more money and get a zoom lens that can give you more features and benefits. There is nothing wrong with owning a 50mm lens, but once you have zoom lenses or an assortment of fixed-focal-length lenses, I doubt you will have much use for your "normal" lens.

Mirror Lenses Can Leave Round Spots on Your Images

Many photographers dream of owning a powerful telephoto lens. These lenses tend to be very expensive, and they can be as large as an elephant's leg. One cost-effective

alternative to a traditional telephoto lens is a mirror lens. A mirror lens is usually short with a large diameter. Photographers pay a price when they buy a relatively inexpensive mirror lens. The first concession is accepting the fact that a lot of light is needed to utilize the lens. A typical aperture is f-8. (See Chapter 16 for more advice on creative uses of aperture settings.) In addition to needing a lot of light, mirror lenses are notorious for creating doughnuts, or round spots, on finished photographs.

The big selling point of mirror lenses has always been their price. You can buy a 500mm, f-8 mirror lens for a mere fraction of what a 500mm normal telephoto lens would cost. If you are looking for perfection in your photographs, you won't get it with a mirror lens.

What makes a mirror lens so different from a typical telephoto lens? Mirror lenses are short and light. They use mirrors to fold light in a way that regular telephoto lenses can't do. There are trade-offs for this advantage. As an advantage, mirror lenses with long focal lengths have an ability to focus on items close at hand. The downside is that the aperture is fixed. It cannot be adjusted like a typical lens. A variable diaphragm, such as the type found in common telephoto lenses, can't be incorporated into a mirror lens. If it were installed, it would cause vignetting. The only exposure control is in the form of film and shutter speed. While mirror lenses offer some advantages, you must weigh the limitations that they place upon you.

Are mirror lenses worth considering? If you are using an older camera system, one that doesn't rely on auto-focusing, a mirror lens can come in handy for occasional long shots. Overall, they don't produce quality photographs. If your goal is to document something at a distance, like a moose standing in a pond, a mirror lens will work. Should you be interested in getting a tight shot of the same moose with magazine quality, don't even consider a mirror lens.

Jargon Alert
Resolution: This is the ability of a lens to distinguish between objects that are close together.

In general, you would be better off to save your money until you can afford a long telephoto lens that won't dot your prints with doughnuts.

The resolution quality of a lens has to do with its ability to separate subjects that are close together. If you don't want images in your photographs to blend together in a montage, opt for a lens with high resolution.

Super Telephoto Lenses that Can Cost More than Your Car

Can you imagine spending more for a lens than what some people pay for a car? Well, there are lenses with price tags that do compete with cars. The last time I looked, a

600mm, 4.0 lens for my brand of camera was selling for more than $9,000. A 300mm, 2.8 lens was going for about $4,600. In either case, the price of these lenses is steep, and some lenses cost considerably more.

This telephoto lens is fit for a real pro.

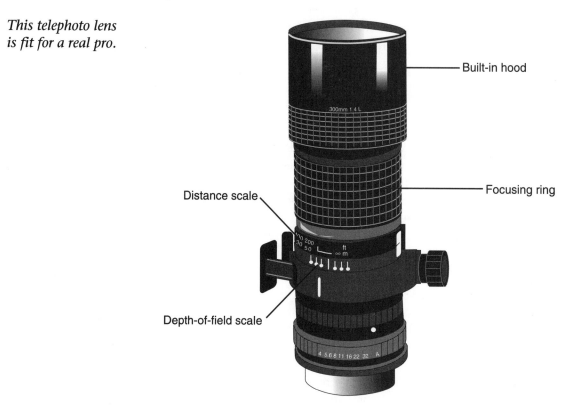

Built-in hood

Focusing ring

Distance scale

Depth-of-field scale

A Working Combination

To establish a working combination in a good photograph, you must consider *aperture, shutter speed,* and *film speed.* An aperture is a circular hole, in or near a lens, that controls the amount of light reaching film in a camera. Aperture also controls the depth of field experienced in a photograph. Shutter speed refers to the amount of time that a shutter remains open during a photographic exposure. Film speed is a measurement of a film's sensitivity to light. These three elements combine to make a proper exposure. A lens that has a slow aperture, one with a large number at the bottom of the scale, requires the use of a slow shutter speed or a fast film. In some cases, it requires both. For optimum results, you should be able to use a slow film speed, something in the neighborhood of ASA 100, with an average shutter speed of at least 1/125th of a second. (American Standards Association [ASA] is a rating assigned to film based on the sensitivity of the film. It is a

benchmark of a film's speed.) If lighting is poor, then you need a fast lens, one that has a small number at the end of its aperture scale.

Aperture is figured in f-stops. An f-stop of 5.6 is about average for a typical telephoto lens. A faster lens, one with a open aperture of f-2.8, will cost more. Slower lenses, such as mirror lenses, that have apertures of f-8 are less expensive. You have to match your shutter speed, film speed, and aperture to your applications. We will talk more about this in Chapter 16.

You can buy a long lens at a reasonable price if you are willing to sacrifice a fast aperture. In other words, if you don't mind working with slow shutter speeds when lighting is poor, you can get a lot more lens for your money. For example, I could buy a 75-300mm lens for less than $200. What's the difference between a 300mm zoom lens at $200 and a 300mm fixed lens at $4,600? About $4,400! The big difference in the field is the minimum aperture. The expensive lens operates at 2.8, and the cheaper lens operates at 5.6. This may not seem like much of a difference, but it can be to some photographers.

If you need a lens that will allow fast shutter speeds in low-light conditions, you have to pay handsomely for it. Why would you need a fast aperture? If you were a sports photographer, your subjects would be moving quickly. To capture them on film without having their images blur due to motion, you need a fast shutter speed. On a bright, sunny day, this would not be a problem with most lenses. However, a cloudy day could render a lens with a slow aperture useless. If you make your living taking fast-moving or low-light pictures, you have to be prepared to pay steep prices for your equipment.

If you're not a working pro, you can compensate for a slower aperture by loading a faster film. Why can't the pros do this? Fast films produce grainier pictures than slow films. Many publishers want original slides that have been shot at a slow film speed, like ISO 64. (International Standards Organization [ISO] is another rating of film speed. ASA and ISO numbers are the same in terms of film speed.) A pro using 400-speed film might not be able to sell the images. If your goal is to have good slides or modest enlargements, a faster film will work fine. Film with an ISO of 200 is a good middle-range film for most amateur photographers.

What length lens do you need? It depends on what you want to do with it. A 200mm lens is very effective for many types of telephoto work. Using a 300mm lens will allow you to take the same picture that you could with a 200mm lens without being as close to your subject. Few amateur photographers

Insider Tip

Don't use a film with a speed higher than ASA 200 if you want to have enlargements made from your negative or slide. The more a negative is enlarged, the more grain in film will stand out. Faster films, like an ASA-400 film, become very grainy when enlarged.

carry lenses that are longer than 300mm. If you want to take pictures of elusive wildlife or similar subjects that are difficult to approach, a longer lens may be called for. Some wildlife photographers use extremely long lenses. Lenses in the 400mm, 500mm, and 600mm ranges are all common equipment with professional wildlife photographers. However, you can accomplish a lot with a 300mm lens if you learn the habits of animals well enough to anticipate them and to hide from them.

Anti-Distortion Lenses at Extortion Prices

Anti-distortion lenses, lenses with special coatings on the glass, are very expensive. The coating does improve image quality, but few amateur photographers need it. A 300mm, 4.0 lens for my camera is sold by a major dealer for just under $650. If the lens is coated and classified as an "L" lens, the price jumps to almost $1,450. Paying more than twice as much to get the slightly better quality lens is usually hard to justify.

If you are buying a long telephoto lens, you may choose to pay extra for coatings and special glass. Extra-low dispersion glass is used to reduce chromatic aberration. This is the primary cause of fuzzy pictures taken in good focus with long lenses. Paying out the nose for anti-distortion glass and coatings may make sense for some professionals, but it is probably foolish for the average photographer.

Zoom Lenses—Can One Lens Do It All?

Manufacturers of zoom lenses would like you to believe that their wonder lenses can do it all. Can they? No, but they can come close. Zoom lenses are an excellent choice for photographers on a budget and for photographers who have not yet determined their exact needs. Many professional photographers have independent lenses in various focal lengths instead of zoom lenses. This is because zoom lenses are said to lose some quality in photographs when compared with fixed-focal-length lenses. If you buy a quality zoom lens, I doubt you will be able to tell the difference between pictures taken with it and those taken with a fixed lens.

You should be able to acquire a good zoom lens for around $300 or less. This one lens is likely to take you from 75mm to 300mm, which is a lot of coverage for the cost. Zoom lenses are very effective for cropping unwanted elements from a photo before you snap the shutter. They are convenient because you have to carry only one lens, and it is attached to your camera. You won't be fumbling to change a lens when a good photo opportunity comes along. Shop for your zoom lens carefully. Make sure it's easy to use and that it meets your requirements for aperture ratings. Some zoom lenses combine a close-focus arrangement with the telephoto lens. This is a nice feature. You should be able to meet the majority of your photo needs with a good zoom lens.

Macro Lenses Make Mountains Out of Molehills

If you like the idea of taking pictures of insects and other small objects, you should invest in a macro lens. Close-focusing lenses let you get pictures of small objects, but they can't compare with a macro lens. Many photographers use close-up filter attachments for occasional close-up work. However, if you plan to spend much of your time taking aim at little creatures, buy a macro lens.

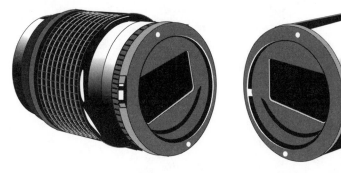

Get close to tiny subjects with a macro lens.

Macro lens Extension tube

When a macro lens is coupled with the extension tube that is usually supplied with the lens, you can get incredible close-up photos. Tiny items will appear life-size on your film. You can photograph a watermelon seed and make a work of art out of it. Ever want a picture of the eye structure of a house fly? You can get it when you shoot with a powerful macro lens.

Macro lenses are designed to focus in extremely close-up situations. A coma, or aberration, is less likely to occur in close-up work when a true macro lens is used. In addition, a macro lens can also be used as a regular lens. If you have a 50mm macro lens, you don't need a standard 50mm lens. A 100mm macro lens is, in my opinion, the ideal one to choose. This one lens gives you a close-up lens, a portrait lens, and a short tele-photo lens all in one package.

Jargon Alert
Coma: This is a lens aberration that results in the blurring of picture edges.

If Big Is Better, Bellows Are Great

When you want to really get serious with close-up photography, buy a bellows to work with your macro lens. The head of a straight pin can be enlarged to a point where it commands attention on film when a bellows is used. A bellows is a collapsible

contraption that fits on a camera between the camera body and lens. Turning a knob on the side of the bellows will extend or compress the bellows material. Tiny objects can be magnified several times their true size with the use of a bellows and a macro lens.

A bellows can be used with a macro lens for extreme close-ups.

A bellows is not the type of equipment most photographers pack in their camera bags and vests. However, if you enjoy photographing small, stationary objects, a bellows is a good investment. Due to the high magnification and minimal field of focus experienced when using a bellows, your subject must remain still. Even a light wind will make it extremely difficult to capture the inner beauty of a wildflower or strand of wheat.

Before you buy a bellows, get a macro lens and try it out. If you find that you are fascinated with the world of close-up photography, put a bellows on your want list. This is not a piece of equipment that you need, but it can be a lot of fun to use. To give you an idea of cost, an auto-bellows for my Canon equipment costs less than $250 through a mail-order dealer.

Tilt-And-Shift Lenses Can Make a Crooked Building Straight Again

Perspective is often difficult to maintain in architectural photography. Have you ever studied a picture of a city and noticed that the buildings seem to be leaning backwards? This is a common problem when shooting architecture with a standard lens. Tilt-and-shift lenses solve this problem by allowing you to shift the lens and maintain a vertical perspective on the buildings. Few photographers have enough need for this type of lens

to justify its rather expensive purchase. However, if you plan to work extensively with tall objects, such as buildings, sculptures, and so forth, a tilt-and-shift lens could benefit you.

A tilt-and-shift lens is unlike any other type of lens in its capability. It is the only lens that can keep a tall object straight in your photograph. To accomplish this, however, you must be willing to pay a steep price. A 35mm, f-2.8 tilt-and-shift lens for my Canon system is presently advertised at a price of just under $1,500. Believe me, this is no toy. It is a specialty lens that is usually used only by professionals.

Fun with Fisheyes

Fisheye lenses can be fun to work with. They allow you to create great special effects. However, they don't have many practical purposes. Of all the lenses available to you, fisheye lenses are one of the least important.

People are often captivated by images made with a fisheye lens. The reason for this is simple: Fisheye photographs are different. Any subject you shoot with a fisheye lens will attract attention. The downside to this is that part of the subject will be distorted. This is both the appeal and the disadvantage of fisheye lenses.

Any lens with a rating of less than 24mm is headed toward fisheye status. There will be definite distortion in lenses with a focal length of less than 24mm. Prices of wide-eyed lenses increase as focal length decreases. Let me give you some examples of current pricing for lenses that work with my system. My dealer sells a 20mm lens for about $570, a 17mm lens for almost $700, and a 15mm lens for just under $1,200. If I were buying one of these lenses, I would go for the 17mm version.

Some Key Factors in Choosing Lenses

Some key factors to consider when buying a lens should be committed to memory.

➤ Buy a lens that is made by the manufacturer of your camera whenever possible. Exceptions to this rule might be made if you are buying a specialty lens that will not see a lot of use.

➤ Make sure that the lens has an aperture rating that suits you. In other words, is the lens fast enough to handle the kind of work you will use it for? Does the lens have a floating aperture? Some zoom lenses have aperture ratings that change with the focal length. This is okay as long as you are aware of it, but you could be very disappointed if you don't investigate this aspect of a lens.

Jargon Alert
UV-haze filter:
This filter absorbs ultraviolet light. It cuts down on haze in long shots, such as landscapes, and gives a sharper image with better color saturation. It also serves as protection for your costly front lens element.

Bet You Didn't Know
Unwanted sun bursts on your prints and slides are the result of sun flare. A lens hood can reduce the occasions when unwanted sun ruins what would have been a great picture.

➤ Will the lens accept screw-in filters, and what size does it require? Buy a UV-haze filter when you buy the lens and install it right away to protect the actual lens.

➤ Does the lens have a retractable lens hood to block sun flare? Can you install a rubber lens hood yourself? Be advised, wide-angle lenses, like a 24mm lens, often will not allow the use of a lens hood. If a hood is used, it shows up in the picture by blacking out the corners.

➤ Make sure that the lens you are buying will mount on and work with your camera.

If you follow these guidelines, your lens purchase should be relatively painless.

The Least You Need to Know

➤ Zoom lenses are an excellent choice for beginning photographers. Buying just one zoom lens can allow you to tackle most types of photography.

➤ Protect all of your lenses with UV-haze filters. This inexpensive investment will protect your major investment from scratches.

➤ A macro lens is unique. If you want top-quality close-up photographs, you should own a macro lens. Some manufacturers call their lenses micro lenses, and others call them macro lenses.

➤ The aperture rating of a lens affects the purchase price considerably. To give yourself the most flexibility in shutter speeds and film speeds, buy lenses with the lowest aperture ratings you can afford.

Flashes: Fake Lighting

In This Chapter

➤ Independent flash units

➤ Stopping time with strobe lights

➤ Seeing shadows before you shoot

➤ Taking your show on the road

➤ Flash accessories

Artificial lighting solutions for modern photographers have never been so good before. If you have the time and the money, you can create almost any lighting effect you would ever want. Many new cameras have built-in flashes, but that is only the tip of the iceberg when it comes to electronic flashes and studio lighting. Most photographs live and die by their lighting and composition, so lighting is a critical concern for serious photographers. So, if you're ready—"Lights, Camera, Action!"

No More Powder and Smoke

You've probably seen old movies where a photographer took a picture with a flash that exploded to create the light, leaving smoke and powder in its wake. There is no powder and smoke associated with today's flash photography. Light is generated from batteries and electricity, which are cool, non-explosive materials that are more dependable and easier to use than the flash powder of days gone by.

Many photographers, even some professional ones, don't understand how to use lighting to their best advantage. Average people who buy a camera with a built-in flash assume, incorrectly, that the onboard flash is all they need. You can get viewable pictures with a built-in flash, but you will get few shots that show professional quality. This doesn't mean that you have to spend your entire paycheck for a new flash. A simple, pocket-size flash that is used off the camera is all it takes to make a big difference.

You can buy a portable, electronic flash for less than $25. Better models, with more features, stretch the price up to around $70. Big, long-range, pro-quality units get much more expensive, but you probably don't need anything so fancy. If you are willing to spend around $50 for a new flash, you can certainly start to see better pictures in the making.

There are different types of flashes available to you. The least expensive models require manual selection of exposure settings. This can be a hit-or-miss proposition unless you own a light meter that reads for flash photography. Many cameras can be equipped with auto-exposure flashes. This type of arrangement is usually best for people who are just learning the ropes in flash photography. You will have to pay more for an automatic or dedicated flash unit, but the expense should prove to be worthwhile.

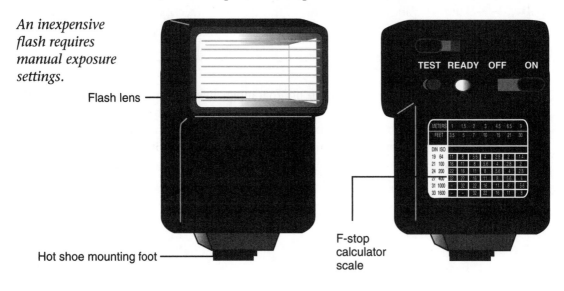

An inexpensive flash requires manual exposure settings.

Flash lens

Hot shoe mounting foot

TEST READY OFF ON

F-stop calculator scale

When you shop for a flash, there are a few other features that you may be interested in looking for. Will the flash accept color filters? People who enjoy special-effects photography often color their lighting with filters, and you might like this too. Does the flash head tilt and/or swivel? Experienced photographers know that bouncing light from walls, ceilings, and reflector cards will produce even, soft lighting that is pleasing to the eye. Some inexpensive flash models offer both a tilt and swivel feature. As a minimum, I suggest that you find a model that will allow you to tilt the head for bouncing flash.

Jargon Alert
Bouncing Flash: This is light that is bounced from a reflective surface onto a subject. The scattered light rays that result from the bouncing produce softer illumination.

Knowing what the coverage area of a flash is can be quite important. If you are using a wide-angle lens with a flash that doesn't offer wide-angle coverage, your photos are not going to be satisfactory. The same holds true if you are using a standard flash with a telephoto lens. Ask your camera dealer to explain the various ranges of any flash you are considering buying. If you look on the back of the flash unit, you may find markings that indicate its range. There should certainly be some documentation pertaining to range in the manufacturer-supplied paperwork provided with a new flash unit.

If you are buying a high-quality flash, it should be capable of handling standard, wide-angle, and telephoto photography. Adapters are normally placed over the standard flash head to either concentrate the beam of light for telephoto shots or to disperse it for wide-angle work.

What is the recycling time for the flash? Product literature usually gives information on the recycling time. This is also something you can test easily. Put batteries in the flash you are looking at and press the test button when the unit is ready to fire. Time how long it takes for the ready light to come back on. If you are into high-speed photography with the use of a motor drive, you will need a fast flash to keep up with you. See Chapter 3 for more information on motor drives and auto winders. Another less important, but still viable consideration, is the number of flashes you will get from one set of batteries or from one battery pack. Product literature will usually give you this information as well.

Bet You Didn't Know
A thyristor is a feature in an electronic flash that retains unused electric power in the flash's capacitor for reuse. By doing this, the battery life of the flash unit is extended.

This high-quality flash unit is suitable for a professional.

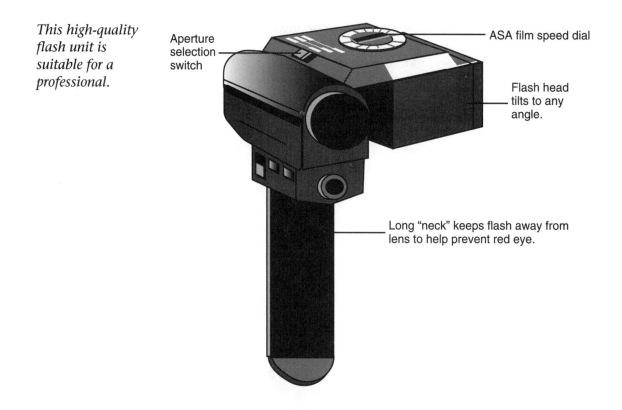

Aperture selection switch

ASA film speed dial

Flash head tilts to any angle.

Long "neck" keeps flash away from lens to help prevent red eye.

Bet You Didn't Know

WOW!

Daylight film comes in different speeds and is used with natural light and electronic flash. When daylight film is used with other types of lighting, corrective filters are needed to produce true colors. No filter is needed when using daylight film with an electronic flash. Most film sold is rated as daylight film. However, you can buy other types of film for shooting under photo-flood lamps and indoor lighting. Corrective filters must be placed over your lens if you are using daylight film with incandescent, tungsten light. These filters balance the color in the film to create a natural look.

Many dedicated photographers use two independent flashes, one on each side of the lens, to produce even, shadowless lighting. This type of lighting is very popular with close-up work, and it is effective with portraits and other photography. If you decide to buy two flashes to work together, make sure that they are compatible with one another. A little peanut slave (a remote firing device shaped like a peanut) can be installed on one of the

flashes so that both flashes fire simultaneously. Slaves like this can be bought for less than $20. Brackets are made to accept two flashes at one time, and this type of arrangement provides high-quality lighting, even when low-powered flashes are used.

One other consideration to keep in mind is whether the flash units you buy work with a hot-shoe attachment or a sync cord. Your camera may not have a hot shoe. If it does have one, it will be on top of the camera. Some cameras have flash holders that are not hot shoes. Don't let this fool you. Take your camera with you when you shop for a flash. Mount the flash and see if it fires when you press the shutter button. If it doesn't, either your camera or the flash unit isn't hot-shoe equipped.

Jargon Alert
Hot Shoe: A hot shoe is a fitting on a camera, generally positioned over the viewfinder, that accepts the mounting of a flash and is electronically in sync with the camera to fire the attached flash on demand. When a hot shoe is present, a PC cord or sync cord is not needed to connect the firing mechanism of the flash to the camera.

This close-up shows the hot shoe on a camera where the flash "plugs in."

Flashes that don't link automatically with a camera through a hot shoe require the use of a sync cord. This is simply a cord that runs from a port on the flash to a port on the camera. Sync cords usually work fine, but they do get in the way sometimes. Also, sync connections are sometimes loose, resulting in a flash that will not fire.

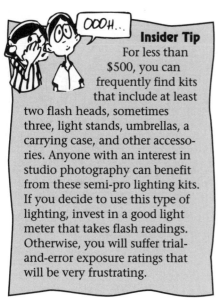

For less than $500, you can frequently find kits that include at least two flash heads, sometimes three, light stands, umbrellas, a carrying case, and other accessories. Anyone with an interest in studio photography can benefit from these semi-pro lighting kits. If you decide to use this type of lighting, invest in a good light meter that takes flash readings. Otherwise, you will suffer trial-and-error exposure ratings that will be very frustrating.

Studio Strobes: Faster than a Speeding Bullet

When I say that studio strobe flashes are faster than a speeding bullet, I mean it. This type of lighting system, combined with a camera that offers a fast shutter speed, can literally stop a bullet in midair. No, I'm not suggesting that you shoot the lights and watch them explode on impact. And whatever you do, don't stand in front of an oncoming bullet with your camera to photograph it, ha ha! Studio strobes are very powerful electronic flash units. The light they emit is rated as daylight, so no corrective filters are needed when using daylight film. Studio strobes are sold in various power ratings, but they are all much more powerful than any on-camera strobe/flash. Studio strobes can stop all sorts of motion without the risk of blurred images.

If you plan to convert a spare bedroom, basement, or attic into a studio, you should give serious consideration to buying some studio strobes. This type of lighting is not cheap, but you can get name-brand lights that do a wonderful job for reasonable prices.

This studio strobe light is a very powerful electronic flash.

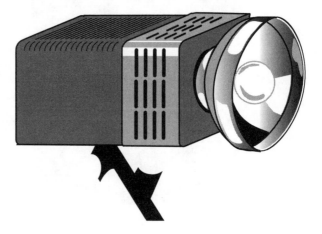

My studio strobes are made by Novatron, and I'm very happy with them. This company is known for its excellence in lighting equipment for both serious amateurs and professionals. It is common to find kits offered by Novatron and other quality manufacturers that will give you all the basics of good studio lighting.

Quartz-Halogen Lights: An Alternative

Quartz-halogen lights are an alternative to flash heads for studio photography. Problems occur with flash photography. One of the most common is finding out after film is processed that the flash units created unwanted shadows. This doesn't happen with quartz-halogen lights. These lights are on while you are composing a picture, so you see the exact effect the lighting has on your subject. This is a big advantage for a lot of photographers. An added bonus to this type of lighting is that it's less expensive than flash units. A good quartz-halogen starter set will cost you about $150. It will include the lights, barn doors (which allow you to angle the lighting), light stands, and a carrying case.

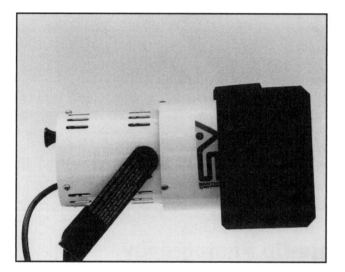

This quartz-halogen studio light is focused by the barn doors attached to it.

I started my studio lighting with quartz-halogen lights and continue to use the same lights today. My flash heads see a lot of use, but so do my steady lights. Both types of lighting have their advantages and disadvantages. One drawback to quartz lights is that they get very hot. This can make a model's makeup run and present a fire hazard if flammable materials come into contact with the lights. There is also some risk of serious burns if someone touches the lights.

Jargon Alert
Barn Doors: The hinged metal flaps that are used to control the beam of light produced by studio lighting.

Another problem with quartz lighting is that it can't stop motion like a flash unit can. Since quartz lighting produces tungsten lighting, you will also have to put a corrective

Watch Out
Quartz-halogen and other photo lamps get extremely hot during use. They can easily inflict serious burns and are capable of starting fires if they come into contact with flammable materials.

filter on your lens to maintain accurate colors in color photography if you are using daylight-rated film. But, this is no big deal.

Quartz lights allow you to take normal light readings. This can be done with an independent light meter, as we will discuss in Chapter 7, or the one that is probably in your camera. A flash meter is not required. Since quartz lights are on at all times, you can see shadows and lighting effects before you fire the shutter. This is a big help. If you want big-time lighting on a limited budget, quartz-halogen lights are the way to go.

Jargon Alert

Tungsten Light: This is the type of light that most household lights emit. It is the result of a light that uses a tungsten filament. Tungsten-rated film can be used with this light without the use of corrective filters. However, if daylight-rated film is exposed under tungsten lighting, the images will take on an orange tint. If you use daylight film with tungsten lighting, use a corrective filter to color balance your film saturation. One filter to use is an 80-A filter, but check with your film recommendations for a precise filter selection.

Ring Lights for Close-Up Photography

Ring lights are specialty flashes used with macro lenses when taking close-up pictures. These units often consist of a sensor that mounts in the hot shoe of a camera, a battery pack, and the flash attachment. The flash mounts on the ring of a lens, similar to the way a filter is mounted. Since the flash element surrounds the lens, it gives good, even illumination of your subject. Some models, like the one I have, allow you to disable one-half of the ring for creative photography. Other models fire all at one time. For documentary photography of close-ups, ring lights can't be beaten.

A ring light would not normally be used for anything other than documentary work. Taking a picture of a human model with a ring light used for flash would result in a bright, well-lit photograph that would probably be boring. Ring lights bring out extensive detail in subjects. This is usually not desirable when photographing people or pets. If you don't chase after grasshoppers, mushrooms, and wildflowers, you shouldn't need a ring light. But, if you love to bring nature home with you in a film canister, a ring light might be right for you.

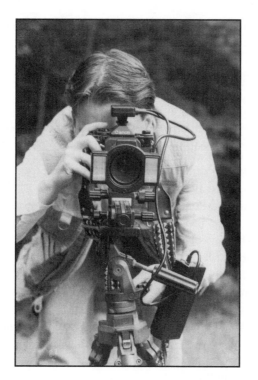

Ring lights around the lens provide even illumination.

Flash in a Box: Portable Studio Flashes

Some photographers like to take their flash shows on the road. If you are one of these road warriors, look into portable studio flashes that can travel with you. Any studio lighting can be used where electricity is available, but if you take your photos off the beaten track, you may want some battery-powered flashes to go along with you. There are two ways to do this. One is much more expensive than the other.

If you want to take full-power studio strobes out into a meadow to photograph a model, be prepared to spend between $1,000 and $1,500 for the privilege. You might find a portable, battery-powered location kit for less than $1,000, but they are not numerous. It might be cheaper to take your regular studio lights and rent a small electric generator for your location session. For that matter, it might even be cheaper to buy a small generator to run your AC lights. It's very difficult to justify or afford location strobes. But, don't get discouraged; I'm going to show you how to beat the system.

Jargon Alert
Electronic Flash:
This is an artificial light source produced by passing a charge across two electrodes in a gas.

Most photography doesn't require super-powerful studio strobes. If you want to take models on location and get some great shots, you can do it with inexpensive, portable, battery-powered flash units. I'm talking about the same electronic flashes that you might normally mount on your camera. These flashes, when put together with either sync cords or slaves and some light stands, make a good substitute for expensive location kits. You can still use umbrellas and reflection cards, and you will save a tremendous amount of money. Granted, you won't have the full power and control you would have with a location set, but you probably won't need it.

To give you an idea of the results you can receive with inexpensive, pocket-size flash equipment, let me share a story from my past with you. When I started doing wedding photography, I couldn't afford the best equipment, but I needed my work to look good. My second wedding assignment was a tough one. I was going to have to light a large dance room with electronic flash to meet the demands of my customer. This would have been a good time to own a location set of strobes, but I didn't. To compensate for my problem, I took several modest flashes, some inflatable umbrellas, and some light stands to the reception area. My wife and I positioned the lights prior to the crowded arrival of guests. Each electronic flash was equipped with a peanut slave. When I fired my powerful, bracket-mounted camera flash, all of the slaves would trigger the other flashes. This simple, inexpensive setup allowed me full light coverage of a large room and crowd with minimal cost.

I have never owned a location set of strobes. During all of my years in the field, I've always used simple, battery-powered flashes with good results. You can spend a lot of money on flashy pro gear if you want to, but it's rarely needed.

Hot Shoes, Cables, and Other Flash Factors

There are a number of accessories available for photographers who use flash equipment. Whether you're using a $30 pocket flash or a $1,000 pro setup, you can always enhance your flash photography with accessories. Buying stuff is half of what makes photography so much fun! The accessories available are not mandatory equipment, but many of them can improve your photography and produce nice special effects.

Hot Shoes

We've already talked about hot shoes. If your camera has one, that's great. Don't panic if you don't have one. A sync cord will work nearly as well and in many cases is the most effective tool you can use to trigger a remote flash. Cameras that are fully automatic are usually made with hot-shoe capabilities. This allows you to buy and use an automatic flash with your automatic camera. These flash units are remarkably accurate in their readings under normal circumstances.

Multiple Flash Sources

Many photographers advance to a point where they want remote and/or multiple flash sources. If you reach this level, you will likely use a sync cord for your remote flash. Slave devices can be used to trigger multiple flashes. There is one problem often encountered with sync cords. They don't always maintain good connections with the camera body. You can reduce flash failures by using a sync key, a small device that resizes the connection pieces to keep your connections tight. This is a very inexpensive accessory that should be kept in your camera bag or vest at all times when doing flash photography.

Slaves come in a variety of shapes and sizes. Peanut slaves are inexpensive and work well under most conditions. This is the type of slave that I use, and I recommend them highly. Most slave devices are made like a hot shoe. The ones that are not can be coupled with a remote flash by using a sync cord. The cord runs only from the slave to the flash, not from your camera body to the remote devices. Once you get to the point of doing creative things with artificial lighting, you will want multiple flashes and remote firing devices.

Studio strobes of good quality usually have slaves built into them. When you fire one light, they all go off. Before you invest in any studio strobes, make sure that they have adjustable power settings and built-in slaves. When this is the case, you only have to connect one light to your camera body with a sync cord, which is also known as a PC cord.

Filters for Lights and Flashes

Filters are available for most photographic lights and flashes. Using filters with your lighting can produce some outstanding results. Even inexpensive pocket flashes are often sold with an assortment of colored filters. Some models use gel-type filters, and others use plastic filters. It is a good idea to make sure that any lighting units you buy will accept filters for future interests in special effects.

Snoots and Barn Doors

Snoots and barn doors sound like things you would find down on the farm, but they are accessories for photography lighting. Any reputable studio light will accept these types of accessories. Barn doors consist of two or four metal flaps that allow you to angle light creatively. Snoots are used to concentrate a beam of light. They are often used to highlight a model's hair. There are many other types of add-ons available for studio lighting, so make sure the products you are considering will accept them.

Snoots focus the light from a studio strobe.

Barn doors provide control over how much light is focused on a subject and how the light is directed at the subject.

Umbrellas and Reflectors

Most people have seen umbrellas used in flash-photography sessions. They are used to bounce light in a soft, shadowless, attractive manner. Most photographers use white umbrellas, but silver umbrellas produce more bounce. You should experiment with both types until you are comfortable with which one to use on various assignments. At about $20 apiece, they're an affordable investment.

As good as umbrellas are, they can be cumbersome at times, and they don't allow a lot of mobility. There is a solution to this dilemma. Inflatable umbrellas are the answer to higher mobility and better results when using small flash units. These little blow-up umbrellas are only several inches in diameter, but they produce great results. They attach to an electronic flash with elastic bands. Your flash fires into the clear surface of the device and is reflected by the white or silver interior surface. You get bounced lighting from a small, portable, affordable package. I've used them to photograph modeling sessions and weddings with wonderful results. This is one accessory any serious flash photographer should own.

Reflector cards are often used in photography. They are implemented with natural light and flash photography. A reflector card can be a small, handheld size, or it can be a large unit that is supported by a stand. The painted walls and ceilings of buildings act as large reflector cards for photographers bouncing flashes. By bouncing flash or natural light with reflector cards, you receive lighting that is not harsh and distasteful. Lightweight survival blankets fold to pocket-size proportions and are often silver on one side. These inexpensive items make fantastic reflectors.

Light Meters

Light meters are critical to good photography. Most modern cameras have some type of built-in meter, but these meters can be fooled under certain conditions. The use of multiple flash units is one of these conditions. If you are going to do much flash photography with any type of flash other than a dedicated, automatic, on-camera flash, invest in a decent flash meter. You will save time, frustration, and wasted film many times over. A lot of flash meters can double as reflective meters, so you get two meters for the price of one. This is the type that I would recommend. See Chapter 7 for additional information on meters. Flash photography and studio lighting can add a new dimension to your hobby, so give them serious consideration.

The Least You Need to Know

➤ If you are going to do flash photography with anything less than a dedicated, automatic flash, you need a light meter that is capable of reading flash output.

➤ Before you buy a flash, make sure it will provide the coverage needed for the lenses that you will be using it with.

➤ When you are looking for light to use in your studio, you can choose photo lamps for inexpensive, what-you-see-is-what-you-get lighting, but you will need flash heads if you plan to stop motion in your pictures.

➤ If you want to excel at close-up flash photography, you should invest in a ring light. At the very least, buy two flashes and mount them on a bracket to light your subjects evenly.

➤ Multiple flash units will improve the results of your flash photography. One unit will be triggered by your camera. Remaining flashes will fire with the use of slaves.

Tripods and Supports: Let It Stand on Its Own Three Legs

In This Chapter

➤ Secrets of super pictures

➤ Three-legged monsters

➤ Only one leg to stand on

➤ Sack your next shot

➤ Get a grip with a good clamp

➤ Teaming up for tight shots

A solid camera support is essential to good photography. At high shutter speeds, you can get away with holding a camera in your hands. This is not the case once your shutter speed drops below 1/60th of a second. Most professional photographers try to avoid holding a camera themselves at any speed slower than 1/125th of a second. Human hands, arms, and other body parts are not normally capable of supporting a camera sufficiently at slow shutter speeds to avoid blurred pictures. Chapter 10 points out shutter-speed basics. There are a few tricks of the trade that you will learn here about body positions and makeshift supports. However, most of what we are about to discuss involves mechanical camera supports.

Super Pictures Are Made from Solid Supports

The best pictures are a result of steady cameras. If you are shooting at a slow shutter speed, you need something more than human hands to hold your camera. It's possible for average photographers to take decent pictures at shutter speeds as low as 1/60th of a second without mechanical supports. Possible, but not probable. A good rule-of-thumb is to use a mechanical support for any picture that you will be taking at a shutter speed slower than 1/125th of a second.

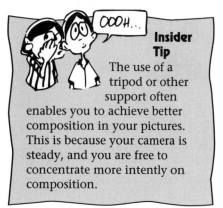

OOOH...

Insider Tip

The use of a tripod or other support often enables you to achieve better composition in your pictures. This is because your camera is steady, and you are free to concentrate more intently on composition.

Many pictures are taken at shutter speeds that require, or deserve mechanical support. If you are using a slow film speed to assure high-quality, low-grain pictures, you are more likely to find a need for some type of camera support. This is also true if you shoot with low levels of available light and without the aid of an electronic flash.

When a shutter speed is slow, movement of a camera results in blurred pictures. There are far too many terrific photo opportunities that require slow shutter speeds to ignore them. Timed exposures result in images that are not seen through a viewfinder, but these photographs can't be taken without the aid of a mechanical support.

Tricky Tripods

Tripods are typically the first type of photo-support system considered. They are a solid seat for your camera. However, tripods are not always the best choice for support, and they can be tricky to use. This is especially true if you buy a low-budget model—you know, the type with only two legs—ha ha. Many consumer-oriented stores sell tripods at low prices. Unfortunately, you usually get what you pay for when buying a tripod. If you are only willing to invest $30 in a support for your camera, you can't expect to get the features and pictures that you would with one costing four times that much.

If you buy what I will refer to as a dime-store tripod, you are setting yourself up for failure. This type of equipment will work well under optimum conditions, but photo opportunities rarely lend themselves to ideal circumstances. To get exposures right on the money, you're going to have to put in more than your two-cents worth.

What's wrong with a cheap tripod? Many things can be a problem. The legs on cheap tripods often slip and are difficult to lock into place. Few inexpensive units offer the flexibility needed for uneven terrain. The heads may pan and tilt, but they seldom do so smoothly or quickly. Additionally, a camera with a heavy telephoto lens may cause the support panel of a cheap tripod to slip. In fact, a heavy camera combination could cause a lightweight tripod to tip over, breaking expensive photo gear and ruining any shot for the perfect picture.

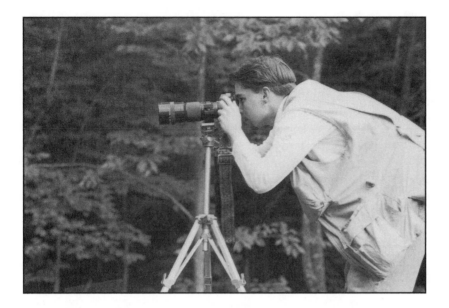

This tripod helps stabilize the camera.

You may find it difficult to justify spending over $100 for a tripod, but don't discount the idea too quickly. Like most photography-related items, you have to pay a higher price to get quality merchandise. Top-notch tripods don't come cheap, but they are worth every penny you spend. Why? Let me tell you why.

A quality tripod offers you plenty of versatility with little chance of frustration. When you lock the legs of a solid tripod in place, they stay there. Professional tripods are made to work in nearly any situation. If you are standing on a steep slope, you can position the legs of a pro tripod to hold your camera steady. Unlike cheap tripods that don't allow the legs to be set at independent angles, good tripods are versatile enough for any terrain.

Tilting and panning the head of a good tripod is a joy. Many models have levels mounted on the head so that you will know when your camera is sitting properly. Some models, like the one I have, offer a quick-detach feature that can be very convenient. If I move one lever, my camera is free of its tripod base and ready to go into handheld action. This is a lot better and faster than unscrewing the connector post from the tripod socket of a camera.

> **Bet You Didn't Know**
> Gyro stabilizers are electrically powered camera supports that use a gyroscope to cushion a camera from vibrations. This type of support is very helpful when taking pictures from a moving helicopter, car, train, or similar means of transportation. However, the expense of such a contraption and the rarity of its use leaves it out of the realm of most non-professionals.

Jargon Alert
Panning: This is the smooth movement of a camera needed to keep moving subjects in the proper film placement. It also aids in reducing a blurred image in some situations when a subject is moving quickly.

Stability and durability are both good with pro-quality tripods. These units are heavier and more of a burden to carry than dime-store tripods, but this disadvantage becomes an advantage when taking pictures. A lot of good tripods have sectional center posts that allow you to open up the tripod legs and gain a very low angle of view. This is essential in close-up photography of plants and insects. Another good thing about quality tripods is that they are not apt to flip over when you mount a camera with a long lens attached to it. If you rarely shoot at slow shutter speeds, you may not want a tripod. However, if you are going to make an investment in a tripod, go for a good one.

Magnificent Monopods

Monopods may be one of the best inventions to come along for outdoor photographers. These stick-like supports do a super job, and they can be packed and carried with ease. They are lightweight, don't take up much room, and can provide a very steady platform for your camera. As with tripods, don't waste your money on cheap models. Buy a good quality monopod and enjoy it.

A monopod in use.

Monopods are great for photographers who are covering sporting events, capturing wildlife on film, or focusing in on a final sunset. A one-legged support can't give you the rock-hard steady platform that a tripod can, but it will provide more than enough support for most types of shots. The big advantage to a monopod is that because it is so easy to carry with you, it will be there when you need it, while a heavy tripod may not be.

Bag Great Pictures with a Photo Support Sack

You can improve many aspects of your location photography by acquiring, or making, support sacks for your camera lens. These devices are available commercially, but they are also easy to make. What is a support sack? It is basically a bag that is filled with some type of moldable material that will conform to the shape of your camera lens. The filling could be Styrofoam beads, buckshot, sand, kitty litter, foam rubber, or even pine needles. Since bags that are lightweight are more enjoyable to carry, I would stay away from sand and buckshot as a filler material. The heavy weight of these substances makes carrying a support sack filled with them difficult.

The concept behind support sacks is simple. You place the sack on a solid object, like a rock or the edge of your vehicle, and then nestle the lens of your camera into the sack. Once the lens has settled into the material, you have a very sturdy support for your camera and lens. For a sack to work, you need something stable to place it on, and you are limited by the availability of such places. Another drawback to a sack is that you cannot adjust its height, like you can a tripod.

Every type of camera support has its own strong points. Sacks are great for photographers who are shooting from their vehicles or who want a low camera angle to capture something close to the ground or floor. This type of support won't do you a lot of good at the zoo or while taking wedding pictures, but there are many times when a support sack is just the right tool for a steady picture.

Clamps that Help Create Sharp Shots

You can use a variety of clamp devices to secure your camera to all sorts of stable objects. A simple C-clamp that is equipped to thread into the tripod socket of your camera body is great for occasions when you are taking pictures from your vehicle. Install the clamp on a window and mount your camera. Raise or lower the window to change the height of your camera. You can tilt and pan this type of support for more versatility. It's amazing how much help such a simple and inexpensive item like this can be.

C-clamps can be attached to tree branches, railings, windows, and all sorts of other items. However, they are limited in their size, and this can be a problem. For example, you would not be able to get a C-clamp secured on the trunk of many trees. But never fear, tree clamps are available. These clamps circle a tree and provide a very sturdy support for your camera. When you start to shop for photography accessories, you may be amazed at how many exist. If there is something that you want to do with your camera, you can be pretty sure that someone is selling something that will allow you to do it.

Teeny-Weeny Tripods

Tiny tripods may not seem like much of a support system, but even they have their place in good photography. I have a little tripod that has retractable legs. The entire unit has a diameter similar to that of a D-cell flashlight battery. Total length is probably about six inches when the legs are contained. This itsy-bitsy tripod works well for table-top setups and low-to-the-ground shots, but it does require me to hold it. The tripod is not sturdy enough to support a camera and lens safely on its own.

I have found another very good use for my table-top tripod. It can be used as something of a chest-pod. By extending the legs and pressing them into my chest, the little tripod makes an excellent support. The ball-and-socket swivels to put my viewfinder at eye level while the tripod extends outward from my chest. This creates a surprisingly stable shooting platform.

Gun Grips

Gun-type grips are another support option for your camera. A pistol grip can be attached to the bottom of your camera to allow the whole unit to be held with one hand. A shutter-release button on the grip acts as a trigger to fire your shots. Personally, I've never seen much advantage to this type of arrangement. The grip doesn't provide substantial stability.

Another type of gun grip that is very effective is similar in design to the stock of a rifle or shotgun. Your camera is mounted on the device and is fired by a shutter-release that is incorporated into the system. By pulling the shoulder stock in tight to your body and supporting the extended end with one hand, it's possible to get very steady shots.

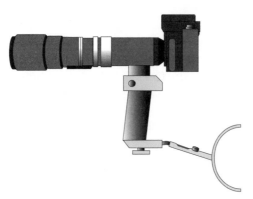

A rifle stock used to support a camera.

Combination Support Systems

Combination support systems sometimes work best. One of my favorites for wildlife photography involves the use of a shoulder stock and a bipod. The bipod is sold through hunting stores and catalogs. It is not a photography accessory, but it works fabulously as one. My shoulder stock is made to accept a stud that is normally used to mount a shoulder sling on a rifle. This stud is what the bipod attaches to.

When the bipod is not needed, it collapses into a small package and rides under the forearm of the shoulder stock. In a moment's notice, the bipod can be deployed to give incredible support from a standing, sitting, or prone position. The legs of the bipod are spring-loaded and easy to work with. Total weight of the unit is only a few ounces, but the support provided is invaluable. With the bipod supporting the front of the stock and my shoulder supporting the rear, I have a very stable shooting platform and the freedom to use my hands.

Combining a monopod with a support sack is another excellent way to take advantage of a combination system. You might, as an example, support the lens of your camera on a support sack that is resting on a rock while the monopod supports the rear of the camera. Learning to use your tools in conjunction with one another is a sure way to get better pictures.

Another combination trick that is worth mentioning involves using a tripod, a C-clamp with a ball-and-socket head, and a remote flash. Set your camera up on the tripod. Attach the C-clamp to some portion of the tripod, and mount the flash on the head of the C-clamp. You will need a flash holder that is tapped to accept the treads of a socket head to do this. They are inexpensive and readily available from all major camera suppliers. This technique will give you off-camera flash from some unusual angles. Do this with colored filters for special effects that you are not likely to see duplicated by many other photographers.

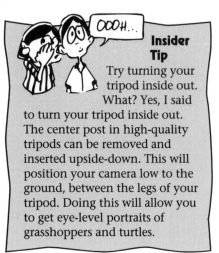

Insider Tip

Try turning your tripod inside out. What? Yes, I said to turn your tripod inside out. The center post in high-quality tripods can be removed and inserted upside-down. This will position your camera low to the ground, between the legs of your tripod. Doing this will allow you to get eye-level portraits of grasshoppers and turtles.

If you get caught afield without a commercial camera support, you may have to improvise. Brace your camera or lens against the trunk of a tree to stabilize it. Settle your lens between the forks of a tree or tree branch to hold it still. Use a fence to support the base of your camera. Fences, rails, and posts are frequent supports for zoo photographers. If you're doing your photography indoors, a door frame will work as a makeshift support. The back of a chair can be used to steady your lens. If you take the time to look around, you are almost certain to find something that will add some stability to your camera. The few moments spent looking for such a support can mean the difference between a great picture and a blurry one.

The Least You Need to Know

➤ Always use a tripod or some type of solid camera support when shooting at slow shutter speeds. Ideally, don't hold your camera at speeds less than 1/125th of a second. You might get a good picture by holding the camera yourself at 1/60th of a second, but this is the absolute limit. Anything slower must be supported solidly.

➤ When you buy a tripod, make sure it has a head that tilts and pans. Experiment with the legs to see what angles they can be put into. Tripods with levels on them are very helpful during composition. Remember, heavy tripods are more solid than light ones.

➤ Use C-clamps and support sacks to steady your camera and lens when shooting from a vehicle.

➤ Never trust a cheap tripod to support your camera when a long, heavy lens is attached to it. The weight displacement of the lens may cause the tripod to tip over, breaking a very expensive lens.

➤ If you want to shoot wildlife with your camera, invest in a gun-stock support and bipod. This combination is very hard to beat for wildlife photography.

Gadgets and Gizmos

In This Chapter

➤ Uniform metering of natural light

➤ Pinpoint accuracy with spot meters

➤ Measuring electronic flash lighting

➤ Special effects with filters

➤ Get a bug's eye view with close-up rings

➤ Packing your gear on your back

➤ Hands-off shutter releases

Few photographers enter their hobby or profession without being drawn to the many gadgets and gizmos offered to complement their photography systems. Unless you are very unusual, you too will be pulled into the lure of buying this and that for no good reason. Many accessories are not needed. A lot of other ones are useful only on rare occasions. Some accessories, however, can make a big difference in the quality of your photography.

Good Exposure Is No Coincidence with an Incident Meter

Independent light meters are an example of a worthwhile expense, so let's talk more about them. Light meters are indispensable tools for photographers. They take the guesswork out of making good exposures. Most new cameras have built-in light meters, but these meters cannot perform the functions of independent meters as well as they should. Most in-camera meters work on an averaging system. This procedure works fine frequently, but it fails often enough to be a considerable bother.

Jargon Alert
Incident Light: This is light that is falling on a subject, rather than being reflected off the subject.

The answer lies in buying an independent meter. But what type should you buy? Some light meters can do it all. They can read natural light in a reflective or incident mode and take flash readings. These meters aren't cheap, but they are very nice to have. Other meters read only natural light. Some handheld meters read only in an incident mode, but many will perform incident and reflective readings.

An incident meter reads the amount of light falling on an object. It does not allow for shadows or harsh lighting that may be affecting a subject from an angle. When a reading is taken in the incident mode, it is done through a milky-white dome. The translucent white dome diffuses falling light for an accurate meter reading. The reading represents the overall lighting in the area.

If you take a reflective reading, it should be similar to what you would get by using your in-camera meter. Reflective readings can be fooled by light subjects and dark backgrounds or by the reverse of this situation. When there is substantial contrast between a subject and a background, you should take a meter reading of each main element. To achieve the best exposure possible, you must average the two readings to reach a happy medium. This is what your in-camera meter does automatically.

It's starting to sound like your onboard meter is all you need, right? Well, it can produce good results, but it can't take incident readings. Although, some photographers manage to get decent incident readings by putting white translucent materials over their lenses, aiming at the sky, and taking a reading. These readings are rarely as accurate as the ones taken by incident meters, but they are better than nothing if you are in a bind.

Of the three types of light meters we will discuss, the incident and reflective meters are the least valuable to you if your camera already has a built-in meter. While these meters may not be worth buying, there are two other types you should not do without. One is a spot meter, and the other is a flash meter. Spot meters and flash meters are specialized pieces of equipment that can certainly improve your photography. Let's talk about them next.

Spot Meters

The aspect of spot meters that makes them so unique is their ability to take a very precise light reading from an extremely small portion of a subject, even at great distances. A good spot meter will use such a pinpoint perspective that its reading will be based on only 1 percent of a subject. This gives you complete control over making an ideal exposure. Let me give you a couple of examples that show how a spot meter can help you.

Jargon Alert

Spot Meter: This is a meter that takes accurate, reflective light readings from subjects that can be a great distance from the meter. Spot meters are made to read narrow portions of light for a higher degree of accuracy.

Assume that you are at a circus and want to take a picture of an outdoor high-wire act. The acrobats are standing on their platforms, preparing to cross the tightrope. If you were to take a meter reading of the acrobats with an average in-camera meter or a typical hand-held reflective meter, the sky in the background would fool your meter. But, with a spot meter you could take a reading from the faces of the acrobats. The bright sky and reflective outfits worn by the circus performers would not interfere with the reflective reading taken by your spot meter. This is because the meter is able to pinpoint its reading on only the facial area.

A one-degree spot meter in use.

For another example, assume that you are a wildlife photographer. Your subject is a large bison standing in the shade of a tree while the surrounding areas are in full sunlight. Trying to meter this scene from a safe distance with any type of meter, other than a spot meter, would be useless. Spot meters can't be beaten when it comes to long distance readings and pinpoint subject selection.

Flash Meters

Flash meters are nothing like spot meters, but they have their own attributes that make them very special. A flash meter is the only type of light meter that can read the output of an electronic flash and provide you with a proper exposure setting. This, of course, is extremely important if you are doing studio or location photography using multiple flash units. Many cameras can be fitted with one flash equipped with a light sensor that judges when an adequate amount of flash lighting has been achieved. These units are fairly reliable, but they can't compare to the accuracy of a flash meter.

A flash meter tells you what exposure setting to use. This model is a combination incident, reflective, and flash meter.

Shutterbugs who use flash only on infrequent occasions are not prime candidates for flash meters. If you use only the automatic flash that is dedicated to your camera, you probably won't benefit greatly from using a flash meter. But, if you buy studio or location strobes, you nearly have to buy a flash meter. Shop around and find one that will do flash exposure readings, reflective exposure readings, and incident exposure readings. There are many brands and models to choose from. You can't buy this type of meter with pocket change, but it shouldn't cost you a full paycheck either.

Filters: Instant Fog, Greener Greens, and Other Illusions

Filters for your lenses can add color, mood, and unusual special effects to your photographs. If you want people to believe that you have a three-headed dog, there's a filter

that can help you prove your point. Starburst filters make all lights look like stars. Fog filters turn a normal day into a misty mystery. Colored filters can deepen natural colors and provide surrealistic tones to photographs. Graduated filters allow you to color a sky with a gradual lightening right down to the ground. Polarizing filters work like sunglasses by removing glare from reflective surfaces, like store windows. Creative options with filters are nearly endless.

Filters are not inexpensive, but neither are they a major expense. Depending on the size and type of filter you want, you can expect to spend between $9 and $30 for one of the highest quality. A standard, UV-haze filter for a standard lens will set you back less than $9 from my mail-order dealer. Before you buy any filters, other than a UV-haze filter to protect your lens, decide what type of filter system you want. Would a filter holder and gel filters suit your needs and pocketbook? Glass filters are more expensive than gel filters, but they don't scratch as easily. Plastic filters, which are more durable than gel filters, can often be used in these same filter holders.

Will you use screw-in filters? One drawback to screw-in filters is that the filters will not be interchangeable with lenses that have different barrel diameters. You can buy large screw-in filters and step-down rings that allow the big filters to be mounted on smaller lenses. Or, you can buy a gel system with adapter rings that will allow you to use one filter for all of your typical lenses.

Jargon Alert
Gelatin (Gel) Filters: These filters are cut from dyed gelatin and are positioned in a special holder that attaches to the filter threads of a lens. They are inexpensive but not very durable.

If you enjoy creative photography, a filter-holder system will probably work best for you. It allows full creative control. If you want to slide a blue filter into the top of the holder and a red filter up from the bottom to create a two-color filter, you can. It's also possible to slide a filter partway into the holder to essentially create your own graduated filter look. Personally, I like a filter holder with plastic filters, but I also use gels and screw-ins. My polarizing filters are all screw-in models, but most of my other filters are gel or plastic.

Filters are a lot of fun to play with, and they can add much to a picture. Some photographers get trapped into poor pictures by using filters too often or inappropriately. It's okay to go off the deep end occasionally, but remember not to abuse your filter usage. Many photos are best made without the use of filters. See Chapter 20 for more details.

A filter holder mounted on the end of the lens.

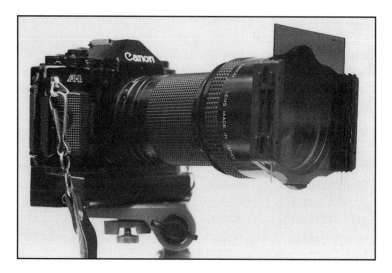

Screw-On Close-Up Rings Are a Cheap Alternative

There usually comes a time in a photographer's experience when a detailed close-up photo is wanted. This can't be achieved with an average lens. If you have a macro lens or a bellows, you're all set. But, if you don't have a close-focusing lens, you simply can't get tight, thought-provoking close-ups. There is an inexpensive alternative for photographers who rarely do close-up photos. If you seldom shoot small subjects at short distances, a package of screw-on close-up rings is most likely the best solution to your desire for close-ups.

Close-up rings are often used in sets. They screw into the filter threads on a lens and allow for increased magnification and a closer distance between lens and subject. Macro lenses and bellows produce much higher magnifications and crisper images, but close-up rings are an economical way of trying out close-up photography. Before you rush out and spend hundreds of dollars on a macro lens and extension tube, test your interest with close-up rings. For a standard lens, they should cost less than $40. As long as your lens will accept screw-in filters, you should be able to mount close-up rings on the lens. If you find that you enjoy going eye-to-eye with a praying mantis, you will have the option of moving up to better equipment.

Why Carry It When You Can Wear It?

Photographers typically want a lot of equipment with them when they are pursuing their hobby. You will probably not be an exception to this rule. If you are going to have to keep track of a ton of stuff, one good way to do it is by wearing it. Camera bags and cases have long been the normal means of transporting photo equipment. They are still good for this purpose, but a photo vest can give you a lot of definite advantages in the field.

I've used a photo vest for so long now that I would be lost without it. No longer do I dig through a cramped camera bag in search of lenses, film, or light meters. My vest is organized with spacious accommodations for all of my most-needed gear. I can change lenses without ever taking my eye off of a subject. Not only is my vest handy, it's comfortable. I don't suffer from a shoulder strap cutting into my shoulder, and I no longer lean to one side like a West Virginia cow standing on a mountainside. With the amount of gear I carry, a camera bag is quite a shoulder full of weight. By distributing the weight in a vest and supporting it with both shoulders, I can go for hours without undue fatigue.

Insider Tip
Photo vests can carry extensive equipment and keep items at your fingertips while distributing the weight to make the transportation of gear comfortable.

My spot meter and incident meter hang from a D-ring on the outside of the vest. I carry two camera bodies on shoulder straps, and a third body is tucked into the vest. A typical load of lenses includes a 300mm, a 200mm, an 85mm, a 24mm, and a 100mm macro lens with extension tube. A bellows is likely to be hidden away in a back pocket of the vest, and a large flash can often be found in the same pocket. The big back pocket also carries a ring light. Other pockets contain film, cleaning supplies, batteries, filters, cable releases, and other essentials. The vest would probably hold more equipment, but this is about all I'm willing to pack without the aid of a backpack to distribute the weight better.

A top-of-the-line photo vest in use.

Some photo vests are better than others. It is also a fact that some cost more than others. I have two identical vests, or at least they were identical when they were purchased. One vest is in its natural tan color, the other one has been camouflaged for wildlife work. The vests were made for journalists and photographers, and they work extremely well for my needs. They came from a company called Banana Republic. I've seen many other vest styles, but I like mine best.

You probably won't carry a full studio in your vest like I do, but believe me, a vest can be much more comfortable than a camera bag. Whether you are walking through tourist attractions, chasing elusive wildlife, or going for a nature stroll in the local park, a vest is one great way to carry your gear.

Cases and Bags for Carrying Your Gear

Soft camera bags can be the best way to carry your gear. Hard-shell cases afford more protection and should always be used if your gear is being shipped or transported by a commercial carrier. You might even prefer a hard-shell case for day-to-day activities, but soft bags are often easier to use. If you open a hard case, you are exposing all of your gear. This can result in lenses rolling out, items getting mixed together, or prying eyes putting the criminal touch on your expensive toys.

> **OOOH...**
>
> **Insider Tip**
>
> How can you discourage crooks from grabbing your bag or breaking into your vehicle to get at your case? There are many good ways to hide what you are carrying. When I go on location with a lot of gear, I pack it between foam pads in a beat-up ice cooler. Anyone looking in my vehicle assumes that I've got a cooler full of ice. Little do they know that there is over $10,000 worth of camera equipment packed inside.

When you work out of a soft bag, you can access equipment in compartments without disturbing other gear. Outside pockets let you get to extra film and batteries without showing the world what else is in your bag. Just seeing a hard, aluminum case gives some people the impression that whatever is in the case must be very valuable. A beat-up camera bag doesn't present this same image. However, any camera case or bag can attract unwanted attention, and photography gear is a favorite target of thieves.

When I'm walking about, I'm usually wearing a photo vest. A quick-grab thief can't make off very easily with a vest being worn. An armed robber could get it, but the job of ripping you off when wearing a vest requires much more determination than it does when you are carrying a shoulder bag. If you carry your stuff in a bag, it's likely you will set the bag down to compose and shoot pictures. While you are focused on your subject, some low-life might lift your bag.

I created another inconspicuous way to carry my gear by converting a black rucksack into a camera bag. I wear the miniature backpack and it looks like I'm out for a stroll with the camera gear that's in my hands. In more than 28 years of photography, I've never had a single piece of equipment stolen. Many unfortunate photographers can't boast of such a record. Keep the criminal element in mind when you choose your means for transporting precious cargo.

Timers: Look Ma, No Hands!

Few good cameras are sold today that don't include a self-timer. This type of shutter release allows you to get in your own pictures. It is also very effective for timed exposures and slow shutter speeds when you can't afford to jiggle your camera. Self-timers are great, but there are some other means of remote activation that you might want to consider.

A cable release is an inexpensive item that you should own. If you do any type of slow shutter-speed work, a cable release is very helpful. You push the plunger on the cable and your picture is taken. Motion of the camera is minimized, so shots come out crisp and clear.

Bet You Didn't Know The "bulb" setting on a camera allows the shutter to stay open for the duration of time that the shutter button is depressed. This is the setting used for timed exposures.

Some photographers, like wildlife photographers, find it beneficial to trigger their shutters from a considerable distance away. If, for example, you wanted to snap a picture of a fox emerging from its den, you probably wouldn't be successful if the animal saw or smelled you. This means you have to get hidden away from the camera that is trained on the den entrance. In doing this, you need some way to fire the camera on demand. One inexpensive, yet effective, way of doing this is with an air-actuated remote release.

Using a special air hose and squeeze bulb, you can be about 20 feet away from your camera and still operate the shutter. When you squeeze the bulb, air pressure depresses a plunger and triggers your shutter. A more costly, but less cumbersome, way of accomplishing the same goal uses an electronic remote control. This type of unit allows you to be even farther from your camera and still fire the shutter remotely. Additional types of more complex systems are available that will fire when a beam is broken. This type of unit allows you to take pictures without even being on the scene. For example, a deer walking down a trail would break a beam that exists between a sensor on either side of the trail and trigger the shutter of a camera. If you really want to get into James Bond accessories, they're available. However, an air-actuated remote is affordable and suitable for most casual photography.

All I Want for Christmas...

When it comes to photo accessories, you will probably never run out of things to buy. Levels that mount in the flash holder of a camera can be useful. They let you know when your camera is level; a tilted camera results in a crooked picture. Lens hoods serve a justifiable purpose. Auto winders and motor drives are worth their price to many photographers. Santa could fill your stocking with filters for years without running out of options. Databacks that record dates and times are sometimes useful, and a magnifier for your eyepiece is extremely helpful when doing extreme close-ups. All you have to do is browse through a few camera stores or flip through the pages of camera catalogs to see that there is no end to a photographer's wish list. You are entering a hobby where you can spend a little money or a lot of money. Make your purchases wisely.

The Least You Need to Know

➤ Light meters are essential tools of the photography trade. Flash meters are needed to read and rate light from electronic flashes. Spot meters are ideal for taking extremely accurate, reflective light readings from subjects at a distance. Incident meters are good general-purpose meters, and reflective meters are similar to in-camera meters.

➤ Filters can be used to correct coloration, reduce reflections, and create special effects. Glass filters are very good, but plastic and gelatin filters are also handy. You can achieve better photographs when you use filters wisely.

➤ Close-up rings are a cost-effective alternative to expensive macro lenses and bellows. While the rings will not produce images of a similar quality to those made with a macro lens, they are an inexpensive way to introduce yourself to close-up photography.

➤ Photo vests allow you to keep your gear close at hand, and they distribute weight well. Of all the transportation methods available to field photographers, vests are usually the most effective.

Playing Dumb,
Buying Smart

In This Chapter

➤ Words of wisdom

➤ Cutting off the stream of sales talk

➤ Department store deals

➤ Mail-order miracles

➤ Gray-market materials

➤ Dodging bullets and getting real deals

Buying photographic gear is no walk in the park. In fact, you might feel more like you have entered a minefield when you start looking for ways to spend your camera money. There are so many products, and so many places to buy them. It's easy to become confused and fall prey to an aggressive salesperson ready to sell you components you don't want or need. If you don't want high-pressure salespeople pinning a target on your back, read this chapter. It will show you the ins and outs of buying quality equipment at bargain prices.

Watch Out for the Bad Guys!

A man named Henry tried to explain something to me when I was 18 years old that I didn't understand until I was about 30 years old. He told me that I didn't possess enough life experience to compete with people in the big leagues. When I asked what he meant by life experience, he tried to explain it all to me. At the time, the words were wasted. As I got older, I learned the meaning of life experience. Henry was right!

If you are new to photography, you don't have enough photographic experience to beat the bad guys who will try to sell you junk equipment at outrageous prices. You need help. After thirty-some years of using and buying camera equipment as a hobbyist and professional, I now know many of the tricks and traps that you have to look out for. My mistakes and experience will give you the edge needed to stay a few steps in front of the rip-off artists who hunt the jungles of photography shops.

Start Your Shopping Locally

As a neophyte, you are at the mercy of other people when it comes to assessing and buying photo equipment. Reading books like this one is a big step in the right direction, but there is no substitute for actually handling a piece of equipment and having it demonstrated to you before you buy it. Some people need hands-on help and demonstrations to understand technical matters, and camera equipment today can be pretty darn technical.

Local photo dealers often charge more for their goods than mail-order discounters and chain discount stores. However, your local, established, reputable camera dealer is the best place to start your search for good equipment. Just because you look at a camera and learn about it in a local store doesn't mean that you have to buy it there.

Business owners who are deeply rooted in a community can't afford to scam their customers. Word gets around, and bad word travels fast. If you are working with a dealer who has been in business for several years, you should get fair treatment. However, be prepared to put up with new clerks who don't know beans about their products. Every employer has to struggle to get and keep good help. When possible, ask to speak with the owner or manager of the shop you are dealing with. People in these positions tend to know more about what they are selling than counter clerks do. It probably won't take long for you to determine if the sales associate helping you is knowledgeable or not. Give the clerk a chance, but don't hesitate to ask for more competent help if you need it.

We talked earlier about defining your needs and desires. Go to a local dealer and get various types of cameras demonstrated for you. Insist on having batteries put in the cameras you are most interested in. You can't know how a camera works if it isn't in working condition. Any viable dealer will be glad to waste a battery or two to make a sale.

Once you are sure of what you want to buy, make written notes regarding model numbers, brands, and other identifiable information. If you want to shop for a better price, explain to the sales associate that you want to do some more research before making a buying decision. This will give you an out for not buying right away. Then, go shopping and see what types of deals you can find. Once you know exactly what you want to buy, making a purchase by mail order or some other discount way will be easier and safer.

The Risks and Rewards of Chain Stores

Chain stores that sell at discount prices have popped up all over. It is possible to buy name-brand, quality merchandise at this type of store for a lower price. But, you have to be careful. What you are buying may be a discontinued product that is being liquidated at sell-out prices. The odds of getting qualified sales assistance or after-purchase support are poor. It may be worth paying extra to deal with your friendly, local dealer to have the peace of mind that there is someone at the other end of a phone who will help you if you can't figure out how to load your film or change your lenses.

When you are buying a specific brand-name product, discount chain stores might save you some cash. As long as you are getting exactly what you want, and are willing to do without hand-holding help during your break-in period with the equipment, this can be a feasible route to take. Personally, I think there is a lot of value in having a known, knowledgeable source for any future questions that may develop. A chain store selling ABC brand cameras today may switch to XYZ cameras next week, and that will leave you in a difficult position for local help.

> **Watch Out**
> If you decide to buy cheap, you may find yourself struggling for help later on. Most manufacturers will be willing to help you by phone, but they can't be there to look you in the eye and put your mind at ease. This is a dilemma that you have to deal with. Either pay a premium price at your local dealer, who will always be there to help you, or gamble on not needing much technical support.

In a chain store, you may find salespeople working on commission, which means they may try to push you to buy expensive equipment that will boost their take-home profits. Cutting through sales hype can be difficult, especially if you are a person with feelings and no desire to be rude. There comes a time in some deals where you have to take off the kid gloves and speak up for yourself.

Don't let a salesperson talk you into a different brand or model of equipment because it's on sale or the item you requested is temporarily out of stock. This type of maneuver is often a diversion to get you into a product that offers a higher profit margin to the dealer. When salespeople start to double-talk you, ask them to listen carefully and tell them

again exactly what you want a price on. Confirm its availability. Don't let a big-mouth salesperson push you around.

Mail-Order Buying: Dialing for Dollars Saved

Mail-order purchasing is one way to almost always save money. It can also be one of the riskiest ways to buy products. When you call a phone number from an ad, you have no way of knowing who or what you are dealing with. Is the dealer operating out of a basement or from a luxurious commercial storefront? You don't know, and it may not matter. If you get what you order for the price you agree to pay, there's no harm and no foul.

I buy almost exclusively by mail for cameras, computers, and other big-ticket items. In doing so, I'm always very specific about what I want and in learning about what I will be getting. The financial savings on everything from film to lenses is substantial. After a while, you develop a relationship with mail-order dealers, and you learn which ones deliver promptly, accept returns when needed, and so forth. It's the learning curve here that is dangerous.

Mail-order dealers are not the best place to figure out what you want. I would not order by mail unless I were certain of model numbers and specifications. Some mail-order dealers will give you advice after a purchase, but they can't compare with the local shop owner who can walk you through a problem on a face-to-face basis.

One of the main keys to successful mail-order buying is knowing precisely what you are ordering and what you should be getting. Before you place an order with a mail-order dealer, confirm availability, shipping costs, unexpected dealer surcharges, return policies, and so forth. Don't leave any stone unturned that may fall on your foot later.

Watch Out

Some dealers sell equipment that has been stripped of parts that should be standard equipment. For example, you might be interested in a 35mm camera that is intended to be sold with a standard 50mm lens. To get the price down in an ad, some dealers may advertise the brand and model of the camera body and disclose only in tiny print that it is being sold without a lens. Maybe you don't want the 50mm lens—and if that's the case, and you can save money by purchasing a body only, then do it. The important thing is to know what you are getting for your money. Pin dealers down with specific questions to avoid major disappointments when you place an order.

Mail-order dealers often offer imported products for less money than a USA product costs. There is a fine line here. We're not talking about where the product was made, but where it was meant to be sold. You could buy a name-brand camera cheap that is being sold without a valid USA warranty card. Are you willing to do this? If you are a big gambler, go ahead. However, buying what is often referred to as gray-market goods is risky.

Watch Out
Some "gray-market" photo equipment is sold without a valid USA warranty. Always make sure that the gear you are buying is provided with full warranty coverage.

I've bought gray-market film for years. The film has always produced good results, but I know of photographers who complain that the film is not as good as premium USA film. Rumors indicate the film is not kept cool during transportation and loses some of its qualities. I did run into a problem with one batch of film when it came time to have it developed. The problem centered around the processing mailers between various countries. This is the only problem I ever experienced. While I've been willing to gamble on film, I wouldn't buy major equipment that didn't come with a valid warranty.

You can run into all kinds of traps when buying gray-market equipment. As good advice, I urge you not to accept any products that are not meant for sale in the United States. Use your own judgment and be prepared to accept responsibility if your penny-pinching doesn't pay off.

Buying Strategies that Have Worked for Me

Making all the right moves when buying camera equipment is difficult for anyone, even seasoned professionals. For people just entering the hobby or profession it's even tougher. How can you protect yourself and still take advantage of the best prices available? You may not be able to dodge all of the bullets, but you can avoid most of them if you follow some simple guidelines and use good common sense. Let's talk about some procedures that have worked for me in the past.

➤ *When you see deals that look too good to be true, they probably are.*

Greed is a mighty motivator. If you get greedy, you are likely to be taken advantage of. Fight the temptation to find the one super deal that never really comes along. Accept the fact that you are going to have to pay a fair price for a fair product. You can find some excellent deals if you do enough shopping, but don't expect to get something for nothing.

➤ *Before you buy, you need to know exactly what you want.*

We've talked about this before, but it's so important that it's worth reiterating. Don't go into a buying mode until you are sure of exactly what you want. Until you can compare products equally, apples for apples as they say, you can't know if you are getting the good deal you think you are.

➤ *Gain some product knowledge before you buy anything.*

Read published reports on the types of equipment you are interested in. Join a photography club and talk with other members about their experiences. Now that we are in the age of the Internet, you can log on to photography forums and ask for advice and comments. This type of information is invaluable in sorting out the best, and worst, deals. It's absolutely essential that you do all of your homework before you start buying equipment.

➤ *Novice buyers normally have fewer headaches when they buy equipment from established local dealers.*

Buying from local dealers will provide you with support after your purchase. While you can call a mail-order dealer and discuss questions or problems, a telephone is a poor substitute for the hands-on instruction you can get from local dealers. You will probably pay more for what you buy if you don't deal with mail-order suppliers, but the extra cost is often offset by the ongoing support you get from a dealer in your own area.

➤ *Document the purchase process.*

If you insist on saving money and buying by mail order, document all your actions. Ask dealers to send you written quotes and details on what you will be buying. If you have access to a fax machine, this is a quick and painless process that can save you a lot of trouble down the road. Without something in writing, you will have a difficult time proving what you were told by a dealer over the phone. Require the dealer to present you with return policies and guarantees as part of your documentation process.

➤ *Know your salesperson by name.*

When you place a phone order for equipment, get the name of the person you are speaking with and ask for your order number. Having the order number will help you track down shipments that don't arrive as scheduled. Obviously, you should never send cash through the mail. Use a credit card to pay for mail-order purchases. This will give you more leverage if a problem arises.

➤ *Check out your new equipment thoroughly.*

Make sure that you have the manuals and warranty information that should accompany your purchase. Confirm that all the parts of your purchase have been delivered. Test the equipment as soon as possible. If a product is defective, the sooner you discover the problem the better off you will be.

➤ *Don't ever be lulled into a false sense of security.*

You might feel safe with a dealer after a few good buying experiences. Don't let your emotions cloud your judgment. Follow strict procedures every time you make a purchase. Document your phone calls and order information. You never know when a problem will arise. If you can't avoid trouble, at least you can be prepared to deal with it.

Buying smart is a trait you can learn. It may come naturally, or you may have to work at it. Either way, it's a skill that is well worth the effort of mastering. Most of a smart buying strategy is common sense. Always get price quotes in writing. Return policies and guarantees should also be provided to you in writing.

Get to know the people you are dealing with. Always request and record your order numbers. When you buy from a mail-order supplier, it is best to pay with a credit card. Once you receive your products, inspect them carefully. Make sure that all manuals and warranty cards are packed with the goods. Keep your sales receipts for at least one year.

Getting too comfortable with a dealer can be a problem. The best dealers can turn bad, and unexpected events do happen. A deal you make without written documentation could become a real mess if your contact meets an early death. Document all of your dealings completely and you will have less trouble resolving potential confusion and problems at a later date.

The Least You Need to Know

➤ You should do your shopping locally. Area camera dealers are more likely to devote time to your needs than mail-order dealers are.

➤ Whenever you are about to buy photographic gear, provide dealers with an itemized, detailed specification sheet listing exactly what you want. This will allow you to compare apples to apples and avoid being sold items that don't meet your standards.

➤ Mail-order buying is an inexpensive way to obtain quality equipment, but you should begin your hobby with a local dealer. Don't deal with mail-order houses until you are knowledgeable of your needs and hobby.

➤ Don't get greedy! If you look for deals that are too good to be true, you will probably find that they are just that—too good to be true.

➤ Before you rush out and buy equipment, mingle and communicate with people who share your photographic interests. You can do this by joining clubs, taking photo classes, and by interacting with forums on the Internet.

Part 2
Shutterbug Basics

Did you ever hear the old expression, "Sleep tight and don't let the shutterbugs bite"? I didn't think so. Well, if you're not familiar with shutterbugs now, you will be after reading this section.

Here we will start by teaching you how to feed that film-eating monster that some people call a camera. Not only will you learn the mechanics of loading film, you will get a full education on the many types of film. Then we will take a tour of all the buttons, levers, and other unidentified objects found on cameras.

Once you understand the mechanical side of your gear, we will cover composition. This is one of the most important elements in a good photograph. Light is also critical to the success of a picture, so we will talk about it next. Then we are going to put you to the test of taking real pictures. Before we finish, I will share 25 common mistakes that I've made and you can avoid.

Shh! Be quiet. I think I hear a shutterbug coming out of its cocoon. Could it be you? Maybe so.

Feeding Your Film-Eating Monster

In This Chapter

➤ Decoding cryptic codes

➤ Selecting film speeds

➤ No color—no problem

➤ Transparency tricks of the trade

➤ The All-American film

➤ Film storage tips

➤ Getting all wound up

Wow, you've got your new camera and are ready to start snapping pictures. But, first you have to load it with film. Which type of film should you use? What's the difference in film speeds? Come to think of it, do you even know how the film fits into your camera? These are just some of the questions that may come up when you are ready to start taking pictures. Don't worry, the answers are simple and easy to understand. You can have your camera ready for work in a matter of minutes.

There are a number of different types of film available to you. Each of them can come in various speeds. Selecting the right combination is important, but it is not difficult. Loading a camera with film usually only takes a matter of seconds. Modern cameras often set their own film speeds and wind the film in for you. It doesn't get much easier than that. However, before you load a roll of film, you must decide what you want to load. So, let's solve this mystery right now.

How Film Works in Your Camera

You don't have to know how film works in your camera to take good pictures, but you may be curious. Are you? Well, there are two types of film. Positive film is the type that slides come from. Negative film is what most amateur photographers use. Negative film is available in both color and black-and-white composition. The process of film exposure and development is a complicated one if you opt to know all of the details. Consequently, we will hit the highlights and leave the chemical comparisons and fancy math to people who have more time to solve equations than they have to take great pictures.

Black-and-white film has a yellowish or gray surface that is dull. This is the emulsion side. The emulsion is a light-sensitive layer of silver halide. Basically, it is a colorless compound of silver mixed with compounds of potassium. (Are we building a nuclear bomb or taking pictures?) As you push the shutter button on your camera, exposing the emulsion to light, the emulsion accepts and carries a latent image. This image is maintained on the film, in the film canister, until development in an entirely dark room is completed.

Jargon Alert
Silver Halides:
Light-sensitive silver crystals in film emulsion that form a photographic image.

Color-negative films have several layers of black-and-white silver-halide emulsions. There are, in fact, three different emulsions. One responds to blue light, another reacts with green, and the final one is sensitive to red. As with black-and-white film, images are retained on color film as the film is exposed to light. How much light a film is exposed to depends on the aperture and film-speed setting on a camera when the shutter button is depressed. Too much light will wash out a film. When film doesn't receive enough light, a dark image results. Matching film speed, aperture, and shutter speed is critical when obtaining an optimum exposure.

Film used to create color slides also has emulsion layers. However, negative films are first developed and then printed to make photographs on special photographic paper. There is a two-stage process required to obtain an accurate print. With positive film, there is also a two-stage process, but the film is never printed on paper. It remains on the film, which is usually mounted in a slide mount for viewing on a light table or with a slide projector.

Slide film is exposed to light in the normal way, with an open shutter, to record a latent image. After exposure, the film is processed in black-and-white developer to give black silver negatives in each emulsion layer. Remaining silver halides are given a color developing. The developing forms a dye in the remaining halides and gives a positive image in each layer.

Film Speed Facts

Film is rated in terms of speed. It's not quite like the difference in speed between a Porsche and an Escort, but there are some similarities in the comparisons of performance. There are two basic factors to remember about the speed of film. The faster a film is, the more grain it has. This means that as pictures from a fast film are enlarged, the quality of the enlargement suffers in terms of clarity. The trade-off for added grain is the ability to use the film to take recognizable pictures in low-light conditions. Are you confused yet? Let me explain more fully.

If you are going to photograph your children acting in a play, in a darkened theater, you should use the fastest film you can get, which is usually one rated at a speed of 400. But, if you want to take portraits of your children that will be enlarged and hung up in the living room, use the slowest film you can find. Speed is relevant to the amount of light available to take a picture in and the amount of grain that will blur the picture as it is enlarged beyond snapshot size.

Maybe you don't have kids, so let me give you another example. If you are a wildlife photographer who is hoping to capture a deer on film at dawn, you need a fast film to work with. On the other hand, if you are doing landscape photography in full sunlight, a slower film is a better choice. For simplicity, remember that low-light conditions require fast film, and enlargements require slow film.

ASA and ISO: The Film Ratings Boards

All film is assigned an ASA rating, which stands for American Standard Association. This acronym may not be important to you, but the meaning of a film's ASA rating should be. This rating identifies the speed of a particular film. For example, film rated at an ASA of 200 is twice as fast as film rated at an ASA of 100. Films rated at ASA 200 and higher are considered fast films. They contain higher grain than slow films, but allow pictures to be taken at low-light levels.

There is also another film rating system: ISO (which stands for International Film Standards). An ISO rating is the same as an ASA rating in terms of speed. If a film is listed with an ASA of 400, it will also be considered a ISO-400 film. For your purposes, it is enough to

know that the ISO or ASA rating indicates the film's speed. Both ISO and ASA ratings are just industry rating standards. There is no difference between them in terms of photographic use. Simply concentrate on the film speed.

What Film Speed Should I Use?

Matching film speed to your photographic needs is not a big mystery—it's a fairly straightforward process and an important part of getting good pictures. There is a wide range of film speeds available. Some are more popular than others. You can choose from very slow films (like 25) to extremely fast films (like 1000). Films rated at ASA 100 or less are slow films. A film with a speed of ASA 200 might be considered a medium speed. Those that are 400-speed films and higher are fast films.

You can usually select a film speed based on your subject matter and lighting conditions. In general, the faster the subject is moving, and the less light is available, the faster the film you need.

Insider Tip

When you are taking pictures that will be enlarged, use the slowest film speed possible. Slow films have less grain and enlarge to create smoother, better images.

Let's start out by talking about the very slow films first. A very popular slow film has an ASA rating of 25. However, a film this slow is normally used by professionals in studio settings. This film produces photographs with very little grain and a lot of detail. The drawback to such a slow film is the need for bright lighting. If you own expensive lenses that have wide apertures, you are not as restricted as photographers who use typical lenses. Under very bright lighting conditions, an ASA of 25 is a good choice. As a compromise, many professional photographers use film with an ASA rating of 64. This is my typical choice in slide film.

Given equal lighting conditions, you must balance film speed with your available aperture settings. Let's assume that you have a good amateur lens that offers a 5.6 aperture at its most open setting. Now let's also assume that you must have a minimum shutter speed of 1/125th of a second to hold your camera in your hand without camera shake and a blurred image. What does this mean to you in terms of film speed?

The film speed you select will be relevant to the amount of light that you will have to work with. The examples I'm about to give you are not scientific; they are based on usual light-meter readings that I get with various lighting conditions. Assuming that you are shooting outdoors on a fairly bright day, you can use a film with an ASA of 100 to meet your needs. On a cloudy day, you would have to step up to a film with a minimum ASA of 200, and maybe one with an ASA of 400.

If your camera has a built-in light meter, or if you have an independent light meter, you can do your own tests to determine average film speed requirements. Since I'm thinking that you don't yet have an independent meter, but that your camera does have a built-in meter, we will use this scenario for our example.

Your camera doesn't need film in it for this test. Set your film-speed dial at ASA 100. Move your aperture ring to 5.6. Now set your shutter speed at 1/125th of a second. Depress your shutter-release button halfway. What do you see? If your readout is blinking, you either have too much or too little light to get an accurate exposure. Experiment with different combinations of aperture and shutter speeds until you find a spot that signals to you that the setting is right. Change film speeds to assess other films of higher speeds.

Not all cameras have built-in meters or digital readouts. You may have a needle that comes to rest at a certain point on a scale. The concept is the same. To find out the difference in film speeds with the most accuracy, you need an independent light meter. With a meter, you can see clearly how film speed, aperture, and shutter speed relate to each other.

As a beginner, I suggest that you work with film that is rated at ASA 200. This film is fast enough to allow you good working exposures, even with relatively slow apertures, while producing good-quality photographs that can be blown up to moderate enlargements. Once you start taking pictures in the real world, you will soon recognize the advantages, and disadvantages, of various film speeds.

The reason so many professionals use slide film with a rating of ASA 64 or less is that most magazines, stock photo agencies, and similar buyers require a low-grain film. An ASA of 64 produces very little grain and is fast enough to allow photographers who have expensive lenses with wide apertures to shoot in most lighting situations. Faster films, when used in print media, produce grainy pictures that do not reproduce well in publications.

Photographers who shoot color print film often start at the low end with a film speed of 100. This is a good, low-grain film. By shooting a film with a lower speed, you get prints that have better resolution. This is true even in snapshots, but the real proof comes when negatives are enlarged for portraits and wall hangings. Grain can be compared to dots. The more grain a film has, the more dots it takes to make an image. Film with fewer dots will make a smoother picture. Overall, the less grain you have, the better your image will be.

Insider Tip
Slide film is much less expensive to use than print film, and it allows you the freedom to project your images on a screen.

A more versatile and faster film has a rating of ASA 200. If you are looking to do enlargements beyond an 8 × 10 format, 200-speed film will start to get grainy. The big advantage of 200-speed film over 100-speed is that you can shoot at lower light levels without a flash or slow shutter speed.

If you will be shooting at dawn or dusk, a 400-speed film is a good choice. This is also a popular speed for black-and-white film. Color film with a rating of ASA 400 does get grainy when it is enlarged. (With this film, 8 × 10 enlargements are about the maximum.) This is the trade-off of a fast film. In general, slower films produce better pictures. On the other hand, a fast film can allow you to get a picture that you couldn't take with a slow film. The aperture rating on your lenses also plays a vital role in the film speed you must use.

When we discussed lenses, we talked about paying big bucks for fast lenses. If you are after top-quality photos, you should have the fastest lens and the slowest film that you can work with. Money can be a problem when it comes to buying super-fast lenses. They are expensive. Moving up in film from ASA 100 to ASA 200 could save you hundreds of dollars in the lens needed to record a decent photograph.

What constitutes a fast lens? It depends on the focal length of the lens. A 300mm lens with a wide aperture of 2.8 is extremely fast and very expensive. One with an open aperture of f-4 is still fast, but more affordable. An amateur-grade lens with a 300mm focal length will have a maximum aperture of about 5.6. A lens with a focal length of 85mm and a maximum aperture of 1.8 is very fast. One with a wide aperture of 2.8 is good. You have to put focal length and open aperture into context to determine what a fast lens is. Essentially, you want your aperture ring to have the lowest number on it that you can afford. This allows you more flexibility in film speeds and lets you shoot in lower light conditions.

If your main interest is snapshots, a fast film is fine. The grain in this type of picture is not objectionable in small prints. However, if you want your photograph enlarged to a poster-size print, you will want to use a slow film. To give you some basic guidelines, let's assume that you have a typical consumer-grade lens. This is a lens with a moderate to slow aperture rating. An aperture of 5.6 is not uncommon, and a fast consumer-grade lens with a moderate focal length will have a maximum aperture of 3.5 or 4.0. Based on this assumption, you can create a profile for which films to use for various types of subjects.

Slow films, those with a rating of ASA 100 or less, should be used for stationary subjects, studio photography, and when lighting is good. A medium film, like an ASA-200 film can normally be used on cloudy days and for stopping action with slow-moving subjects, like people. If you are clicking your shutter early in the day or late in the evening, a fast film, like an ASA-400 rating, will be desirable. Fast film is also useful for fast-moving subjects, like race cars and airplanes.

Some cameras automatically set the film speed for the film being loaded. If you've got antique gear, like me, you have to set it yourself. Look at your film canister to determine the film speed, and set it appropriately on your film-speed dial. This dial is usually on the left side of the camera where the film-rewind crank is located. Film speed is spelled out on both the box that the film is sold in and on the film canister. Many photographers fail to set their film speeds when moving from one type of film to another, resulting in bad exposures. Slow down. Take the time to make sure that the dial on your camera is set properly. If you have a modern camera that sets the speed automatically, this is a step that you can skip.

There is a very simple test that you can do to see the effect of various film speeds. Set the film speed on your camera at a given speed and take a meter reading. If you know that you have to shoot at 1/250th of a second to stop motion, it won't take long to determine what the best film is for your needs.

How will you know what shutter speed to select? A shutter speed of 1/60th of a second is usually considered the slowest shutter speed at which a person can hold a camera without enough shake to result in a blurred photo. Setting a shutter speed of 1/125th of a second is normally adequate for most slow-moving photographic targets, such as children at play. Faster speeds, like 1/250th of a second, can stop running subjects, birds in flight, and similar fast-moving targets. The faster your subject is moving, the faster your shutter speed must be set.

Assuming you are using an automatic camera, go to aperture priority mode, if you have one. When in aperture-priority mode, automatic cameras will automatically select a suitable shutter speed. However, not all automatic cameras have this function. The internal light meter in many automatic cameras, but not all, will combine aperture settings with shutter-speed settings for the best average exposure. By changing shutter speeds and aperture settings, you can find a combination that will work best for you.

Set the aperture as low as possible for your meter reading. If you start with a film speed of ASA 64 and see that you will need a shutter speed of 1/60th of a second, you know this film is too slow for your type of photography. Move the speed dial up a notch or two and take another reading. When you get to a speed that gives you at least a 1/250th exposure rating, you know that you have found the film speed that suits your needs. This is a simple test, but very few photographers ever think to perform it.

Some inexpensive cameras, like many point-and-shoot models, don't offer full control over shutter and aperture priority. With these cameras, you are at the mercy of the film speed you select. I suggest a film speed of ASA 200 as a good starting point. Until you move up to a component system, you are not likely to get the full range of options that should ideally be available to you.

Black-and-White Film Basics

Photographs with a lot of contrast are often photographed best with black-and-white film. However, in our color-crazy world, black-and-white film has fallen out of favor with casual photographers. Journalists use it. Artists swear by it, and photographers who must deal with poor lighting often rely on it. There is probably some place for it in your camera bag. Black-and-white film is a terrific medium for photographers. Learning to see pictures in black-and-white, as opposed to color, takes some experience. However, since black-and-white is a contrast-type of film, it can be "pushed" to much higher exposure ratings. For example, you can take a roll of black-and-white film that is rated at an ASA of 400 and expose it as though it were rated at an ASA of 1600. If you try this with color film, the grain and contrast will be dismal. Granted, the contrast and grain will be high with black-and-white film, but it will yield a usable picture. In extremely low-light conditions, it's hard to beat a fast black-and-white film that is pushed to its limits.

Jargon Alert
Pushing Film:
When film is underexposed and overdeveloped, it is *pushed.* This is a common method for artificially increasing film speed. For example, you could take a roll of ASA-400 film and push it to a speed of ASA 800 or even up to ASA 1600.

Should you consider loading a roll of black-and-white film? It can be an interesting experience. However, learning to see photographically in a black-and-white format is not easy. Many pictures, those with minimal contrast, simply don't do well when taken on black-and-white film. A lonely oak tree standing on a hill in winter makes a good black-and-white print. Kids dressed up in colorful Halloween costumes do not.

If you want to dabble in a darkroom, black-and-white film is the way to go. It's inexpensive to process and the chemicals used for processing have a longer shelf life than those used for color. Shooting and developing your own prints is an excellent way to establish good photography skills. You can buy used equipment to set up a temporary darkroom in your bathroom for only a few hundred dollars. If you go this route, you are almost certain to obtain a new appreciation for photography. See Chapter 22 for more details.

When you need an extremely fast film, black-and-white film is a good choice. This type of film can be "pushed" in a darkroom to give the equivalent of blinding speed. (Pushing film is a darkroom term that we will talk more about toward the end of this book.) Use black-and-white photography for graphic shots, artistic photos, and fast photography. If you want to start from ground level and work your way up the photography ladder, black-and-white photography should be on your agenda.

Sorting Out Slide Film

Slide film is a cost-effective medium for taking color pictures. Shooting slides is less expensive than taking pictures on color print film. The cost of buying print film is less than that of slide film. In fact, it can be more than two dollars a roll less. But, when you have exposed film that you want processed, watch out! Print processing can cost more than twice what slide processing does.

Many professional photographers bracket their shots. This means that they take multiple pictures of the same subject at different exposures to guarantee a good shot. By shooting slide film, the wasted exposures are not so expensive. Another reason why so many pros use slide film is that publishers prefer transparencies (slides) over color negatives.

Slides are positive images, just the opposite of color negatives. Positive images are meant for immediate viewing. You can look at a slide by holding it up to light, laying it on a light table, or projecting it on a reflective surface. In doing so, you will see a color image. This is not the case with print film.

Slides offer you many advantages and only a few disadvantages. Cost is one of the biggest advantages to working with slide film. The per-image price is low when compared with color prints. Since 35mm slides are small, they are easy to store. You can put them in projector cubes, carrousels, or keep them in slide pages that fit a three-ring binder. Slides take up much less space than prints do.

The disadvantages to slides are that they can't be viewed as easily as snapshot prints, they require the use of an internegative to print on photographic paper, and many types of slide film cannot be processed in a home lab. As a photographer, you must decide what type of finished product you want and how much control you want over it. As your own darkroom technician, you can do a lot with negative films. You don't have this freedom with positive films, such as slides. A majority of professionals shoot slide film, but it may not be the best choice for you.

As an amateur photographer, you may prefer print film. It allows you to see your work clearly without the aid of a light table and magnifier or a slide projector. On the other hand, you might like the idea of projecting your images on a screen or wall for a big-picture look. Choosing between slide film and color-negative film is usually a personal decision.

> **Jargon Alert**
> *Internegative:*
> This is a negative made on a special color film for making copies of prints or prints from slides.

Film for Color Prints

Color print film is a favorite among casual shutterbugs. This film produces a negative image that is transformed into a print. If your goal is to create enlargements and wall-hangings, print film is probably your best choice. This is also true if you want to create a typical photo album. Having prints made from negative film is easier and less expensive than it is with slide film.

The major drawback to color print film is the developing cost, although many labs will produce prints at very affordable prices if you are willing to wait a day or two to see what you caught on film. The many one-hour-photo services that have become so popular are expensive on a per-print basis. Waiting a few days to get your prints can produce substantial savings.

If you have aspirations of selling your photos to magazines and books, negative film is a poor choice. Stock photography agencies are not keen on negative film either. You have to decide what you want to do with your pictures in order to pick the best film. If you want six reproductions of a negative to send to relatives, go with print film. When you want to place your work with a magazine or agency, choose slide film.

OOOH...

Insider Tip

Stock photo agencies are a good outlet for the results of your hobby. Agencies will market the work you put on file and pay you when an image is sold. Usually, you get half and the agency gets half of what is paid for the rights to use your photo. Agencies pick their photographers based on ability and inventory, so you don't have to be a big-name pro to sell your work. Pick up a copy of *Photographer's Market*, published annually by F & W publications and available in book stores, for a substantial listing of stock photo agencies to submit your work to.

Slide film tends to be the choice of professionals, while print film commands most of the consumer market. Either type of film is capable of giving you a rich reward for your photographic effort. Should you want to grow into having your own darkroom, negative film will provide the most enjoyable opportunities for you. See Chapter 22 for more details.

Bet You Didn't Know

WOW!

There's a special kind of film, infrared, that you can experiment with either as a tool or a toy.

This type of film is often used to test the health of plants and foliage. When color infrared film is used with a yellow-orange filter, healthy foliage presents itself in a bright red color.

A professional use of black-and-white infrared film involves hot spots and heat loss. Heat sources show up very well on infrared film. Contractors who want to pinpoint heat-loss areas in a home can use infrared film to capture the heat loss on film.

You probably won't have much need for this use of infrared film, but there are many creative ways to make eye-catching photographs with the film. Landscapes are a natural subject to record with infrared film. This can be done with either color or black-and-white versions of the film.

Using a red filter with black-and-white infrared film will produce high-contrast prints. A variety of filters can be used with color versions of the film to create a wide array of special effects. You may not use infrared film on a regular basis, but it's a lot of fun to play with.

Film Storage: Don't Lose Your Cool!

Unused film should be stored in a cool place, such as your refrigerator. If you go to a professional camera store, you will see that film is keep in refrigerated areas. Most photographers agree that film can be stored for a short time in temperatures near 65 degrees F, but long-term storage should be done in a cooled container where temperatures will not rise above 56 degrees F.

Film that is stored properly at cool temperatures and protected from humidity can last a long time. Check the expiration date of film that you are buying before you buy it. You should use and process the film prior to the expiration date. When you take film out of cold storage, allow it to warm to room temperature before opening the film canister or envelope. Opening the protective covering too soon can result in a condensation build-up on the film. Avoid leaving film exposed to direct sunlight, closed vehicles where summer temperatures soar, and other hot spots.

Loading Film into Your Camera

To load or unload film, you'll need to open up the camera back, of course. Pulling up on the rewind knob will open most older style 35mm cameras. Newer, point-and-shoot models often have some type of little latch on the back or side that will release the clasp that holds the back shut. Since camera manufacturers are not consistent in their designs, you should consult your owner's manual for help on this matter. If you don't have paperwork available for your camera, experiment with the various buttons and latches. When the back flies open, you will know you found the right one. If you are completely stumped, take the camera to a camera store and ask for help.

An example of film being loaded into a 35mm SLR camera.

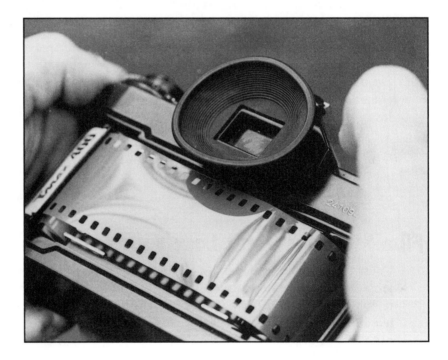

Putting film in your camera should be simple. Read and follow the directions provided by the camera manufacturer.

There are, however, some problems that can pop up when you are feeding film to your little black box. First of all, it's best to load a camera with fresh film in an area that is protected from direct sunlight. Step into the shade of a tree or use your body as a barrier between the sun and film. Handle your film carefully. Don't pull it out of its canister too far, but provide enough of a film leader to make sure that the film sprocket will pick it up.

The film leader is the first section of film that comes out of a canister. The end of it is narrower than the rest of the film. This is the part that you start on the film sprocket in your camera.

Many new cameras have automatic film loaders. With these models, you put film in place and close the back of the camera. A whir of the winder tells you that the film is being loaded. This sounds great, but sometimes these automatic monsters don't load the film. You can hear the noise and not know that your film advanced. Take your time loading film and do it right. When you load your film, you may be able to see the film winding around the film sprocket. This will be the case with older 35mm cameras. In newer, auto-load cameras, you have to trust in the instruments that tell you the film loaded properly. In most cases, it does; however, it's very frustrating to shoot 36 exposures and then find that your film never loaded.

Older cameras require you to wind the film into place. You can see the film being wound on its spool, and this is a comforting sight. However, if you don't load enough of the film leader before you close the camera back, you could run into trouble with the leader slipping from the spool. Wind film onto the sprockets until you have a couple layers of film in place. This almost guarantees that the film won't pull out. Close the camera back and advance your film to its starting point.

Remember to set the film-speed adjustment on your camera so that it corresponds with the film being loaded. Some cameras do this automatically, but many require you to set the film-speed rating. Cameras that are equipped with film-speed dials require you to set the appropriate film speed. Many photographers, including professionals, fail to do this when using a new film speed. Most point-and-shoot cameras set the film speed automatically. Refer to your camera manual, if necessary, to see what your responsibilities are in terms of setting film speed. If you forget to do this, you could have pictures that are either over- or underexposed.

Loading up is easy, but don't take the task lightly. A camera without film moving through it is pretty useless.

The Least You Need to Know

➤ ASA and ISO ratings are identical in terms of film speed.

➤ Slow film provides a finer grain in a photograph and is more suitable for enlargements. Fast film is more forgiving of less-than-optimal light conditions.

➤ When you are choosing a type of film to use, consider shooting color slides. Slide film and processing works out to be much less expensive than what color print film and processing costs.

➤ Keep your film cool. You should keep your film in your refrigerator for long-term storage. However, take it out of the cold well before you expose it to hot temperatures. Film that is taken from a refrigerator and put into use on a hot day can suffer from water condensation, and the water can cause problems in your camera.

➤ When you buy film, check the expiration date on the film box. Most film can be used successfully after it has expired, but it's kind of like milk—how long after the expiration date are you willing to trust it?

Understanding Your Camera's Controls

In This Chapter

➤ The eye of your camera

➤ Film speed requirements

➤ Slamming the shutter on time

➤ Ten seconds and counting

➤ Push this button before you fire the shutter

➤ Getting your film back

Cameras come with a host of buttons, levers, and functions. Figuring all of them out can take several hours. Some people never fully understand how to use their equipment to its fullest extent. Reading manuals that come with cameras is the best way to overcome the confusion of buttons and do-hickeys that you don't know what to do with. But, suppose you buy used equipment and don't get a step-by-step manual? This chapter should help you, with or without your camera manufacturer's literature.

Spinning Your Wheel of Fortune for the Right Aperture

Aperture is the opening of a lens. Take a lens that is not attached to a camera and look through it. Rotate the aperture ring as you do this. You will see that the light allowed through the lens is affected by turning the aperture ring. The settings you choose in this mode of photography have much to do with the finished product that you will see once your film is developed and printed.

Illustration of a typical aperture ring.

Aperture ring

Finding the best aperture for a picture is simple if you let an automated camera do the work for you. However, you may not get the results you want. Setting an aperture manually is frequently the only way to get outstanding photographs. In the old days, photographers made all of their own exposure settings. Today's technology has removed all but the most minimal effort on a photographer's part. This is not to say that relying on automatic settings will get you the pictures that you deserve.

You must use aperture settings in conjunction with shutter speeds and film speeds to achieve proper exposures. This part of aperture adjustment is essential. Additionally, you can use the aperture settings on a lens to control depth of field, which determines what will and will not be seen or in focus. If you master aperture manipulation, you can do magical things with your camera.

When you choose an exposure setting for your camera, there are three elements that you must consider: film speed, shutter speed, and aperture. They all work together in a complex relationship to determine the amount of light captured on the film.

For an image to be recorded on film, the film must be exposed to light. The amount of light reaching the film and the film's speed, or sensitivity to light, controls how well the image is recorded. Aperture and shutter-speed settings determine how much light reaches your film.

The faster a film speed is, the more sensitive to light the film is. In other words, film rated at ASA 400 requires less light to make a definable image than film with a speed of ASA 100. Your aperture setting controls the opening in your lens. A small aperture, one with a high number, allows less light through the lens than a wide aperture.

Lenses have different aperture settings. The number and size of the settings depends on the focal length of the lens and its cost. Expensive lenses are usually faster than inexpensive lenses. This means that they are capable of opening up more to allow good pictures to be taken in less light.

My 85mm lens has a wide aperture of 1.8 and a small aperture of 22. A less expensive lens might start with an aperture of 2.8 and go up to 22. If I set my lens at 1.8 on the aperture ring, the opening in the lens is as large as it will get. This allows the maximum light possible to reach the film in my camera. Setting the aperture at 22 will allow the least amount of light to pass through the lens.

Another way of controlling the amount of light reaching the film is possible with a shutter-speed setting. It is not usually advisable to hold a camera in your hand with a shutter speed slower than 1/60th of a second. Shutter speed determines how long the shutter of your camera will remain open, allowing light to reach your film. A fast shutter speed, like 1/250th of a second, will allow much less light to reach the film than a slow shutter speed, such as 1/15th of a second, will.

Shutter speeds vary on different types of cameras. Some cameras don't even have shutter-speed settings or aperture rings for you to work with. When a shutter-speed dial is available, it will normally provide a range of more than one second to as little as 1/2000th of a second. If your camera has a setting for shutter speeds, it will probably be on the top right corner of the camera.

When you take a light meter reading with either a built-in meter or an independent meter, you will be given a suggested shutter speed and aperture setting. Remember, however, that not all cameras have internal light meters, and some cameras don't display light readings. Your camera may have a light that flashes if there is not enough light for the camera to record a good image. Some cameras read light and decide automatically when to fire a built-in flash to accommodate for low light. Ideally, your camera will give you some type of meter reading and control over what you are doing. Let's say that your meter indicates an exposure setting of 1/250th of a second at f-5.6. (F stands for f-stop. Apertures are measured in f-stops.) You can take a picture at this recommended setting, but should you? What are you photographing?

Assuming that your camera allows you to make aperture settings on your lenses, you can control the depth of field in your photographs. Depth of field has to do with what is, and isn't, in sharp focus. You may want a shallow depth of field to blur out a distracting background. Or, you might want a deep depth of field, so that an entire field of flowers is in focus.

An f-stop of 5.6 is an average setting. It will give reasonable depth of field. But, let's say that you are taking a picture of a monument. You want the background behind the monument to be blurred, so that it will not be distracting. A larger aperture opening will be needed to accomplish this. The smaller a number is in an f-stop rating, the larger the aperture is. For example, an f-stop of 2.8 is larger than 5.6.

To blur the background of a picture, you will want an open aperture. An open aperture is one where the lens opening is large. This means that your aperture ring will be set at a small number. Each number on an aperture ring is rated as a stop. For example, if you went from a setting of 5.6 to 8, you would have moved one stop on your aperture ring. The recommended setting is f-5.6 at 1/250th of a second. In this case, you don't want too much blurring, so you decide on an aperture of f-4. This is one stop larger than the recommended 5.6 rating. To compensate for your change and to avoid overexposure, you have to increase the shutter speed by one stop. Your revised setting will be f-4 at 1/500th of a second.

Insider Tip

To get as much of a picture as possible in focus, you must use a stopped-down aperture. In other words, you must set your aperture ring at the highest number possible when setting your final exposure.

If you open your aperture by two stops, you have to extend your shutter speed by two stops to maintain a balanced exposure. For every stop you move your aperture ring, you have to move your shutter-speed dial one stop. If you are opening your aperture to allow more light to reach your film, you must move your shutter speed to a faster setting to maintain an equal exposure. When you close down your aperture, allowing less light in, you must move to a slower shutter speed to maintain a balanced exposure. If you wanted more depth of field in the above example, you might choose an f-stop of f-8. Since this is closing the aperture by one stop, you have to compensate on shutter speed by one stop. The correct setting would be f-8 at 1/125th of a second.

The large numbers on your aperture ring will allow the most depth of field. In other words, more objects in front of and behind your subject will be in focus when your aperture ring is set at a high number, which results in a small aperture opening. Little numbers on the ring will blur backgrounds. This type of knowledge allows you more control over your photography. Remember though, if you change either the aperture or the shutter speed, you have to change both to maintain a balanced exposure.

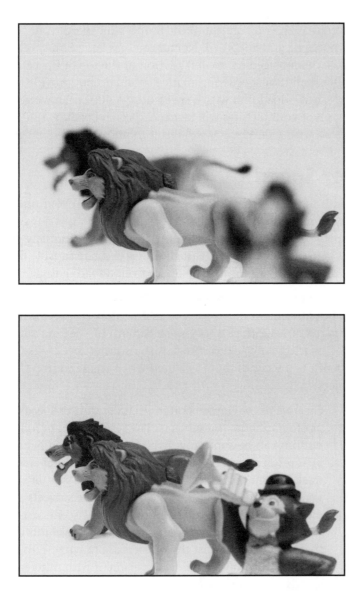

This picture was taken with an open aperture, f-2.8. Notice how the center object, the subject that was focused on, is the only part of the picture that is in focus.

This picture was taken with a small aperture opening, f-32. You can easily see that this picture has much more subject matter in focus than the first picture.

Setting Film Speed on Your Camera

We've already discussed ASA and ISO ratings for film in Chapter 9. You know the uses and advantages of different film speeds. It is important, however, that you remember to set the proper film speed on your camera when you load it with film. Failing to set a new film speed is often a source of problems for photographers. (Some new cameras do it automatically; others don't.) Even pros forget to change the speed settings sometimes.

If you don't set the film-speed dial on your camera to the proper film speed, your photographs will be either overexposed or underexposed. Not all cameras have film-speed dials. The ones that do usually have them placed on the left portion of the top of the camera. Many inexpensive cameras set their film speeds automatically and do not provide a dial for user settings. For example, if you load film with a speed of ASA 400 and have your camera set for ASA-200 film, all of your pictures will be overexposed. Loading ASA-100 film and shooting with a speed setting of ASA 200 will result in underexposed images.

Setting Your Shutter Speed

Shutter speeds are not difficult to set, but they can have a huge impact on your photographs. Slow shutter speeds are needed when lighting is poor, when film speed is slow, and when lenses are not capable of large apertures. Flash photography is normally done with a shutter-speed setting of 1/60th of a second. Fast shutter speeds are capable of stopping motion, such as a moving car, a running person, or even a soaring eagle.

You should not try to hold a camera in your hands while taking pictures at shutter speeds of less than 1/60th of a second. Movement of the camera at slow shutter speeds will result in blurred photos. Shutter speeds of 1/125th of a second or 1/250th of a second are common settings that work fine with handheld cameras. Faster shutter speeds, like 1/500th of a second or 1/1000th of a second, should be used when trying to stop the motion of a fast-moving object.

Insider Tip

Using a slower shutter speed when photographing a moving object will result in blurring that can translate into an image that implies very fast action.

Creative photographers often use slow shutter speeds to photograph moving subjects. The result is a blurred image, but this can be appealing. Assume that you are taking pictures of a local track team. People are running around a track and jumping hurdles. If you use a fast shutter speed, say 1/250th of a second, you can freeze the subjects' motion for a clear picture. Shoot the same scene at 1/60th of a second, and you will get a streaking blur of motion that indicates how fast the runners are moving. This special effect can be quite pleasing. Experiment with different speeds on various types of subjects to experience the full capability of your camera outfit.

Self-Timers Control the Action

Self-timers allow you to star in your own pictures. Set your camera on a tripod, focus it on a spot, set exposure settings, and push the self-timer button on your camera. Then, run like crazy to get in front of the lens. In a matter of seconds, the shutter will release and

you will have taken your own picture. This is one use of a self-timer, but it's not the only one.

The self-timer control on your camera is very useful when taking slow exposures. Pushing your shutter button with a finger can jiggle the camera. This is all it takes to ruin a picture. When you use a self-timer, the camera settles down from your touch before the picture is taken. The result is crisper images.

Self-timers are frequently located near the shutter buttons on cameras. Some, like the ones on my cameras, allow the timer to be set for different intervals. For example, I can set mine for 2 seconds or 10 seconds. This is done by moving a little lever over either of the settings. Some cameras allow only one setting, and other cameras don't have a self-timer feature.

Checking It Out with the Preview Button

Most good cameras are equipped with preview buttons. These buttons allow you to preview the depth of field that you will achieve when a picture is taken. Few photographers take advantage of their preview buttons, but they should use them more often. Without previewing your composition, you can't be sure of what will and will not be in focus as the depth of your shot changes.

Not all cameras are made to allow you a full preview of depth of field prior to an exposure. Check the owner's manual with your camera. If you don't have a manual, look for a button on the left side of where your lenses mount. This is a favorite location for preview buttons. If you have a preview button, use it. Seeing what you are doing before you shoot can save a lot of wasted film.

How Fresh Are Those Batteries?

You should make frequent battery checks so that you don't discover a loss of power at a critical moment. How you check the battery in your camera will depend on the type of camera you have. My cameras are set up with a test button on the top of the camera body. It is to the left of the viewfinder. When I push the button, a red light flashes on top of the camera. The speed of the flashing repetitions tells me how strong my batteries are. A faster flashing means greater battery strength. There is a good chance that your camera has some type of battery check built into it too. Your owner's manual, if you have one, will show you where it is.

If you don't have any way of checking your battery without removing it from your camera, invest in a cheap battery tester. You can get these from most any electronics

Insider Tip

If you do a lot of work in cold weather, your battery will not last as long as in warmer weather, so plan to bring lots of extras on a cold-weather shoot.

store. You have to make sure that your batteries are powerful enough to provide service throughout your shoot. In a worst-case situation, change your battery frequently. Always carry at least one spare battery in your vest or camera bag. There are few things worse than having an automatic camera with a dead battery. Also, make sure you do not have film in your camera when you change the battery. Some point-and-shoots will lock up and you could lose the film.

Rewinding: Where's the Reverse on this Dang Thing?

Rewinding the film in your camera should not be a difficult chore. Many new cameras rewind used film automatically. When they do this, they usually leave a short piece of the film leader exposed. This makes removing the film for home processing easier. Other cameras will rewind spent film automatically once a button is pushed or a small lever is activated.

Watch Out

Don't get your rewind lever confused with the one that opens the back to your camera. If you do, your film will be ruined. Get to know your camera well before you put it into active use.

Old timers, like me, often use cameras where the film must be rewound manually. In my case, a small button on the bottom of my camera must be pushed to enable the film to be rewound. Once this is done, I can flip up a small crank and turn it to rewind the used film into its canister. Assuming that you want some of the film leader exposed after rewinding, you must obtain a certain feel for what you are doing. Experienced hands can tell when film has left the loaded spool. You can usually hear the film being released.

There is some argument among pros about leaving film leaders hanging out of the ends of used film canisters. For one thing, it's easy to mistake the film for unused film. Doing this can be very disappointing. Not only will you ruin the film you shot to begin with, but your second batch of pictures will also be junk. This concern is a valid one. Mark your used film by bending the end of the leader. Once the end of the film is crimped over, you will know it has already been exposed.

Another concern with not rewinding film fully is that dirt will slip into the canister as film is carried around. You can overcome this by putting spent film back in the plastic holder it came in. Frankly, I doubt this is necessary, but it's better to be safe than sorry.

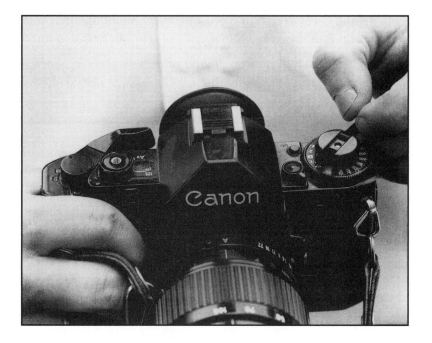

A small crank is used to rewind film in this 35mm SLR camera.

Don't panic if your film winds completely inside its canister. Professional processing labs won't mind. If you do your own processing, you can remove the film in your darkroom with a standard bottle opener. It is easier in the darkroom if you can pull film out by the leader, but this is not a big problem to overcome.

The Least You Need to Know

Modern cameras can have more buttons, knobs, and latches than you might care to keep up with. It is important, however, to know what every control does. Practice with your camera before you load film into it. Get familiar with the layout of all controls. This may save you from lost memories and wasted time once you put film into the magic box.

➤ When you set your camera for a perfect exposure, you must consider film speed, aperture, and shutter speed. All three of these elements are crucial to a proper exposure.

➤ An open aperture, one where the number on the aperture ring is low, will blur a background and result in a setting that is not distracting.

➤ When you use a stopped-down aperture, one where the numbers on your aperture ring are large, you will have more objects in focus than you would with an open aperture.

111

➤ Always remember to set and check your film speed with every roll of film that you load. Having your camera set on the wrong film speed will result in poor exposures.

➤ Batteries are essential to most modern cameras. If your camera uses battery power, and it probably does, don't leave home without spare batteries. You should check your batteries frequently and replace them when they become weak.

YOUR THUMBS IN IT AGAIN...

A Little to the Left, A Little to the Right

In This Chapter

➤ Horizontal or vertical framing?

➤ Low-down techniques for better pictures

➤ Creating depth of field

➤ Taking the edge off of curves and angles

➤ Breaking center-spot bad habits

➤ Cleaning out your viewfinder

Composition is a critical component of fine photography. It is often what separates snapshots from outstanding photographs. There are, of course, other elements needed to make a wonderful picture, but the best lighting, the most expensive equipment, and the finest film will not overcome poor composition. Fortunately for you, composition is not an aspect of photography that requires professional-grade equipment or a large investment in either time or money to learn.

Depicting Life Horizontally

Anyone can pick up a camera, aim it at a subject, and press the shutter release. But you probably want more in your pictures than dull images. Making your photographs interesting, exciting, and meaningful requires a little more effort and skill.

Some subjects are meant to be captured on film horizontally. Others are not. Creative photographers know no boundaries. They let their artistic senses run wild. However, art takes on many forms, and which one to use may not be so evident to you.

When your goal is to create eye-catching scenic shots, a horizontal shot is often best. Pictures of cities, houses, cars, boats, and other similar objects are normally captured this way.

One rule-of-thumb to remember is if your subject is wider than it is tall, a horizontal format works best. Here's an example. Let's say you are at a family reunion, and you want to take a picture of your favorite niece and nephew. How should you frame this photograph? Vertically, since two people standing side by side are taller than they are wide. But, suppose you want to take a group shot of everyone attending the reunion. This would be a good time to shoot horizontally.

Many newcomers to photography don't consider holding their cameras in any way other than horizontally. Does your camera have lettering on the top of it that says, "This end up"? Don't get locked into looking at the world in only one way; you'll stifle your creativity and lower the quality of your photography.

Using a horizontal format for this photo has made the mother and daughter appear distant. There is too much background on the sides and top of the photo. A vertical format would have been a better choice.

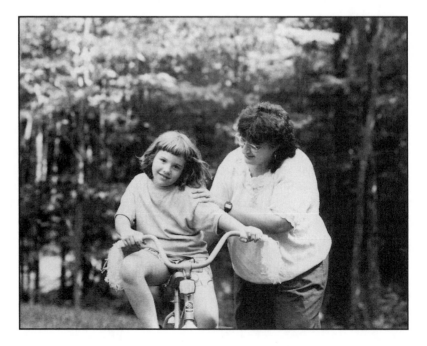

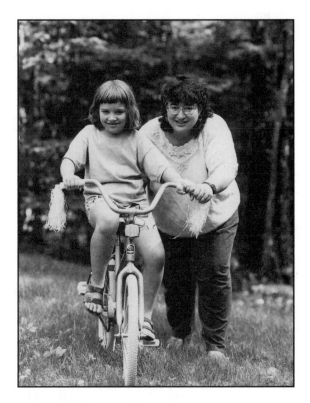

The subjects in this picture seem to be coming right at you. By using a vertical format, the background doesn't swallow the subjects.

"Your Camera Is Sideways"

You know a person is a rookie when you are taking a vertical shot and someone walks up to you and says, "Your camera is sideways." Look through your photo album or slide files. How many of your memories are stored left to right instead of from top to bottom? Were most of your photos taken horizontally? Yes? Hey, turning the album sideways doesn't count!

Learning to take vertical shots comes naturally to people with a photographic eye, but the process is much more difficult for most people. Go to a zoo, a park, a museum, or any other place where shutterbugs are prolific, and observe how the photographers are taking pictures. Most of them are probably holding their cameras all in the same position.

If you were to tag along with a professional photographer for a day, you would witness pictures being taken in a variety of formats. Think back to the last television show you watched that featured a model in front of a wind machine while a photographer twisted and turned a camera at all angles. The truth is, professionals know that different angles produce different effects.

Pictures of people are almost always more effective when they are taken vertically. This is assuming that the person is standing up and is not part of a large group. If your child is

115

stretched out on the floor looking particularly cute, or your subject is skiing, running, or involved in some similar activity, shoot horizontally. Having empty space in front of your subject gives space for the subject to be moving into. However, vertical shots are still generally best for people.

Architecture is often framed vertically. So are wildlife subjects. Common sense plays a large role here in deciding which slant to use. When you look through your viewfinder, imagine the image you are looking at hanging on your wall. Turn the camera body and view the subject vertically and horizontally. Which looks best? Where is open space needed? As you become more comfortable with looking at your subjects through a lens, you will develop a natural feel for which angle works best.

Going Low for a Better Perspective

Lowering your body for a better perspective can produce stunning photographs. How often have you seen photographers get down on their knees to get a better angle? Or, lie down to take a picture? When you are taking pictures of live subjects, it is usually best to keep your camera at eye level with them. An adult taking a picture of another adult might do very well standing up. But, the same adult taking a picture of a child should lower the camera to the child's eye level. If you are taking a picture of your dog, an even lower camera level might be needed. Viewers of your photographs will want to see the subject eye-to-eye. If you stand up and aim down at a dog or child, the picture will not be of professional quality. Seeking eye level with your subject is a rule you should always remember. However, if you're into snakes and scorpions, use a long lens.

As a professional photographer, I've gone to great lengths, and depths, to take the best pictures possible. When I wanted pictures of pink water lilies, I didn't stand on the bank of the pond and simply snap my camera. Instead, I went into the water and got up close and personal with the aquatic flowers. If you want exciting and professional-looking pictures, you have to do more than just point and shoot. Get involved with your subjects. Try lying on your back under a colorful tree, and shoot upward. The results can be astounding. One thing though, make sure there are no birds sitting in the branches above you; they may decide to take target practice on you and your lens.

Rolling up your sleeves and getting down and dirty with your subjects might not be your idea of a great way to enjoy photography. However, the results of putting your camera on the same level as your subject will result in much better wall hangings. The next time you find yourself aiming up or down, think about the possibility of changing your position for better composition.

Here is a cute picture of a brother and sister enjoying fresh strawberries on a summer day. The picture was taken at normal adult height. Notice the bright spot of sun behind the boy's head and how the entire picture has a "looking-down" perspective. Now compare this picture to the one below.

This picture was taken while the photographer laid on the ground. Eye contact is present with the children, and there is no distracting background. Overall, this is a much better picture.

Put a Tree Limb in the Picture

The next time you are taking a picture outdoors, consider including a tree limb in the picture. This tactic will add depth of field to your photograph. Assume that you are standing on the shore and watching colorful sailboats breeze by. You can aim directly at the boats and preserve their image on film, but the photo may not have much personality. If you position the sweeping limb of an evergreen in one corner of the picture, however, you will create a new look.

You don't have to run around with a tree limb in your back pocket to use as a prop. If you look around as you envision the composition of your picture, you are likely to see a host of natural elements that will add appeal. Let's look at a quick example of this.

Imagine that you are attending a wedding and want your memories of it to be special. Lots of people are burning through rolls of film with standard snapshot procedures. When it's your turn to photograph the bride and groom, you ask them to stand just on the far side of an open, arched doorway in the church. Your picture will stand head and shoulders above the rest. Adding the doorway has done many exciting things for your picture. It has provided depth, identified the location, and framed the couple. Simple little tactics like this make your main subjects stand out, and your photographs become more than casual snapshots.

Here, an arched opening was used to frame the person in the picture. By doing this, depth has been created in what otherwise would have been a typical snapshot.

Composing Odd Angles

When you slow down and look at a potential picture from all angles, you are more likely to find an ideal composition. Simply shifting from one side to another can give you a whole new perspective on a subject. Too many photo enthusiasts rush through their picture-taking techniques and miss out on unique photos.

This is a direct view of a mushroom. The picture was taken with a macro lens, so depth of field is very limited. The brown center of the mushroom makes for a dark shot. Compare this picture with the one below.

This is the same mushroom that is shown above. By getting down low to shoot the picture, the mushroom stands out better.

Buildings with dome roofs, the cap of a mushroom, and a weathered rock are all objects that curve. Photographing these objects can be especially frustrating. Finding the right composition and maintaining a good field of focus can be difficult. When you are composing a picture where curves are present, you must decide where the curves will begin and end in your viewfinder. The size of your subject will, of course, dictate how much of it can be included in a picture.

Let's use the mushroom as an example. Assume that you are a nature photographer who wants to highlight the color and texture of a wild mushroom. The mushroom to be photographed is white with brown pigment mixed in along the top cap. Pine needles cover the forest floor and create a base and backdrop for your picture. All the conditions are right. How will you compose the picture?

The first step is to squat or kneel down low, so that your subject and lens are on the same eye level. A vertical format should be used to accommodate the stem of the plant. But, where will the curve of the mushroom cap be placed? One way is to place the cap near the top of your viewfinder. Focus until the edges of the curve nearly touch the edge of the frame. The open space in each of the top corners of the viewfinder should be uniform in size. By keeping the lens level and shooting straight on in this manner, the field of focus will remain consistent. After taking this shot, experiment with shooting from the underside of the mushroom to capture the fluted sections of the umbrella.

Finding the Right Angles

Angles, like curves, can create composition problems for photographers. Learning to use angles in your composition, however, is not difficult.

Imagine a pheasant standing still, head up, tail down, posing for you in profile. Would you consider the pheasant to be an angle? Huh? Photographically speaking, the pheasant is an angle. The tail is low to the ground and the head is held high. If you could trace the bird's outline on paper, you would see a distinct angle being formed from head to tail.

How should you compose this picture? If the bird is standing still, one way is to put the tail in the bottom corner of your viewfinder and the head in the upper corner. This diagonal composition complements the bird's natural form. If the pheasant were walking or running, the tail could be placed in one corner, while the head lay just above one side of the middle of the frame. This would allow space for the bird to be moving into. If the pheasant were in flight, you could put the head in an upper corner, the tail in a lower corner, and allow the outstretched wings to reach into the two remaining corners. This would be an awesome shot.

The pheasant in this photo doesn't have anywhere to go. There should be more space in front of the bird. The tail feathers are angled into the bottom right corner, which is good composition, but the head is held too low.

Avoiding Dead-Center Syndrome

Dead-center pictures are a sure sign of amateurish work. Many cameras have circles in their viewfinders that indicate the center point, and far too many photographers use these circles as an aiming device. Just like many people who have trouble learning to invert their cameras vertically, many photographers have difficulty in breaking away from the dead-center syndrome. In the case of a single-lens reflex camera, the center circle in the viewfinder is there as a focusing aid, not an aiming spot. People see the little circle and assume that it should be right in the middle of Aunt Alma's nose. Well, it shouldn't be.

Single subjects can be framed near the center of a photo, but they should be slightly above center and a little to the left or right of center. If you are taking a picture of a person but will not be doing a full-body shot, you must decide where the frame should terminate. Cutting someone off at the knees is not a good idea. Moving in closer or rearranging the subject for a better break point is more sensible.

Bet You Didn't Know Many first-time photographers are disappointed with their photos because of cluttered backgrounds. Bad backgrounds and poor exposures account for most rotten pictures.

Also, before you shoot, scan the edges of your viewfinder. Most poor composition is not recognized until the film has been developed and printed. By this time, it's too late. To avoid wasted film, lost memories, and agonizing moments reviewing your prints, clean up your viewfinder before you click the shutter.

People often photograph much more than they have to. This problem is most often associated with background interference. When a background is not adequately blurred with the use of a small aperture opening, distracting elements take away from the main subject. A common cause for unwanted interference is that photographers are so focused on their subjects that they don't notice surrounding objects. If you spend all of your energy concentrating on your subject, you are sure to make some mistakes in composition. There is, however, a way to avoid this. Compose first, focus second, and then compose again.

This is an example of what can happen if you don't make sure that there are no unwanted items in your viewfinder. The distortion in the upper right corner of this picture was caused by leaves that went unnoticed in the composition of the photo.

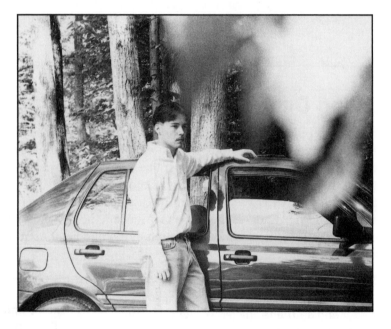

After you have done your initial composition and focusing, scan all areas of the viewfinder for distractions. Start by going from edge to edge and corner to corner. Next, look for background flaws. If your camera has a depth of field preview button, use it. Many good pictures are tainted by busy and distracting backgrounds. Use a long lens or an open aperture to blur out such confusion. You want your subject to be the focal point of the picture. For more information on how aperture settings can affect your pictures, see Chapter 10.

Reflections, Shadows, and Other Hazards

Have you ever taken a picture of someone or something standing in front of a window or glass door while using an electronic flash? If you have, you've probably been plagued by blinding reflections of the flash in the glass. Avoid this during the composition stage by pulling drapes or curtains closed, or by relocating your subject.

Shadows can also be a big problem when flash pictures are taken. Get your subject to move well away from any wall or surface that might show off a shadow. By simply moving your subject during composition, you can save yourself from the shadow monster. If you're on vacation and taking family portraits, beware of signs, posts, and other objects that might sneak home with you in your film canister. You must preview pictures before you take them.

Insider Tip
When using an electronic flash, don't allow your subject to be placed in front of a reflective surface.

If you can use a tripod to hold your camera, the process of checking a viewfinder is easier. The use of a zoom lens makes it easy to crop out side interference, and a fixed lens can eliminate bothersome images if you simply change position. The bottom line is this, don't push the shutter button until you are sure that the viewfinder contains everything you want and nothing that you don't.

The Least You Need to Know

➤ Don't limit yourself to only horizontal shots, but do use them when your subject is wider than it is tall.

➤ Lower your body to get a better perspective on your subjects.

➤ Seek the eye level of your subjects with your lens.

➤ Don't rush to take a photo; slow down and look your subject over closely first.

➤ Get great images by composing first, focusing second, and then composing again.

➤ Add elements of depth and separation to make your pictures more lively.

➤ Preview all subjects in your viewfinder before you take a picture.

Using Light Right

In This Chapter

➤ Shimmering images

➤ A little around the edges

➤ Artistic lighting

➤ Afternoon glows

➤ Morning mist

➤ Outdoor portraits

There is an old saying in the real estate business that says there are three things that are important to a property's value. Those three things are location, location, and location. A similar statement could be made about photography. What three things make or break a photograph? Light, light, and light. Of course, composition and exposure are both important elements to a wonderful picture, but light is frequently what makes a picture a winner or a loser.

As you progress in photography, you will probably work with various types of lighting. Natural lighting and artificial lighting are the two broad categories, but these areas break out into a number of different lighting situations. You might be working with household lighting, electronic flash, fluorescent lighting, sunlight, photo lamps, and so forth. You will have to adjust for and adapt to the type of lighting that you are using. To do this, you must learn the principles of good lighting.

If I were to guess, I'd say that most photographs are taken with natural lighting. A lot of professionals use artificial lighting, even outdoors, but pros don't account for the mass number of photographers. People like you, who pursue photography as a hobby, are much more numerous than professionals.

So, if pros use artificial light so frequently, why don't you? I believe the answer is that natural light is easier for an amateur photographer to work with. Professionals often want to control every element of their shots. This is rarely the case with casual shutterbugs. But, to get the most out of your pictures, you have to learn to use natural light correctly.

Back Lighting Turns Dew into Jewels

There is some unwritten rule among amateur photographers that says the sun should always be at your back when taking pictures. This type of logic is what separates the pros from the rookies. Back lighting a subject often makes a picture much more appealing.

Back lighting is when the light for an exposure comes from behind the subject. This type of lighting is done all the time by pros, but few weekend warriors do it. Set yourself apart from the crowd and start back lighting your subjects. I'll even tell you why and how to do it.

The occasions when this type of lighting is appropriate are numerous. Let's look at two examples of when lighting your subject from behind is beneficial.

In our first example, you are a studio photographer working with a female model. The model has very nice hair, and you want her mane to stand out from the blue background you are using. To do this, you should use a hair light. This is typically a studio flash with a snoot attached to it. The snoot is a tube that narrows the beam of a flash. When you shoot your exposures, the snoot will blast light into the back of the model's hair. By doing this, the hair will almost glow, and it will not melt into the backdrop.

Maybe you aren't into studio sessions with models. Maybe you prefer nature photography. Well, let's say that you are out on an early-morning walk when you come across a spider web that is covered in dew. The spider who made the web is resting comfortably in the center of it. Looking at the web, you see that it is suspended between two trees, offering you an opportunity to shoot it from either side. Which side will you choose?

Where is the light coming from? Early-morning light is low and angled. If you can get it behind the web, you can make the dew stand out like jewels surrounding the princess of the web. You can take a good picture with the sun behind you, but a great picture will result from having the sun behind the web.

Back lighting works well for separating your subject from a background. This is a factor both in a studio and in the woods. Additionally, it often makes a subject seem to sparkle and stand out from other elements of a photograph.

You can also use back lighting to create silhouettes. If your subject is in front of a light source, take a meter reading on the bright background. Set your exposure for the background exposure. This will turn your subject into a silhouette.

Rim Lighting: Not Just for Basketball Stars

Rim lighting is related to back lighting, but with a few significant differences. When a subject is posed with rim lighting, the light source is behind the subject, as with back lighting. But with rim lighting, the light is also either higher than the subject or to one side of the subject—perhaps both. This creates a nice effect.

Rim lighting is very effective when you wish to bring out the shape of a subject. Think of a silhouette that has lighted edges, and you can begin to see what a rim-light shot will be. Flowers, people, bottles, almost anything can be photographed with rim lighting. The times when you use this type of lighting will not be numerous. For most photographers, rim lighting is a rare feat. However, the effects are so powerful that you should at least experiment with them. There are certainly times when no other type of lighting can do a subject justice.

Creating Depth and Form with Lighting

Learning to use light to make images that a sculptor would appreciate takes practice. But, it can be done. A lot of photography is based on shape and texture. To bring out these two elements, you must have a strong grasp on lighting techniques. Let me give you some examples.

Side lighting (light hitting a subject from one side) is used to bring out the texture in a subject. If you want your pictures to have as strong of a three-dimensional look as possible, use side lighting. The drawback to side lighting is that you don't fill in shadow areas and get a full and complete lighting situation. This is often advantageous, but you must learn when by practicing with various types of lighting.

Back lighting and rim lighting give you strong shapes, but not much detail. Since the lighting is behind your subject, you are forced to accept the shape and structure as your

subject. This can be a powerful tool, but don't expect to see smiles on the faces of people who are back lighted or rim lighted. It's not because they are unhappy, it's because the light is not on their faces.

Front lighting is when you have the sun at your back and in your subject's eyes. This is the typical lighting arrangement for most photographers. When you opt for front lighting, you will get good color saturation and a lot of detail in the face or frontal part of your subject. Shape and dimension will be minimized. Simply shifting your position by a few feet will alter the lighting enough to create a different type of picture.

How you position your lighting, whether in a studio or out in the field, will affect the appearance of your subject. Once you understand the basic principles of different lighting positions, as we have just discussed, you can control your images. It's really not difficult. You can choose between only four fundamental lighting circumstances—side light, front light, back light, and rim light. Each one gives you a different perspective. If you are in doubt of which one to use, use them all. Photographers who are afraid to shoot multiple shots at different angles and exposures are photographers who come home with boring pictures. Splurge a little on your film and processing. The end results will prove satisfying.

Warm Glows in the Afternoon

Afternoon sunlight gives a warming effect to photographs. This is often a pleasing and appropriate type of light. You can even enhance the warming effect with filters. If you are interested in landscape photography, mid- to late-afternoon lighting will probably be what you will want to use.

OOOH...

Insider Tip

You should buy a photographic gray card and carry it with you to get ideal exposures. This card is gray in color and is used to measure accurate exposure readings. All you have to do is hold the gray card in whatever light your subject will be in and take a meter reading from the card. You can use an independent light meter or one that is built into your camera.

Many types of pictures benefit greatly from the warming effect of afternoon lighting. Consider an old barn with weathered wood siding. Try to visualize the siding. It is gray for the most part, with many deep brown segments. Old square nails hold the rotting

wood in place, and the heads of the nails have turned to a bronze color with rust. Cracks in the siding leave shadow-filled voids. Shooting this scene with front lighting in the early morning would probably be a waste of time. However, a side-lighted shot in the afternoon would pull out all of the color and texture. The afternoon light would make the brown spots darker, and the nails would stick out as miniature main subjects.

Afternoon lighting is ideal for hay fields, earth-tone colors, human complexions, and a lot of other subject matter. Typically, the lighting you get late in the day is the best photographic lighting that you can use. There are, of course, exceptions to this rule. But, it's hard to beat warm images that have their shadows cast well out of range of your lens.

Cool, Powerful, Electric Vibes with Morning Light

If you are a morning person, you will be faced with natural light that can tint your shots in a haze of blue. This effect can be reduced with corrective filters. However, you might like the bluish tint. Shooting early in the morning will give you very different results from what you will get in the latter part of the day.

Advertisers have told me for years that blue is a power color. Many ad campaigns have been built around electric-blue backgrounds. Is blue a power color? I don't know. Some people say gray is good, others say blue is boss. I'm not an advertising guru, so I can't really say. I do know, however, that morning light tends to be blue. If you are using slide film with a fast rating, the blue tints can be very blue. So blue, in fact, they'll turn you blue once you see what you thought was a great picture.

There are reasons, mostly commercial, to take advantage of cool, blue lighting. As a not-for-profit photographer, you may find that using corrective filters will make you happier with your early morning shots. Maybe you want blue, maybe you don't. Personally, I don't shoot many blue shots. Misty shots are a different subject altogether, and they are often available only in the early part of the day, so let's talk about them next.

Misty-Morning Shots

Some of my fondest photo memories have been made on misty mornings in the mountains. An early sun rising behind dew-laden hemlock trees is a perfect backdrop for my camera. The back lighting and rim lighting makes nature's splendor soar. Foggy mornings can also induce a photographic mood that is unparalleled. Whether you are on a beach, in the mountains, or floating across a mirror-still lake, morning light can give you photographs that you can't get under any other circumstances.

Insider Tip

If you take your photographic gear out in a canoe or boat, invest in inflatable pouches that will protect your valuable equipment if it should wind up in the water. These pouches can hold a lot of stuff, and they work wonderfully.

If you choose to shoot on misty or foggy days, you might want to experiment with your exposures. Overexposing your film can add to the coolness of these types of pictures. You can overexpose your film by setting a shutter speed that is slower than what your light meter calls for or by opening your aperture to a wider stop. A rising fog or a light drizzle of rain gives a scene a perspective that you won't get on clear days. You may not like the isolated feeling or the sterile look of misty photos, but don't knock it until you try it.

Cloudy Days Spread the Light Around

When you want to take portraits of people outdoors, try to work on cloudy days. I'm not suggesting that you take your subjects out under the veil of dark storm clouds. Choose a day when cloud cover is uniform and light. The ideal circumstances will have the clouds acting as a diffuser for the sun. When this is the case, you can take fast exposures on slow film and not be worried about shadows and harsh lighting.

Portraits of people are not the only types of pictures to take on overcast days. Many subjects can benefit from diffused lighting. Landscapes will not be as dramatic, but any type of portrait-type picture will normally look better if it is taken with subdued lighting.

Natural light, and we're not talking about the beer, is a strong tool for you to work with as a photographer. Learning how to use it to your advantage will take some time. You will experience bad exposures, shadows, sun flare, and other common problems as you begin to master outdoor lighting. But, once you tame the beast, it will be one of your best friends.

The Least You Need to Know

Getting your lighting right is easy if you practice and keep track of your test results. Read books, watch videos, and talk to other photographers. This is all good advice on how to improve your lighting. But, when the curtain goes up, the thing that will make you the most proficient as a photographer is practice and recorded notes that can be assessed. You just can't beat hands-on learning.

➤ When you want a subject to be separated from a background, use back lighting. This type of lighting is also ideal for giving special appeal to a model's hair.

➤ Many photographs are good because of the texture that the subjects exhibit. To obtain maximum texture, you should utilize side lighting.

➤ Afternoon light is warm and golden. Morning light is cold and blue. Corrective filters can alter the appearance of either type of light. When you want a special picture, you must know what time of the day to take it.

➤ Who's afraid of a little mist and fog? If you are, get over it. Putting your camera to work in conditions where the sun is not shining may be the best move you ever make. Protect your gear from moisture with plastic bags and get out there and shoot.

➤ Save your outdoor portrait work for cloudy, overcast days. Shooting under these conditions will produce images that are lit by diffused lighting, which is an ideal choice for portrait work.

Taking Your First Pictures

In This Chapter

➤ The rights of passage

➤ Don't be shy

➤ Dry runs

➤ Your first pictures

➤ Accepting failure

➤ Getting busy

When you buy new camera equipment, you will probably want to load and go as soon as possible, without reading the directions and familiarizing yourself with all the controls. True, you can learn about your new system by filling the camera with film and rushing about with an itchy trigger finger. But, the results of your first photographic attempts will probably be disappointing.

The old saying about how you have to crawl before you walk can be applied to photography. In order to take superior pictures, you must know your equipment extremely well. What's the best way to coordinate a formal introduction? Well, let's find out.

Working Through Your Photography Apprenticeship

A majority of casual photographers buy their new gear and then start taking pictures with it. This type of trial and error method is eventually effective, but it can be both expensive and disheartening. Is there a better way? Yes, and more than one way for that matter.

Photography can be a complicated hobby. It doesn't have to be, but if you want to get the most out of it, you need to educate yourself. This can be done by reading books and experimenting with your equipment. Another way of getting to know the mechanics of fine photography is to attend classes on the subject. Many colleges and adult-education providers offer photography classes. Some camera stores also offer classes on photography skills.

Structured learning programs for photography range from beginner levels to professional levels. Whatever you want to know can normally be discovered in a class, book, or seminar. Photo clubs are another good place to learn about photography. Computer users can turn to the Internet and photography forums for help. There are so many sources of information available to you that there is no excuse for stumbling through the learning process. Depression and frustration can take the air out of your sails. Letting yourself feel inadequate as a photographer is a sure way to lose interest in this wonderful hobby. Don't let this happen to you.

Decide on some course of action for learning the basics of photography before you start to beat yourself over the head with a heavy lens for making mistakes. If great photography was simple, there would be many more people pursuing the profession. And names like Richard Avedon, Ansel Adams, and Leonard Lee Rue III would not mean so much to so many people.

Give yourself a break. Accept the fact that you will have to invest time and energy in learning photography skills in order to get above the snapshot level. This is not a bad thing; it will be fun to learn. Who knows, your name may go down in history as that of a great photographer.

A Blind Date with Your Camera

Think of your first few days as a budding photographer as being on a blind date with your camera. No kissing on the first date! You have a new toy that you don't know much about. With a little help from an owner's manual or salesperson, you can load the beast and get it to take pictures. But, you still will not truly know your new friend. Get intimate with your camera. Avoid lip prints on the lens, but do take the time to explore your camera's body.

We talked in Chapter 10 about discovering the uses of various controls on your camera. Take this advice to heart. Find a quiet place where you will not be disturbed and study your photographic friend. Go through your owner's manual and try out each and every control. Once you know where everything is and what it does, put the viewfinder to your eye and try to find the various controls without looking for them. It's easy to spot a button when your camera is in your lap, but when the eye cup of a viewfinder is pressed tightly against your face, finding the controls can be more difficult.

Watch Out
When buying interchangeable lenses for your camera, make sure that the lenses you pick have the proper mounts to work with your camera. Also, pay attention to whether you need auto-focus lenses or manual-focus lenses. See Chapter 4 for additional details.

When you are getting the feel of a new camera, you should simulate actual conditions as much as possible. Go through the motions of loading, winding, shooting, and rewinding film. If your camera has interchangeable lenses, change them. Try to get to where you can do it without looking at what you are doing. Work with all aspects of your new equipment. Once you know where everything is and how it works, you are ready for a test with real film.

Trial Runs

Going through the motions with an unloaded camera is not quite the same as using a loaded camera. Buy two rolls of film. They can be print film or slide film. Get two different film speeds. Start with an ASA of 100 and an ASA of 400. Load the first roll of film in your camera. It doesn't matter which film speed you decide to work with first.

Before you start snapping away, accept the fact that the pictures you will be taking are for testing purposes only. They are not meant to be remarkable photographs. Getting into this mind-set is important. If you don't acknowledge that your first work is experimental, you could be frustrated with your first images.

Your goal in trial runs is to get more familiar with your equipment. With film loaded, you will have the advantage of seeing the results of your efforts. They may not be good, but don't let this get you down. You have to learn sometime, and the price of two rolls of film and processing is a cheap way to see what your camera is all about. After all, it costs less than a good dinner for two, so you can't find a cheaper date.

During your trial period, take photographs of different types of subjects under various conditions. Take some flash photos inside and some natural light pictures outside. Use all of the lenses you have. It's a good idea to record your aperture and shutter speed settings for future reference. A small notebook and a pencil is a good investment during this stage

of your development. Keep notes of how you take different pictures. You will be able to refer to numbers on the film negatives to determine which pictures are which. Slide mounts will also be numbered for your reference purposes.

Subject matter shouldn't be of great importance in the earliest stage of your experimentation. Take pictures of your pets, your kids, your car, or of anything else you can find. Don't rush through your film. Make a serious effort to take good pictures, but don't get down in the mouth if they don't turn out perfectly. Remember, you are in training.

After you get the pictures back from your processor, look them over. Refer to your notes and see what worked and what didn't. Did you forget to remove a lens cap? How often did you get underexposed pictures? Is the focusing in your prints good? How is the depth of field? Did you remember to change the film-speed setting on your camera when you switched rolls of film? These types of questions will help you identify your strong points and the areas you need to work on as you take your first few rolls of good pictures.

"Mistakes" Make Great Learning Tools

No matter how hard you try, you are going to have some pictures that don't turn out well. This is to be expected. It happens to professionals and amateurs. Photography depends on so many elements being right that there are certain to be times when errors occur. Don't look at your poor pictures as mistakes. Look upon them as learning tools. Mistakes amount to experience.

My mother used to tell me that the first time I did something wrong, it was not a mistake. It was experience. She has contended that a person has to make mistakes to gain enough knowledge to perform functions flawlessly. According to my mother, the second time is the mistake. My mom has proved to be right in many ways, and this is one of them.

While I agree with the philosophy of my mother, I think that photographers are entitled to more than one similar failure before they must classify their problems as mistakes. Creative people often arrive at their best work without really meaning to. In other words, mistakes in photography frequently result in unique and intriguing pictures. Leaving a camera on the wrong shutter speed could be considered a mistake. However, the incorrect shutter speed could result in a fantastic picture. You really never know when a mistake will work in your favor.

In order to benefit from your mistakes, you must learn from them. One of the best ways of doing this is to maintain a log. It's not convenient to record every exposure that you make or the weather conditions when you make it, but this type of recording will make you a better photographer. Keeping a written log of what you are doing, when you are doing it, and how you are doing it can be very helpful. Let me give you a couple of examples.

I want you to envision an old cypress tree that is standing in the edge of a swamp. The tree has crooked branches covered in hanging moss. This tree serves as a roosting area for the local crow population. When the sun sets over the swamp, the view of this tree with its feathered inhabitants is intense. Depending upon how the scene is shot, it can be warm and full of life or cold and eerie. If you photograph the scene, you should record your approximate position when taking the pictures. Exposure settings should also be written down. Even the time of day can be important to the overall success of your image.

After taking pictures of the tree in the swamp, you can review your finished prints or slides and see what the result of your work is. Maybe you will find that a lower camera angle would give a more graphic quality to the picture. It might be that the birds are a distraction in the photo. Would shooting with a filter improve the scene? By studying what you have done and when and how you did it, you can return and improve on the shot some other afternoon. This may seem like a lot of work to go through, but it is the type of effort that separates excellent pictures from acceptable ones.

As a second example, assume that you are interested in getting a great shot of your horse. The horse is standing in a pasture when you first photograph it. When the film is processed, you notice that the scene is disrupted by long shadows on the short grass. To avoid this, you should shoot earlier in the day. Refer to your log to see when the first pictures were taken and schedule another session for an earlier time. This type of trial and error is both educational and effective.

Every time you depress your shutter button you stand to learn something new. Remembering the circumstances around every shot is practically impossible. However, keeping records of as much background information as you can is a great way to learn from mistakes and improve your photography. If writing in a log is too much trouble, consider carrying a voice-activated tape recorder with you on photo sessions. The recorder can be used to keep track of your activity without requiring the use of your hands. As you set up each shot, talk to yourself about it. The tape recorder will preserve the moment for later listening. Keeping good records is one of the best ways to become an outstanding photographer.

Putting Your New Skills to Work

When you learn something new, you should work with it until you have perfected the procedure. Whether it's rim lighting or timed exposures, whatever you want to do will be done better when you can do it without thinking about it. Until your camera becomes an extension of your hands and your eye sees like a lens, you won't be as good as you could be. This takes time, practice, and patience.

The old saying that practice makes perfect can't be any truer than when it's used in the context of photography. Many photographers shoot less than 10 rolls of film a year. This amounts to only a few hundred pictures. Serious amateurs shoot 10 rolls of film in a day. Where do you fit in?

Film and processing can get expensive. You don't have to shoot 360 pictures a day to become a great photographer, but it doesn't hurt. What you must do is be consistent in your pursuit of perfect pictures. If your budget allows for only two rolls of film a week, shoot two rolls of film each week. Don't shoot in large quantity and then skip several weeks to make up for your large session. Consistency is critical to your success when the goal is to advance beyond snapshot-quality work.

You will probably be tempted early in your hobby to take pictures of all kinds. This is fine. Go do it. Pick themes to work with. If you like old trains, concentrate on taking pictures of trains. When studio setups are what make you happy, work with them regularly. Once you master the composition and lighting challenges of a particular theme, move on to a new area of photography. Don't overlook or pass up occasional shots of other subjects as you become proficient within a theme, but stay focused on your goal.

You will find that various themes in photography can consume all of your time and money. It might be wildlife, mushrooms, or sunsets that get a grip on you. Maybe you will tour the country in search of every covered bridge that can be photographed. It's difficult to say what will attract you as photography becomes more of a passion for you. As you settle in on certain types of photography, you will learn what you need to know by doing it. There are many good ways to learn in this world, but lessons learned from experience are the last to be forgotten.

The Least You Need to Know

> ➤ Get to know your camera very well. Explore all aspects of your equipment and learn to operate it with a minimum of visual contact.

> ➤ Practice, practice, and practice some more. No learning tool is more effective than firsthand experience. Shoot enough film to become comfortable with your gear before critical shots present themselves.

> ➤ Keep an ongoing log of your photographic endeavors. Recording the steps you take during a photo session will be a big help when you have to troubleshoot pictures that don't turn out well.

➤ Don't be afraid to experiment with your equipment and supplies. Breaking the rules of routine photography is one of the best ways to achieve photographic excellence in creative pictures.

➤ Concentrate your efforts on selected themes as you are mastering your craft. If you bounce from landscapes, to close-ups, to portraits, you will need more time to achieve perfection. Take each theme one at a time and conquer it before moving on.

25 Common Mistakes You Can Avoid

In This Chapter

➤ Film speed failures

➤ No film

➤ Battery bloopers

➤ Meter mess-ups

➤ Shutter shivers

Photography is a hobby where a lot can go wrong. It doesn't take much—sometimes the simplest thing can ruin a good picture.

You will probably experience a few, well maybe a lot of, times when you will feel very foolish. This is not really your fault. It's the shroud of mystery that hangs over all photographers. What makes a person forget to load film on an important trip? Why would anyone leave their favorite lens at home? How could anyone set down a loaded camera bag in a busy airport and leave it to make a phone call? Strange things can, and do, happen to photographers. This chapter is going to show you 25 mistakes that you might be able to avoid.

Remove Your Lens Cap

You've certainly heard jokes about photographers forgetting to remove their lens caps. There is some truth to this old line. Many photographers leave that lens cap on until the last minute. When an event unfolds and calls for fast action, these photographers miss the shot because they have to remove a lens cap at the wrong time. You can avoid this by getting your lens cap off early. Use a UV-haze filter to protect your lens and don't worry about last minute lens-cap failures.

Some photographers complain of losing their lens caps. This is easy to do. I keep my caps in my photo vest, but you might want to attach your caps to your lenses. Manufacturers make and sell small devices that keep lens caps attached to the bodies of lenses.

Set the Right Film Speed

Sooner or later, you are going to change a roll of film and fail to adjust your camera setting to the proper film speed. If you have a camera that sets the ASA for you, lucky you.

Forgetting to change film speeds on the ASA dial of a camera is a problem that hits photographers of all skill levels. I must admit, I've fallen into this trap from time to time. Photographers who typically use the same speed film over and over again are the ones most likely to be affected by incorrect ASA settings. That one time you venture to a new speed will be the time that you get caught. Actually, you will probably remember to change the setting when you load the new film. It will be when you switch *back* to your standard film speed that the little forgetful demon will sting you.

The only way to avoid wasted rolls of film is to check your ASA setting with every roll of film you load.

Load Your Camera

Did you load the film? It's embarrassing, but there have been occasions when I, after more than 20 years of experience, have forgotten to load a camera with film. Few things are more frustrating than shooting a full roll of great pictures only to find that you recorded the image on air and not film. It may seem like you could never forget to load film, but I've done it and I've known many other photographers who have done it.

Insider Tip

If your camera has a rewind crank that must be pulled up to open the back of your camera, leave it pulled up whenever the camera does not contain film. When you pick up the camera body and see the crank in a raised position, you will know that film should be loaded before using the camera.

Did Your Film Wind Properly?

Make sure that your film loads properly. It is not uncommon for film leaders to slip out of spools and fail to load. This is about as bad as never loading your camera. Waste a frame or two of film, if necessary, to ensure that your film is secure on the spool.

The Batteries Are Dead

Finding out that your batteries are dead can be a dreadful experience. Batteries die quickly when exposed to prolonged periods of cold temperatures. Stored batteries may show good readings right before you leave for a photo session and turn up weak after a few shots. The best insurance against battery failure is frequent changing of the batteries and carrying spares. With modern electronic cameras, a dead battery can put an end to your photo session.

I carry a lot of gear with me when I go out in the field. Most of my equipment uses AA-batteries, but some items, like my spot meter, require nine-volt batteries. My cameras require yet a different type of battery. Experience has shown me that putting an assortment of batteries in a recloseable plastic bag and packing them in my camera bag or vest is the best way to avoid ruined days.

Cock Your Shutter

Many new cameras are equipped to wind film automatically as it is exposed. There are, however, still a number of cameras on the market that require you to advance the film manually. Failure to do this can be embarrassing. You may look a bit silly as you frantically push your shutter button to capture the fleeting scene of a sailboat race, only to find that your camera won't fire. You might blame batteries for the failure, but check your shutter lever. Did you cock it after the last shot? Many people forget to advance their film between shots, and the delay in doing so at a critical moment can mean pure disgust for a photographer.

Check Your Light Reading

Don't always believe what you see. In-camera light meters can often be fooled by various types of lighting conditions. For example, taking an accurate meter reading of a skier who is surrounded by snow can be impossible for some meters. The same can be true of people photographed on sandy beaches. Extreme backgrounds can fool meters. Get to know your meter well. Invest in independent meters when you can, and don't believe every reading your in-camera meter gives you. Bracket shots with at least one exposure above and below recommended readings to assure yourself a reasonable chance at a good exposure.

Check Your Camera Settings

Many cameras allow for either automatic or manual exposure settings. If you switch back and forth between these two types of shooting situations, you will probably find some occasion when you think that you are in full-auto mode while you are actually in manual mode. Make sure that your automatic settings are engaged properly if you plan to put your camera on autopilot.

Watch Out for Reflections

Firing an electronic flash in the direction of a reflective surface, such as a window, glass door, or television screen is going to result in bounce-back lighting that you won't want in your picture. Position subjects away from reflective backgrounds when using flash units to light your scenes.

Is Your Camera Secure?

A broken camera body or lens can be an expensive lesson in the hard knocks of photography. If you use a camera strap, be sure that the connections between the strap and camera are secure. Many common types of snaps become worn and can allow a camera to be lost. Wrap duct tape around the snaps to make sure that your valuable equipment doesn't drop suddenly to the ground.

You may not like the idea of using duct tape. It is not the most attractive type of material to use, but it is very effective. As an alternative, you could replace typical snaps with lock rings or other more dependable closures. The main thing is to make sure that your high-dollar camera equipment will not break free of its restraint.

Guard Your Gear

Never set your camera bag down in a public place. While you are composing a picture, some thief may be making off with your gear. I know many photographers who have lost expensive equipment in zoos, airports, and even at weddings! Keep your stuff close at hand at all times. A photo vest is one of your best protections in this situation.

Don't Forget...

You might be cleaning a lens before a trip and forget to pack it. Or, you may have bought new film and failed to put it in your camera bag. Don't get to your photo session and discover that you left critical equipment at home. Use a checklist to make sure you have all your gear with you. This list should include space for film, spare batteries, and similar items. Using a checklist is easy, fast, and efficient in preventing problems with forgotten gear.

Insider Tip
When you buy photographic equipment, record all serial numbers and other identifying marks. Consider engraving your name or a special code number into the metal of your equipment. Make your gear difficult to steal and easy to trace.

Beware of Lens Hoods

Wide-angle lenses and lens hoods don't always go together well. When I bought my first 24mm lens, I installed a rubber lens hood on it. Every picture I took with the lens had a strange, black border around it. I was puzzled. Finally, I realized that it was the lens hood giving me trouble. After removing the accessory, the lens worked fine. Don't let lens hoods ruin your wide-angle photography.

Let Your Flash Recycle

When you are using an electronic flash to light your photography, remember that the flash needs time to recycle between uses. Many electronic flashes cannot recycle fast enough to keep up with auto winders and motor drives. You can waste film and miss good pictures by being too quick on the shutter button for your flash to keep up with you. Fresh batteries are the best way to keep your flash fast.

Electronic flashes have "ready lights" that indicate when a flash firing can occur. However, it is very difficult to concentrate on great composition and a ready light at the same time. Experience is your friend in this situation. The more you use your camera and flash, the more in tune with the recycling time you will become.

Insider Tip
Filters are rated with exposure-compensation numbers that allow you to adjust your exposures when filters are used. Get to know your filters and exposures well before you use them for important pictures.

Filters Can Fool You

Independent light meters are the most accurate way to judge exposures. However, if you are using filters in front of your lens, the exposure reading you get from an independent meter will be useless. In-camera meters take their readings through filters being used, independent meters don't. Make yourself aware of exposure compensations for different filters and adjust independent meter readings accordingly.

145

Eliminate Shadows and Red Eye

Shadows and the red-eye syndrome are frequently the two most common mistakes made in flash photography. You can avoid red eye by keeping your flash positioned away from your lens. The further the better. Shadows are going to show up on light backgrounds when a subject is lit from straight ahead. Either light your subject from high above or from one or both sides to reduce shadow problems. See Chapter 5 for more details.

Harsh Lighting

Harsh outdoor lighting often results in portraits and pictures with unwanted shadows. For example, a subject's eyes may appear very dark due to shadows. Reflector cards can bounce natural light into dark areas to eliminate black spots. A fill flash is another option when working with harsh natural lighting. Learning to see and fill in the rough spots will take experience, but it's easy to do once you get used to the procedure. See Chapter 12 for more details.

Sun Flare

OOOH...

Insider Tip
A baseball cap works very well as a mobile lens shade. Just make sure that the cap is not visible in your viewfinder at the time you snap your shot.

When sunlight shines directly towards a lens, it creates sun flare on exposed film. This is a common problem among outdoor photographers. Shade your lens from direct light. You can do this with a lens hood or with your hand. The problem often occurs only in the top edge of a picture, so scan your viewfinder carefully to see if light is flooding in at some point. Put up a little shade for your lens and enjoy better pictures.

Dirty Mirrors

Dirty mirrors in single-lens reflex cameras can drive you crazy. If you are seeing specks and spots in your viewfinder, remove the lens from your camera and check the mirror. Clean it carefully with an air brush or a can of compressed air. You can scrub your lenses until the cows come home and still suffer from blotched images in your viewfinder until you clean the mirror.

Avoid Blurry Pictures

Poor focusing and camera shake account for a large number of failed photographs. If you get in a hurry, you are likely to experience this type of failure firsthand. When you will be shooting at shutter speeds of less than 1/60th of a second, use some form of solid camera support. An average person can't hold a camera still enough at slow shutter speeds to avoid blurred pictures. Concentrate on your field of focus. Don't aim and shoot haphazardly. If you are using an auto-focus camera, you can shoot more quickly, but do your best to focus for sharp images. See Chapter 6 for more details on camera supports.

Check Your Camera Position

Inexpensive tripods often are not strong enough to maintain stable support of a camera with a heavy lens. If you are using a lightweight tripod that is not of top quality, you must make sure that your camera's view doesn't change before you snap the shutter. You might have a picture composed perfectly while you are focusing and aligning your shot, but the tripod may allow the lens to drop once you turn loose the lens and camera. The drop will normally be minimal, but it will frequently be enough movement to mess up your picture. See Chapter 6 for more details.

If you are going to take pictures like this with the use of a cable release or self-timer, double-check your composition without touching any of the equipment. The only way to avoid a sagging tripod is to buy one that is strong enough to support your equipment.

Bad Color

If you take pictures indoors on a fast color film to take advantage of existing artificial lighting, you will probably notice a yellow or orange tint in your images. This is because a film rated for daylight use was used in conjunction with tungsten lighting, such as household lightbulbs or quartz-halogen photo lamps. Shooting daylight film indoors, without using natural light or electronic flash, will usually produce undesirable film tints. You can avoid this problem by using filters. An 80-A or 80-B filter will allow you to shoot daylight film with tungsten lighting.

Polarizing Filters

Unwanted reflections can ruin your pictures. If you like to take pictures of storefronts or goods in store windows, you should invest in a polarizing filter for your lens. This type of filter will reduce reflections recorded from shiny surfaces. Think of polarizing filters as sunglasses for your camera. Use them when shooting down into water, into glass, or for any occasion when reflections may prevent you from capturing your intended subject on film.

Overexposure

You may take some pictures that appear washed-out. Weak, pale pictures indicate an overexposed shot. Just as underexposed pictures are dark, overexposed pictures are light. To avoid these situations, take several meter readings and average your exposures if necessary. Use an independent light meter whenever possible. Bracket exposures to allow latitude for mistakes in exposure calculations.

Use Your Camera!

Letting your camera collect dust is the biggest photographic mistake you can make. I'm not trying to say that a dusty camera is a huge liability. My point is this: If your camera is not being used, your photographic skills are not being honed and maintained. You owe it to yourself and your hobby to stay active. If you choose to let your camera sit for weeks at a time between photo sessions, you must be willing to accept the fact that your skills will diminish. The only way to be the best that you can be in photography is to shoot, shoot, shoot, and shoot some more.

The Least You Need to Know

➤ Never leave valuable equipment in plain view or in easy reach of potential thieves. Disguise your camera equipment to look unappealing. Consider using an ice cooler as a camera container.

➤ Failure to set the proper film speed on your camera can result in wasted film and opportunities. When you load a fresh round of film, make sure that your camera is set at the proper speed.

➤ Always carry spare batteries with you. So much of today's photographic gear depends on batteries that you can't afford not to tote extras along.

➤ Simple as it may sound, remember to advance your film after each exposure. Failure to do this can result in lost opportunities.

➤ Backgrounds can wreak havoc with in-camera meters. If you are shooting around sand or snow, for example, you must take your meter reading from as close as possible to your subject. The reflective value of some ground surfaces and backgrounds will ruin your shots.

Part 3
A Telephoto Look at Specialties

Have you ever noticed how a lot of snapshots resemble police mug shots or the pictures on drivers' licenses? Well, the pictures you take don't have to look like this. This section starts off by showing you how to make memories without making a mess of it. It will cover everything from snapshots of kids to glorious landscape work. You'll even learn how to take vacation pictures that friends and relatives will actually want to look at.

Both indoor and outdoor photography is going to be discussed here. You will learn how to bounce light, beat bright spots, avoid shifty shadows, and keep trees from growing out of your subject's head. There's more too, but why spoil the surprise?

Have you ever wondered how magazines get those pictures of little insects that look large enough to be from prehistoric times? You can find out in Chapter 18. It's filled with tips and techniques for nature and close-up photography. Then you can go on safari in the wildlife chapter. This trip will teach you all about equipment and procedures required to capture creatures on film.

If you're afraid of spiders and allergic to animals, turn to Chapter 20 for some good advice on landscape and scenic photography. When you get the urge to go a little crazy with your camera, you will find plenty of suggestions to get you on your way in Chapter 21. For example, you will learn about stalking the wild watermelon seed and how plastic rabbits seem to come to life on film.

THIS IS OUR ANNIVERSARY PARTY. SHOT A LITTLE HIGH...

Making Memories Without Making a Mess

In This Chapter

➤ No driver's license photos allowed

➤ Capturing kids on film

➤ Head shots that stand out

➤ Travel photos

➤ Covering the bases

➤ Sharp as a tack, or not!

How many people like the picture on their driver's license? Not many. The pictures on licenses are usually lighted properly and provide an accurate record of a person's appearance, but this doesn't make them good photos. Few people frame their expired driver's licenses and hang them on a wall. As a photographer who is building skills, you have to reach beyond simple recording and put *feeling* into your photos.

What separates a memory from a mug shot? Many elements enhance the beauty and meaning of a photograph. Whether your subject is the Statue of Liberty or your child, the feeling and mood with which the subject is captured on film sets the pace for your work. Film speed, aperture, and exposure settings are tangible aspects of photography. Feeling, mood, tone, texture, and technique are more difficult to describe. Yet, it is these very concepts that you must grasp to go beyond backyard pictures.

When you set out to make memories, you must look for certain elements in a picture. What will make the shot you take special? Are you recording the existence of a monument to prove that you crossed the Continental Divide, or are you telling a story with your camera about Native American culture? The subjects of your work and the conditions under which you are shooting play a part in how you should make your memories.

Up until this point, we have been discussing basic photography principles and practices. This chapter marks the beginning of a new approach. We are going to talk about making professional-type photographs now. The pictures that you take from this point on can have the professional look and a power that is beyond words.

People and travel interests are often key subjects of amateur photographers. It just so happens that these two popular photography subjects are also the main focus of this chapter. We will start our move into interpretive photography with people and expand into travel photos. You may want to take notes as we proceed from this point. In doing so, you can put professional photography techniques to work for you as soon as you pick up your camera the next time.

Children Can Be Challenging

If you have children, they will probably be one of your most-photographed subjects. Children can be very challenging subject matter, though. They move quickly, are unpredictable at times, and almost always go out of their way to ruin a picture if they know one is being taken. If you want to capture your kids on film in natural poses and settings, you may have to do it from a distance. Think of yourself as a wildlife photographer and your kids as the wildlife. Hey, they're probably pretty wild, so they qualify.

Art Linkletter used to say that kids say the darndest things. Well, they also *do* the darndest things. Unfortunately, your camera may not be handy at the moment you need it. There are several rules to photographing children for outstanding results. Rule number one is having your camera ready at all times, and I do mean at *all* times.

Insider Tip

While a point-and-shoot camera is not capable of the versatility and quality that component systems offer, it is an excellent choice for shooting from the hip to catch your kids on film.

One of the most treasured photos of my daughter was taken under unusual circumstances and with difficult lighting. Afton, my daughter, was sitting in the back seat of my 4 × 4. Her mom had gone into a convenience store to get some refreshments. I was sitting in the driver's seat, cleaning the lens on my camera. We were headed to a small zoo, and I planned to get some good animal shots. When I looked over my shoulder, Afton looked adorable. Without a light meter or a moment's notice, I turned the camera and fired three or four exposures. When the slides were processed, the results were more than I had hoped for. This type of impromptu shooting can result in fantastic photos.

The true key to success in getting memorable shots of your children is being ready at all times. If you need a point-and-shoot camera to be ready, get one. Fancy 35mm equipment will often allow you to do a better job, but it's useless if it cannot be pressed into service quickly. Medium-format cameras are ideal for portrait work, but they are often too cumbersome and slow to use in the pursuit of child photography at real-time speeds. Shooting in a studio is one thing, shooting on-the-fly is quite another, and on-the-fly is where the best pictures are captured.

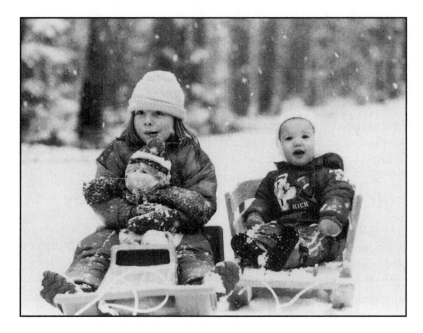

You can get this type of candid shot if you are ready for it and act quickly. Notice how the photographer knelt down to shoot at eye level.

There are some basic guidelines that you should follow when taking pictures of young children. First, be ready for fast action that doesn't last long. Children in motion can be difficult to stop, with a camera or anything else. If you are shooting indoors, have a good, preferably automatic, flash unit on your camera. Choose a film speed that is fast enough to give you the shutter speeds you need to stop action.

You should shoot at shutter speeds of at least 1/125th of a second. Shooting at 1/250th of a second is better. This means that you will need either fast lenses or fast film. Remember, fast film results in grainy enlargements. An ASA-200 film is a pretty solid all-around film for chasing after children on the move.

A zoom lens is a great idea when chasing after children. If you are working with kids on the move, you have to react quickly. Take meter readings before you plan a shot. Get a good idea of what exposures will work and try to bracket shots as often as possible. Few toddlers are going to hold their poses long enough for you to take an independent meter reading, set your controls, and snap the shutter. You have to act fast.

I'm going to talk about candid photography in the next section, but I want to mention it here too, because it pertains especially to children. Posed pictures are rarely the best pictures possible. This is true in most circumstances, and it is especially true when photographing kids. Many children will ham it up for a camera if they realize they are having their pictures taken. To get the best shots of your kids, you have to catch them off guard. You don't have to have a long lens to do this, but you must be a little sneaky and very fast.

Point-and-shoot 35mm cameras with telephoto lenses and built-in flashes are excellent for quick kid shots. These cameras can be concealed in a jacket pocket and put into use very quickly. When you combine all the attributes of 35mm point-and-shoot gear with the low cost of acquiring this type of gear, it's very hard to beat.

Medium-format equipment should not be considered useless when capturing kids on film, but it is the most difficult type of camera equipment to use for fast shots with kids. A single-lens reflex 35mm system is an excellent choice if you are familiar enough with it to use it quickly. A zoom lens is advantageous on any camera used to photograph active children. Some type of onboard flash should also be considered needed equipment.

Captivating Candids and Praise-Worthy Portraits

Candid photography is often the best way to preserve the true feeling of a person. As I said earlier, posed pictures are rarely outstanding. Portraits are typically posed, but some of the best shots derived from a portrait session often come from casual candids. There is a time and place for stiff, posed pictures, but few photographers ever fall into these situations. The best photographers are known for their ability to record natural scenes.

If you want posed pictures of your spouse, children, or friends, send them to a quickie studio where you get a zillion photos for one low price. You know the type of pictures I'm talking about. Fake leaves, painted Christmas scenes, and similar unappealing back-grounds are generally a part of these discount portraits. You can go to a studio photographer who will do a good job with better backgrounds, but you will still wind up with posed pictures. To make true memories, you have to capture the human side of your subject. The same basic principle applies to pets, even though they are not human.

Photograph your subjects in natural settings. If you ask children to sit on a stool and look pretty, you will get the equivalent of school photos. If this is what you want, fine. How-ever, if you want pictures of your kids building a snowman or catching a fish, you have to work outside the parameters of studio photography. Essentially, you must take their pictures without them realizing that the camera is working.

Getting good pictures of people can be difficult. Most people, kids and adults, tense up when they know a camera is looking their way. Those who don't get tense often act silly. We've all seen the fake smiles and strained expressions that are so common in portraits. To avoid stiff pictures, you need to get your subjects involved with something other than posing and saying cheese.

Candid shots are usually done on impulse. If they are planned at all, only the photographer knows it. So, how do you get planned portraits to look like candids? It's easy. Give your subject something to do while you are "testing" your camera's meter, battery, or whatever else will give you an excuse to be holding the camera in firing position. When your subject is engrossed in the task you have assigned, fire away. Focus on the back of your subject's head, and then call to the subject. When the person turns around, click the shutter. By catching your subjects with unexpected shots, you should get better, more natural pictures.

On the Road Again

Vacation photos can be very boring to look at. Anyone who has ever had to sit through a slide show of typical travel photos knows this to be true. You can spice up your travel shots by taking a different approach. It's okay to do some recording photography when you are traveling. Pictures of monuments, signs, and places that are taken from a cold, static point of view are all right now and then. However, good travel photos are not merely evidence that something exists. Great pictures tell a story. Let's look at some examples of this.

Let's say that you and your family are going on a rafting expedition. You are the photographer. How are you going to take pictures of the trip? Here are two suggestions. Ride in a raft in front of the one that your family is riding in. This will allow you to turn around and shoot directly at the faces of your family. Want a really neat shot? Lay down on the riverbank or wade out into the water and shoot with your camera near the water level. Most people would stand on the bank to take pictures of their subjects. Getting down low will give the picture more perspective. Change your shutter speeds. Shoot some film at fast speeds to stop all the action. Then, use slower speeds and pan with the raft to show speed and interesting water designs.

Maybe rafting is not among your vacation plans. Let's say that you are going to Maine. Your trip will include visits to small harbor towns. Lobster boats bob in the water. Weathered docks are stacked high with lobster traps and buoys. How will you record your trip to a working lobster harbor? One approach might be to use a wide-angle lens that will cover the scene completely. This is a typical tourist shot. Instead, get personal with your subject. Use a longer lens and isolate individual subjects. Use the colorful buoys and crusty lobster traps as foreground when taking a picture of the boats. Shoot the wide-angle shot, but then work the harbor with different lenses. Change positions and try to include people in some of your pictures. Putting people in travel pictures helps to make the images more interesting.

When you photograph landmarks, look for unusual angles to shoot from. A straight-on shot of most any landmark will be uninspiring. Grouping your family in front of a sign or monument is one way to prove that you've been there and done that, but it doesn't hold a viewer's attention. Use the signs and monuments as foreground or background for

pictures that will be more interesting. When possible, have your family involved in some activity when recording your vacation shots. A kid splashing in the surf at a beach can be interesting. If the dock in the background sports a sign that tells where you are, so much the better. Avoid the typical posed pictures.

Bracketing Exposures to Ensure Success

The best way to beat the odds of bad exposures is to bracket your pictures. This simply means shooting the same scene several times at different exposures. Many photographers shoot one shot at what they believe to be the best exposure and then shoot a frame at one stop slower and one stop faster than the optimum exposure. For really important pictures, give yourself more latitude by shooting five shots of the same scene. Light meters can be fooled, but bracketing will hedge the odds of success in your favor.

Fuzzy Focus Fiascoes

Fuzzy focus in a picture can be very disappointing. And unfortunately, this problem occurs frequently. You may be in a hurry to get a shot and fail to tighten up the focus. Maybe you will be shooting at a slow speed without a support and wind up with a blurred picture. It doesn't take much to have a picture out of perfect focus. This is, however, something that you can control. Take your time. Focus carefully and then recheck the focus before you shoot. Most focusing problems are caused by photographers who are rushing to get a shot or who are not taking their work seriously. All you have to do is slow down and check your viewfinder before pushing the shutter button. By doing this, you can avoid the frustrating feeling of seeing your prize pictures turning out as fuzzy messes.

The Least You Need to Know

➤ Don't pose your subjects. Let them act naturally and capture them on film as they are doing normal activities.

➤ Use zoom lenses to photograph moving subjects. You will be able to crop undesirable elements and come in tight for close-up shots.

➤ Point-and-shoot cameras are ideal for parents who want to photograph their children on short notice. All-in-one cameras are handy for a variety of photo situations.

➤ Put some action in your travel photos. Include people when possible, and take pictures that tell a story rather than simply recording a moment or scene.

➤ Bracket your exposures to ensure good pictures. As a rule-of-thumb, bracket at least one stop in each direction of a proposed perfect exposure.

Indoor Photography

In This Chapter

➤ Avoiding ugly yellow tinting

➤ Fast and grainy film

➤ Flashing: how far is too far?

➤ Gang flashing

➤ Follow the bouncing flash

➤ Busy backgrounds

➤ Instant backdrops

Indoor photography can provide you with endless photo opportunities. When you take pictures indoors, you are unaffected by the weather outside. You can create your own conditions for fantastic photography. A studio isn't needed; your living room will do just fine. It doesn't take much to set the stage for a lot of fun when you practice your hobby indoors.

Indoor photography normally requires the use of either fast film or some type of artificial lighting. Unfortunately, fast film produces grainy pictures, while artificial lighting can be bothersome to set up and work with. Learning to produce good pictures indoors can require patience and practice. Electronic flash is the typical choice for artificial lighting. The bad part about flash units is that you can't see what they are doing until they are done. This means that your pictures may not turn out so well. There are four basic aspects of indoor photography that you must learn, and they are all about to be discussed.

Filtering Out Incandescent Light to Avoid Yellow Tinting

When you buy film for your camera, it will probably be daylight-rated film. This simply means that the film is intended to be used outdoors with natural light. Using this film in a home with household lights can result in some ugly pictures. The film will take on a yellowish, orange tint. Seeing faces of loved ones turned to a jaundice color is not pleasing.

Incandescent light is the type of light that comes from an ordinary light bulb. This type of light does not work well with color film. Some film is rated for tungsten light, which is the type of light given off by photo lamps. However, most film is rated for daylight use. Daylight-rated film can be used with sunlight or electronic flash, but should not be used with incandescent or tungsten light, unless a corrective filter is used to balance the lighting.

There are two ways to avoid pale pictures. You can either use film rated for indoor use or put a filter on your lens. Indoor film is rated for tungsten light. This is the type of light that you get from photo lamps, not household lights. If you are going to shoot in your home with light that is produced by typical light bulbs, you must filter your film. Otherwise, your pictures will have ugly tints in the color. (Daylight film is balanced for electronic flash, so no filter is needed when using an electronic flash with daylight film.)

Film rated for daylight use should be filtered with an 80-A (blue) filter when used with household lighting. Tungsten film should be filtered with an 82-C (blue) filter. If you use daylight film with photo lamps, an 80-B (blue) filter should be used. Using tungsten film outdoors or with electronic flash requires an 85-B (orange) filter. Any photo store should carry all of these filters and charts for other filters that you might want to experiment with. See Chapter 7 for more details.

Beating Bright Spots

Indoor photography can often be plagued with bright spots. This comes from light being reflected off some object in the picture. Common sources of bright spots include television screens, mirrors, picture frames, and even bright walls. Common sense is your best defense against this problem. Don't place your subjects in positions where reflective surfaces will bounce light back at you. Putting a person in front of a window or glass door is a common mistake. Not only will light from the outside affect your exposure reading adversely, the glass is likely to throw your flash right back at you.

Bright spots are most likely to haunt you when you're using electronic flash. Since you can't see the result of your flash until your film is developed, you won't notice the

bounce-back until it's too late. If you're using photo lamps, you can see what the lighting is doing. Scan your viewfinder for any indication of hot spots before releasing the shutter. As a basic ground rule, keep your subjects away from reflective surfaces. Installing a polarizing filter on your lens will reduce the glare and the reflections from glass and other reflective surfaces, including eyeglasses.

Insider Tip
Remember that polarizing filters are essential equipment when shooting into a reflective surface, such as glass or water.

Granny's Grainy Pictures

Some photographers turn to fast film as a substitute for good lighting. As you learned in Chapter 9, the faster a film is, the grainier your pictures will be. While the grain might not be distracting in a snapshot, it will surely show up in enlargements. There is only one way to avoid grainy pictures. Use slow film. A film speed of ASA 200 is about the fastest film you can use and still obtain reasonably good quality in moderate enlargements. Slower films are a better choice when you plan to have your prints enlarged.

When you slow your film down, you have to have fast lenses or provide plenty of light. Fast lenses are ones that allow a wide aperture, such as a rating of f-2.8. Electronic flash is the best way to compensate for low-light levels or slow lenses and film. I shoot mostly slide film. My standard film speed is ASA 64. When I anticipate having my slides printed as enlargements, I slow down to ASA 25. If you're shooting negative film, an ASA of 100 is a good all-around choice. It gives you a fairly fast speed with minimal grain.

Know Your Flash Limitations

If you are using an on-camera flash, you must know what its distance limitations are. While you will almost never have a problem with distance in your home, you can run into other indoor situations, such as a big party or a concert, where your flash simply isn't powerful enough to reach out and light your subject.

If you are going to use electronic flash often, you should get to know your flash unit very well. One of the best ways to do this is to take a series of test shots. Talk a friend or family member into being your photo guinea pig. Have the person stand at a measured distance from your camera and flash. Ask your subject to hold a card that indicates what the distance and exposure settings are that you will be shooting with. Experiment with different distances and different exposure settings. By working under controlled and recorded conditions, you can determine exactly what areas of your expertise require attention.

After your test film has been processed, review it and note the results of your shots. At what distance was your subject getting out of range of your flash? When was your subject too close to the flash? Was red eye a problem? Did your flash cover the full area of your lens perspective? This type of visual evidence will make it easy for you to know and understand your lighting equipment.

If you are using a flash unit that has a distance scale on it, use the information. It will usually be correct. Even inexpensive flash units usually offer a working scale for your convenience. As I'm writing this book, I'm looking at a simple flash that cost less than $25. It has a chart where I can find the ASA/ISO speed of my film and the distance at which I want to shoot to determine the correct aperture setting when my shutter speed is set at 1/60th of a second, which is the standard shutter speed for flash photography. Let me give you a few sample readings from the scale.

Many electronic flashes, like the one pictured, have distance scales on them.

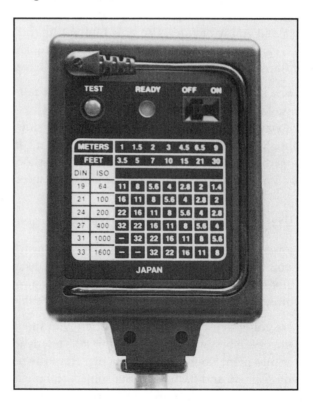

Assume that the film speed is ASA 100. My subject is 10 feet away. Under these conditions, the correct aperture setting would be f-5.6. If I move the subject in closer, to say 7 feet, the aperture should change to f-8. At a distance of 30 feet, which is really stretching a little flash, the aperture should be set at f-2. This type of cross-referencing is easy to do, and it often proves to work well. For the best results, you should take meter readings with a flash meter prior to shooting your pictures. In the absence of a meter, rely on the charts and the results of your test sessions for good exposures.

If your flash is an automatic-only unit, you will not have any creative control over it. In this case, you must do enough test shots to get to know your flash extremely well. This is normally the case with point-and-shoot cameras. Some flash units work automatically but allow you to control settings. These models use a sensor to gauge the amount of light needed to illuminate an image. As with other automatic functions, these devices frequently produce satisfactory results. They can, however, be fooled. There is no replacement for the benefit of test sessions and experience. Shoot several rolls of film while learning the limitations of your flash. You may feel like you are wasting good film, but the lessons learned will serve you well in the future.

Making the Most of Multiple Flash Units

A single flash unit is better than no flash, but it's hard to beat a multiple-flash setup for quality lighting. With the right flash equipment and enough experience, you can take pictures that will rival those of studio artists. And you don't have to spend thousands of dollars on lighting equipment to do it.

How you mount or arrange your flash equipment will depend on your personal preferences and working conditions. You might use a bracket to hold a flash on each side of your camera. This will eliminate red eye and give good, even lighting, without heavy shadows. Light stands work very well as supports for flashes, and they aren't a big bother to set up and take down. Any flash unit designed to slide into the flash shoe of a camera can be mounted on a light stand. You will need an inexpensive adapter, but you can get it from your local camera store. It's a simple metal piece that slips over the foot of your flash. The adapter is tapped with threads so it can be screwed onto the threaded rod of a light stand or tripod.

When you set up multiple flashes, you can use tripods, table-top tripods, or light stands to achieve versatility and varying heights. In a pinch, you can even lay a flash on a flat surface, such as a window sill or shelf.

Jargon Alert
Strobe: This is a slang term for an electronic flash. It is common in photographic jargon.

Once you have your flashes situated, you need a way to fire them in unison. One of your flash units will have to be the dominant flash. This may be an on-camera flash or a remote flash that is connected to your camera with a PC cord. Other flash units can be fired with the use of slaves. Peanut slaves are tiny, inexpensive, and work very well at normal shooting ranges. These slaves plug right into the connectors on remote flashes.

Jargon Alert
Slave Unit: A slave unit is a device that is used to fire multiple flashes simultaneously.

All you do is slip the slave connector into the PC plug on the flash, and you're in business.

When using slaves, your primary flash will fire and trigger other flashes that are equipped with slaves to fire simultaneously. This type of system is very effective for a number of uses. You can use it to light portraits, stop motion, color scenes with filtered flash heads, and so forth. For under $100 you can have an effective multiple-flash system.

Off the Wall, or Off the Ceiling

Bouncing flash off a wall or ceiling is a good way to get soft lighting without shadows. When you take a picture of a person with direct flash, you can experience red eye, forehead reflections, and plain old ugly lighting. Bounced flash avoids this. Obviously, if your flash is built into the body of your camera, you can't use it to bounce light. But, if your flash mounts in a flash shoe or is used off the camera, you can bounce to your heart's content.

My primary flash unit is a professional model. It is mounted to the side of my camera body. A quick-detach button allows me to remove the big flash head from the mounting bracket, so that I can hold it in one hand and my camera in the other. The head of my flash tilts from front to back and swivels from side to side. With a flash like mine, you can bounce light from many angles. A flash like this can cost anywhere from $125 to $300.

Many inexpensive flash units don't swivel or tilt, but some do. Buy one that does. At the very least, get one that tilts. You can use a small reflector card with these types of flashes to help diffuse your lighting. If you are setting up multiple flashes on stands, you can aim them in any direction. The movement of the head on the stand or tripod on which you are mounting the flash will give you mobility.

A neat little rig that I've used often is an inflatable bounce bag. It's basically a balloon that is blown up and strapped to a flash head. The flash fires into the balloon, and a white or silver lining reflects the light back on your subject. These inflatable mini-umbrellas work very well, don't take up much space, and are easy to use even with shoe-mounted flash units that swivel.

Standard photo umbrellas can be used to bounce light, but you must have a pretty powerful flash head to get any real distance out of an umbrella. An alternative to umbrellas is reflector cards. These can be as small as a business card or as large as a sheet of plywood. Colors are normally white or silver, but other colors can be used for special effects. Experiment with bouncing flash from various angles and surfaces to see what effects you like best.

Doing Away with Distracting Backgrounds

Busy backgrounds can detract from a picture. If you have a person standing in front of a drapery that includes a complex pattern, the background might make your photograph undesirable. The same thing could happen if your subject stood in front of a wall where wallpaper created a maze of patterns. Since you can't always control the background that you have to work with, you must learn to tame it with your aperture setting.

The more open an aperture is, the less depth of field you have. Let's say that you want to take a picture of visiting relatives. Also assume that the room you have to work with doesn't offer a great background appearance. First, have your subjects stand as far away from the background as possible. Then, open the aperture on your lens to its widest opening. This combination will put your subjects in focus and the background out of focus. A busy background that would be a distraction if it were in focus can make a pleasing backdrop when it is blurred together with a wide aperture.

All you have to do to reduce the effect of unwanted background is to move your subject away from the background as far as possible. Use the longest lens that you can, and open your aperture as wide as it will go. Keep in mind, however, that you must coordinate your aperture setting with your shutter speed. An open aperture will result in a faster shutter speed. This combination will make the background a blend of color rather than a distracting design.

Portable Backdrops that Set Up Quickly and Work Great

If you do much indoor photography where you want portrait-style pictures, invest in some portable backdrops. Your choices for backdrops are vast. You might pick blue velvet, gray paper, or black satin. Most camera stores stock a variety of background materials. You can even buy background scenes that look like waterfalls, Christmas scenes, and other outdoor and festive occasions.

Once you have your background material, you need an easy way to deploy it. I discovered a very effective way of doing this that is both portable and easy, while remaining inexpensive. Go to a local hardware or building supply store. Buy a wooden closet pole. They come in various lengths, and you can cut them to suit your personal needs.

Drill a hole in each end of the rod, about three inches from the end. The holes should be large enough to allow the threaded studs of a light stand to fit through them. Staple your background material to the closet pole. It can then be rolled up on the pole and stored. If you buy background paper, you can slide the closet pole through the cardboard spool that the paper is stored on.

Set up two light stands and install the pole over the studded heads of the stands. You can raise or lower the pole at will. Once the pole is mounted on the stands, you can unroll the background and have a perfect shooting situation. Your shots will have professional-quality backgrounds with no distractions.

I have used the closet-pole setup for many types of photography. When I go to a person's home to take pet portraits or even pictures of people, the mobile backdrops go with me. I've used the setups outside, in basements, in churches (for weddings), and in business settings. This type of system is inexpensive and very portable. The results are unbeatable. Putting the right backdrops behind your pictures can make all the difference in the world.

The Least You Need to Know

➤ If you plan to have your pictures enlarged, use the slowest film speed you can. Fast films tend to be grainy when enlarged.

➤ Get to know your electronic flash unit well. Learn its distance limitations and recycling times. Not understanding your flash can result in dozens of poor pictures.

➤ Engage in test shoots. Invest in film and processing to learn how your equipment works. Until you shoot recorded shots under controlled conditions, you can't predict your photographic results.

➤ A single flash unit is not normally an ideal light source. Use multiple flash units and a flash meter, whenever possible, if you are lighting your subject artificially.

➤ Diffuse lighting to create soft effects. This can be done with electronic flash by bouncing the light beam off a reflective surface and onto your subject.

➤ Beware of bad backgrounds. Use an open aperture to blur distracting scenes and keep attention on your subject.

Outdoor Photography: As the Sun Shines

In This Chapter

➤ Dealing with ever-changing light

➤ Don't use it, diffuse it

➤ Seeing stars

➤ Wet-weather techniques

➤ Outdoor composition

Outdoor photographers have to deal with changing light conditions, wind, and a number of other uncontrollable obstacles. Are they really uncontrollable? Not as much as you might think. When you take your camera outdoors, you will face different challenges than you would in a studio. They are not necessarily more difficult to deal with, but they are different.

With so many photographers pursuing outdoor photography, companies have responded to the needs of these photographers. With a combination of skill, experience, and accessories, you can tame much of what Mother Nature has to throw at you.

Lighting Up the Great Outdoors

Since lighting is such a critical element of photography, let's start this chapter by looking at some common lighting problems you may see with outdoor photography.

Changing Light Conditions

When you choose to use the sun as your light source, you have to be prepared to deal with changing light conditions. As a part of this, you must put up with shadows that move as the day grows longer. Since shadows can be a photographer's friend, you shouldn't get too upset. However, your shadow friend can become your enemy if you are not prepared for what's to come.

Outdoor light can change in a moment. If a cloud passes between your subject and the sun, the exposure reading you took moments before will be useless. Outdoor photographers must be in tune with their lighting conditions and must check them frequently. Reading the instructions that are packed with film might lead you to believe that you can adjust your camera for set exposures and enjoy a great day afield without changing your controls. Don't even think about believing this line of thinking.

Insider Tip

If you are taking pictures on a day when cloud cover is moving across the sky, try to take meter readings between each exposure. Shooting with a motor drive or auto winder can be done in consecutive shots without new readings, but monitor the conditions closely.

A common mistake made by many photographers is to take a benchmark light reading and stick with it throughout a photo session. This can work in a studio, but it probably won't produce favorable results under the sun. It's not always necessary to meter every exposure, but you must keep track of what nature's light is doing.

If you plan to photograph a subject that is in a shadow, you must be particular about the way you take a meter reading. Assuming that you are standing in the sun, your light meter will be fooled by the subject that is shaded unless you are using a spot meter. Any type of reflective, incident, or averaging meter will have trouble giving you an accurate exposure rating for a subject in the shade while you are standing in light. Move up close to your subject. Get in the shade yourself and take a reading. Then you can move back from the subject and get your shot. A spot meter is the only type of meter you can depend on when you are in the sun and your subject is in the shade.

What do you do if your subject is partially in the sun and partially in the shadows? Well, you can't have your cake and eat it too. You must decide what portion of your subject is the most important to your photograph. Move up close to the subject and meter on the primary spot of interest. If you are compelled to get all of the subject exposed as well as possible, you will have to use an averaging method.

Take a meter reading on the brightly-lit portion of your subject. Record it in your memory or on paper. Get a reading from the shadow-portion of the subject. Look at the two readings and average them to arrive at a tolerable compromise. This is the best that you can do.

Working with shadows can be frustrating. The pain is lessened if you have a one-degree spot meter. Personally, I would feel naked without mine when doing outdoor photography. You can use electronic flash to brighten shadowy subjects. You might never consider using an electronic flash when the sun is shining and you have a gorgeous day for outdoor photography. Don't let the sun fool you. While a bright day provides adequate light to make exposures at fast speeds without the use of a flash, your pictures might suffer from shadows. When light is directional and is not diffused, shadows appear on many photographic

Jargon Alert
One-Degree Spot Meter: This is a light meter that is capable of taking a light reading from a very small portion of a subject. Spot meters can be used effectively even when they are a considerable distance from the subject where the reading is being taken.

subjects. An average photographer may never notice the dark spots, until the film comes back from the processing lab. If you use a flash, take several exposures at different settings to make sure you get an acceptable picture. Always remember to move in close to your shadowy subject for meter readings, unless you are using a spot meter.

That Horrible Harsh Light

Now that we've discussed the trials and tribulations of lack of light, let's talk about an abundance of light.

Do you remember, as a kid, when your parents or grandparents would take you outside to get a picture of you? Didn't they always position you so that you were looking into the sun? The belief seems to have been that if you were not squinting into blinding light, a good picture couldn't be taken. If this is still your perspective on outdoor photography, change it!

Full sunlight can be very harsh. It creates poor conditions for people pictures. Rays from the sun tend to bring out every blemish in someone's skin. Subjects are often forced to squint when the sun is very bright. Intense light can reflect off some skin tones to a point where hot spots are created on your film. A nice, cloudy day is much more appropriate for good portraits. Get your subjects out of intense sunlight when taking pictures.

A professional photographer will sometimes use a large diffuser to soften the light on an outdoor subject. If you have an assistant or two and plenty of diffusing equipment, you can do this too. Since you probably aren't well equipped for major photo shoots, you may

have to compromise. The easiest way to beat harsh lighting is to move your subject into the shade. Another solution is to schedule your photo sessions early and late in the day, when the sun is not so imposing.

People are not the only subjects adversely affected by direct sunlight. As a nature photographer, I run into situations frequently where my subjects are made less attractive by full sunlight. If I'm doing small-scale work, such as mushrooms and flowers, I diffuse the light with a photo umbrella. There have been occasions when I've used a thin, paper-like backdrop as a diffusing screen for larger scenes, but wind is a real problem when doing this. What you have to remember is that one way or another, try to soften the light falling on your subject.

Jargon Alert

Flare: This is a scattering of non-image-forming light that reduces the quality of a photograph. Flare is often caused by reflection or by sunlight hitting the glass of a lens. It can be reduced with protective lens coatings, filters, and lens hoods.

Watch Out

Some lenses, such as fisheye lenses and wide-angle lenses, don't work well with hoods. Since these lenses have such a wide perspective, you can see a hood on your exposed film. It will appear as a dark image on your prints. Before you buy a hood for a wide-angle lens, make sure that it will not interfere with your photography.

Shading Your Lens

It's not only important to diffuse light for your subjects, but also to protect your lens from harsh lighting. If sunlight streams into your lens, your film will suffer from sun flare. This is enough to ruin any picture, but it's easily eliminated. A lens hood will normally block enough light to keep sun flare from being a problem. If your lenses don't already have lens hoods, install them. You can buy rubber lens hoods that will screw into the filter threads of a lens.

There are times when sun flare can be a problem even when a lens hood is in place. If you check your viewfinder carefully, you can see the flare. Putting your hand up to shade the lens is one way of solving this problem. Another way is to tape a piece of cardboard to your lens to act as a shading tool.

If you are taking pictures of people, you have to watch out for shadows around their eyes. A person's nose can also create a facial shadow. Getting rid of these unwanted blemishes is easy if you are willing to fire up your flash in bright sunlight. By combining electronic flash with existing light, you can eliminate shadows and create wonderful exposures.

Fill-in flashes can be used with sunlight or with other electronic flashes. The purpose of a fill-in flash is to produce even lighting for your subjects. A fill flash should

not be too powerful or too close to a subject. Its effect should be subtle. In the case of outdoor photography, don't use a powerful flash for your fill-in work. A small, pocket-size flash will normally give you better results with fill-in work.

If you are using a powerful flash as your primary light source, inside or out, use a smaller flash to fill in the areas where you anticipate shadows appearing. For example, if your main flash is positioned to fire on the left side of a person's face, balance it with a fill flash that will illuminate the right side. This same principle applies with existing light.

The advantage that you have when using fill flash in sunlight is that you can see the shadows that must be eliminated. Aim your flash at the shadows and keep it far enough from the subject so that the light will not create its own shadows. You will have to practice some to see what distances work best with your particular flash unit. The size and power of a flash determines what distances are acceptable for fill-in work. You may feel strange using a flash on a sunny day, but your pictures should turn out better if you do.

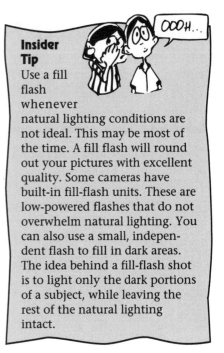

Insider Tip
Use a fill flash whenever natural lighting conditions are not ideal. This may be most of the time. A fill flash will round out your pictures with excellent quality. Some cameras have built-in fill-flash units. These are low-powered flashes that do not overwhelm natural lighting. You can also use a small, independent flash to fill in dark areas. The idea behind a fill-flash shot is to light only the dark portions of a subject, while leaving the rest of the natural lighting intact.

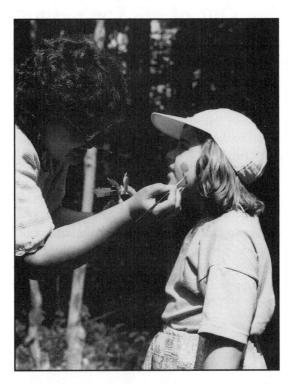

Notice the shadow on the girl's face and how dark the mother's face is. A small burst of fill flash, fired from the left of the camera, would have made this a much better picture.

Raindrops Keep Falling on My Lens

Wet-weather photography can be hard on photo gear. If you are a die-hard shutterbug who is willing to venture forth in rain and snow for coveted pictures, you will have to take some precautions to protect your equipment. If your favorite time to take pictures is when it's raining, you might consider buying a waterproof housing for your camera. If you are an occasional rain nut, you can get by with some large plastic bags.

Sealing your camera inside a reclosable plastic bag is a cheap, effective way to protect the camera and lens from wet weather. You can cut a hole in the bag for your lens to peek through. Cut edges of the plastic can be taped to your lens. If your bag is big enough, you can operate your camera controls right through the plastic. If you are using a long lens and can't find a bag large enough to contain the lens and the camera, use two bags. Put the bags on from opposite directions, allowing the openings to overlap. Make sure that the overlapping is sufficient to block out rain and snow, then tape the bags together.

When you are going afield in foul weather, take along spare bags and tape to cover your equipment with. Carry a few lens-cleaning cloths and some cleaning solution to clear moisture and fog from your lenses. Serious inclement-weather photographers frequently carry several UV-haze filters with them. When one filter becomes spotted or fogged, it is replaced with a fresh one. By rotating filters, you can keep a clear lens and allow filters to dry out and be cleaned in between shots.

There's a Tree Growing Out of My Son's Head

When you are taking portraits outdoors, you have to pay attention to your backgrounds. That adorable picture you take of little Tommy might come back from the processing lab with a mailbox sticking up from behind the boy. Trees, signs, posts, and other objects frequently sneak into pictures. To avoid this, you have to check your viewfinder carefully.

Many photographers are so intent on their subjects that they fail to see the foreground and background of a scene. With the exception of poor lighting, bad composition is probably the major cause of bloopers with outdoor photography. You can use objects, such as trees, to enhance a picture, but they shouldn't be a distraction from your subject.

OOOH...

Insider Tip

Composition is one of the most important elements of a photograph. If you study your viewfinder carefully, you can guarantee good composition.

Learning to control depth of field with your aperture is one way to eliminate distracting elements in a picture. However, you can't expect your aperture to make a tree disappear. To maintain good composition, keep checking your viewfinder before you take your picture. Placing your

camera on a tripod helps to eliminate unwanted objects in your pictures. By having the camera secure on a support, you can concentrate more on what's in the viewfinder.

This is not a bad picture, but the trees are distracting. The photographer should have chosen a different camera angle or moved the subjects. Some light fill flash would have removed the shadows from the girl's face and the mom's arm.

Disasters for In-Camera Light Meters

In-camera light meters are like computers. They're great when they work and a real pain when they don't. Most in-camera meters are designed to work on an averaging basis. While this approach often works, there are many conditions where an averaging meter can be fooled. You can learn this the hard way by taking lots of pictures that are either overexposed or underexposed. Or, you can learn what to look out for and reduce your wasted film.

Sand and snow both have a similar effect on a reflective light meter. Since light is reflected strongly from sand and snow, most light meters are fooled. Spot meters are an exception, but other meters can't handle snow and sand well. If your subject is surrounded by reflective material, move in close for a meter reading. If you can't get a close-up reading of your subject, there are two other ways to improve your odds of getting a decent exposure.

Hold one of your hands out in front of your lens and take a meter reading from it. Do it with your palm facing straight up and then with it facing you. Take the two readings and average them for what should be a good exposure. A better approach is to use a photo gray card. This card is gray in color and is designed to be used with light meters. Gray

cards come in a variety of sizes. A 5 × 7 card gives enough area for good meter readings, but you can get larger or smaller cards. Carrying a gray card with you is always a good idea, and it should be considered nearly mandatory when shooting in high-contrast situations.

You may not think a lot about trees when taking pictures, but you should consider what effect they will have on your photographs. Trees can interfere with good exposures in two ways. Shade created by trees can cause obvious lighting problems. A more subtle, but no less destructive, impact of trees on your exposure reading is the color of their bark. If you have a person standing in front of a grove of dark-colored trees, the dark color of the bark can make your meter go wacky. By the same token, light-colored trees, such as birches, can have a similar effect to the opposite extreme.

Any time that your viewfinder is dominated by objects that are considerably different in tone and contrast from your subject, you are likely to get bad meter readings. Posing Aunt Nellie in front of a draping hemlock tree might make for a pleasant background, but the dark color of the evergreen will confuse your meter. There are only two ways to get around this type of problem. The best way is to invest in a spot meter. Your other option is to move in close and take a reading with your subject filling the viewfinder.

The Least You Need to Know

➤ Shadows can be good. Working with shadows can increase texture and other favorable results. Don't be intimidated by shadows; get out there and pop some shots.

➤ Full sunlight used to be considered an ideal photographic condition. This is rarely the case. Look for your shots under a variety of lighting conditions.

➤ Shade your lens with a lens hood, a hat, or your hand. Do whatever it takes to prevent sun flare.

➤ Inclement weather is a good excuse to stay home, but it shouldn't be a life sentence. Put your camera and lenses in plastic bags and take advantage of wet weather.

➤ Don't trust reflective meters that work on an averaging basis. It is best to use a spot meter or to bracket your shots for a guaranteed good exposure.

➤ Using electronic flash units outdoors shouldn't seem foreign to you. Regardless of your outdoor subject, fill flash can often improve the image quality.

Spiders and Bees and Bugs, Oh My!

In This Chapter

➤ Major magnification is possible with a bellows

➤ Life-size images come from macro lenses

➤ Ring lights are ideal for close-ups

➤ Use a focusing rail for really good pictures

➤ Nasty natural light can ruin your macro photography

➤ Extra light can improve your pictures

If you enjoy taking close-up pictures of nature, you owe it to yourself to get the right gear to work with. Don't expect it to be cheap if you opt for the really good stuff. However, there are some inexpensive options that you can turn to in order to see if the pursuit of tiny creatures is what your photography is meant to be. Crawling through leaves and grass on your belly in search of a praying mantis might not be your idea of fun. But if it is, you will learn about your equipment needs in this chapter.

A Bug's View of the World

To take pictures of insects and small plants, you need to get close to your subject. Trying to make an ant fill the frame of your viewfinder isn't easy with a standard lens. However, you don't have to spend hundreds of dollars on a macro lens to take occasional pictures of bugs. An inexpensive set of close-up rings that screw into the filter threads of lenses will get you started.

Close-up rings look like regular lens filters. They attach in the same way that screw-in filters do. The difference is in what the rings allow you to do. Once you install close-up rings on a standard lens, you can focus on items from a much closer distance. While this type of setup is too elementary for serious bug hunters, it is a good way to test your commitment to close-up work.

Close-up rings perform best when they are mounted on standard lenses and short telephoto lenses. If you have a 50mm lens, it will work fine with the rings. An 85mm lens will also do well with them. You can buy close-up rings from most camera stores or from any number of mail-order photo suppliers.

Bellows: The Next Best Thing to a Microscope

Close-up rings are at the bottom of the close-up ladder in terms of versatility and quality pictures. Bellows are at the other end of the spectrum. You shouldn't buy a bellows until you are sure that your pursuit of close-up photography is a serious one. However, if you are hooked on nose-to-nose pictures, you can't beat a bellows and a macro lens.

Bellows can be used with standard lenses, but they work best with macro lenses. By turning knobs, you can expand or reduce the length of a bellows. This is how you control magnification. The field of focus, or depth of field, you have when using a bellows is very limited. Magnification is what you are gaining. It is amazing what you can do with a good macro lens and a bellows. Tiny objects, like the head of a pin, can be enlarged to become a main subject.

A bellows is not needed for general close-up work. A macro lens will give you plenty of good close-up pictures. It is not until you decide that extreme close-ups are what you want that you will need a bellows. Start building your collection of close-up equipment with less expensive items that you will use more often. As your interest in the area of close-up photography grows, treat yourself to a bellows.

Macro Lenses

Buying a quality macro lens will set you back several hundred dollars. The expense is worthwhile if you enjoy doing close-up photography. There is no other type of lens that will give you the quality and close-focusing ability that you get from a macro lens. You can consider a macro lens a specialty lens, but it can be used for all types of photography.

If you buy a 50mm macro lens, it will do anything that a standard 50mm lens can do. A 100mm macro lens can double as a 100mm telephoto lens. It's almost as if you are getting two lenses for the price of one. Why do macro lenses give better close-up photos? They are corrected for edge-of-field distortion, while standard lenses are not.

When you buy a macro lens, you should receive an extension tube with it. This tube is not always used. When it is used, it is placed on the camera body first, and then the macro lens attaches to the tube. Adding the extension tube allows you to take life-size pictures of your subjects. This means that even very small subjects can fill your frame.

Standard lenses are generally designed to focus no closer than 18 inches from a subject. This is fine for many types of photography, but it won't cut the mustard with close-up work. When you work with a macro lens, you can practically put the lens on your subject and still get good focus. However, the field of focus will be short, very short. This makes taking crisp pictures a challenge. The lens is capable of it, but many photographers are not.

When you use a macro lens with an extension tube, you are able to record life-size images. Couple the same macro lens with a bellows, and you can get pictures that are 10 times the normal life-size.

Jargon Alert
Macro Lens: This is a lens that is made to handle the requirements of high-quality close-up photography. Unlike other lenses, a macro lens is corrected for edge-of-field distortion. By eliminating this distortion, resulting photographs are better.

Insider Tip
The more you magnify, the less depth of field you have. This can be frustrating, but it can also boost your creativity. The soft focus that you get behind a subject will frequently create a beautiful background. With selective focus, you can blur out distracting backgrounds and keep your subject the main interest in your photo.

I started out with a 50mm macro lens. After awhile, I moved up to a 100mm macro lens. The longer lens is the one I still own and use. Other focal lengths are available. If you enjoy close-up photography, you will never give up a macro lens once you have one.

When Is a Macro Lens Not a Macro Lens?

There is only one true macro lens, which works as I described in the preceding section. (Some manufacturers, however, call their close-up lenses *micro* lenses instead of *macro* lenses.) If you don't have a macro or micro lens, you don't have top-notch close-up equipment. Many lenses are sold with the hype of being *close-focusing* lenses. There is nothing wrong with these lenses, so long as you understand that they are not true macro lenses.

OOOH...

Insider Tip

Carry a pair of tweezers with you when you do close-up photography in nature. The tweezers will allow you to move small objects without disturbing other elements of a scene.

A lot of zoom lenses are made with close-focusing features. This is a good feature to have, but don't think that you can use a close-focusing lens to get the same results you could with a macro lens. You can use a close-focusing lens to get decent shots of flowers and other small objects. But, if you want to capture tiny images on film, don't settle for less than a real macro lens.

Achieve Archival Quality Results with Ring Lights

Lighting can often be a big problem with close-up photography. You know by now that lighting is one of the biggest problems that photographers face. This fact looms even larger in the viewfinders of close-up photographers. Lighting subjects that are only an inch or so away from your lens calls for some special equipment and techniques.

There are many accessories on the market that are intended to aid close-up photographers in their lighting dilemmas. The most effective problem-solver for close-up lighting is a ring light. This is an electronic flash unit that mounts on the end of a lens. Since the flash surrounds the lens and illuminates evenly on a subject, pictures are easy to take. Some ring lights are made so that either the entire flash will fire or so that only a portion of the light can be fired. This allows more creative control of the lighting.

Ring lights are not cheap, and they are a specialty item. This is not something that a casual close-up photographer is likely to invest in. Serious shooters who buy ring lights will find, however, that they can't understand how they ever lived without one.

Another lighting option is a bracket that will hold two small flash units. The flashes can be placed to either side of a lens, allowing for good modeling light. This type of system works well when you are not pressed up tight against a subject. However, the system is not nearly as effective as a ring light for extremely close-up shooting.

Ring lights don't allow many options for dramatic lighting. Their purpose is to provide perfect lighting for recording images. For close-up work, no other lighting option is more effective than a ring light.

And Then There Was Wind...

Wind is an evil enemy of close-up photographers who work outdoors. The slightest breeze can make it nearly impossible to maintain focus on a subject when you are working at high magnifications. Few things are more frustrating than composing a perfect picture and then having a little wind come along that takes it out of focus. How can you combat the breezy blues? Create your own wind screens.

In order to shoot close-ups in breezy conditions, you must block the wind. You can do this with a piece of cardboard, a spare jacket, or anything else that will work. One problem you must still face is hauling your windbreak around with you. I have a solution for you.

I do a lot of natural close-up work. Wind is a frequent problem, but I have learned various ways to stop it from ruining an otherwise good day. I have a lightweight survival blanket that I carry with me. The blanket has a silver coating on one side and camouflage design on the other. By folding the blanket up, I can get it to fit into a small pocket in my photo vest. The blanket is pretty large when opened up, and it has grommets around the edges. With a little twine and some convenient trees, I can tie the blanket to the trees and stop all wind from reaching my subjects. The shiny side can be used to reflect light on a subject, and the camouflage side makes a good background when diffused with a short field of focus.

Over the years, I've used cardboard as a wind screen, but it's difficult to secure. Wind just blows it over. Some hard-core photographers carry little dome tents to protect their subjects from wind. The domes diffuse sunlight and allow outstanding pictures to be made. However, I wouldn't want to cover a bumblebee with a dome and try to get a shot.

The survival blanket is the best device I've come up with to use as a windbreak. I've used light stands to hold it in place when trees weren't available. You might come up with something that you like better than my blanket idea. If you do, use it. The important thing is to plan on having problems with wind and be prepared to deal with them.

Keep Your Close-Ups on Track with Focusing Rails

Aside from good lighting, getting crisp focus in close-up shots is one of the most difficult and critical aspects of eyeball-to-eyeball photography. Since depth of field is almost nonexistent in extreme close-ups, the slightest movement or smallest miscalculation in focus can cause a wasted picture.

Under normal conditions, the focusing of a lens is usually done by turning the focusing ring on the barrel of the lens. This is rarely the case when doing extreme close-up work. An easier, and more effective, method is to move your camera back and forth until you

achieve sharp focus. This can be done when you are hand-holding your camera, but human hands are not always steady. A better method involves using a focusing rail mounted on the head of a tripod.

Focusing rails share some similarities with bellows, but only in that the camera lens is moved closer to or farther from the subject by turning a knob. Bellows allow you to increase or decrease magnification. Focusing rails don't. When you mount your camera body to a focusing rail, you can set your close-up lens at the desired setting and adjust the focus of images with the rail system.

A focusing rail, like the one pictured, allows a camera to be moved along the rail for intricate focusing at high magnification. This is a very helpful aid when doing close-up photography with a macro lens.

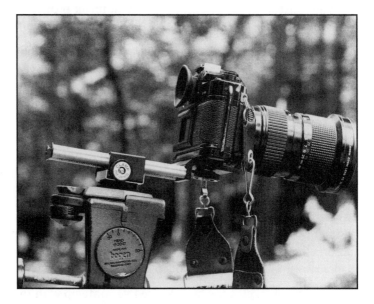

Since focusing rails allow you to move your camera forward or backward in minute increments, they make it possible to take great close-up photographs. The combination of solid tripod support and incremental focusing combines to produce fabulous photos.

You can buy a good focusing rail with very little cash. All it consists of is a calibrated advance system for the movement of your camera. If you plan to do much close-up work, look into getting a focusing rail. The improvements in your pictures should be obvious once you use the rail system.

Eye-Piece Magnifiers

Eye-piece magnifiers don't require a lot of discussion, but I would be remiss not to mention them. These units slip over the eyepiece of a camera. The advantage to using a magnifier on your viewfinder should be obvious. Since you are seeing your composition in a magnified state, much the same as looking at a slide with a magnifier, you can pick out faults in your composition more effectively.

Magnifiers are on hinged mounts, so they can be moved out of the way when they are not needed. Due to their simple mounting procedure, they can be removed and installed quickly and easily. If you have eagle eyes, you may not feel a need for a magnifier. However, most photographers, even those with terrific eyesight, will admit that a magnifier allows them to reduce the number of wasted shots they take.

Problems and Solutions Surrounding Natural Light

Natural light is what a majority of outdoor photographers rely on for good exposures. This type of light can be very effective, and it can produce pleasing results. However, there are times when existing light can cause some difficulties.

Many circumstances can come into play with natural light. A cloudy day can leave you in a bind when using a slow film speed. Bright, harsh days can cast shadows, wash out subjects, and make your photos less than perfect. Early light is often cold in its color. Evening light is warm and embracing. Learning to use, and to overcome, natural lighting is a key element to the success of an outdoor photographer.

Close-up photographers who are serious about their craft often enter the field with an assortment of equipment. Part of this equipment includes diffusers, reflectors, and electronic flashes. We will talk about these items in a moment. Photographers who are willing to gamble on what the sun throws at them often come home with lackluster exposures.

People tend to think that sunlight is the best light to take pictures in. It can be, but it can also be the worst. The position of lighting plays a vital role in successful photography. You can only control the sun to a certain extent. By choosing the hours of the day when you wish to work, you can predict, to some extent, where the sun will be and what it will do to your pictures. To come home with pictures that are consistently above average, you have to do more. The key is in how you use and manipulate your lighting.

Fill Light from Flashes and Reflectors

We talked about fill-flash lighting in the last chapter. The context was a little different, but the principles are the same. When you venture into the woods to take nature close-ups, you will often encounter difficult lighting situations. Shadows may be heavy. Some subjects might be suffering from a low angle of sun, which can result in one completely dark side. Never fear. You can use electronic flash and a variety of reflectors to improve your shooting conditions.

If you are zeroing in on the perfect patch of ferns and notice that the sun's angle is going to leave some of them dark, flash the dark ones. The next time that you are lining up on

the fluted lines of a mushroom's underbelly, consider placing aluminum foil on the ground first. If you put foil under the mushroom, light will reflect up into the protected underside of the cap and give you much better lighting.

You can use white paper, reflective cards, aluminum foil, and a number of other items to bounce existing light around a subject. These same objects can be used to bounce electronic flash. A head-on flash shot is rarely flattering. Angled lighting typically works best. You can do this with flash equipment, but bouncing the light into place is likely to look more natural. As a nature photographer, you will probably want your shots to look as natural as possible.

Fill flash and reflectors should be a part of your field equipment. Natural lighting will often allow you to capture great pictures, but there will be many occasions when existing light just isn't suitable. Pack along a couple of flashes and some reflector material to improve your odds of getting the best pictures possible.

The Least You Need to Know

➤ Test your commitment to close-up photography with inexpensive close-up rings. Once you know you enjoy close-up work, move up to a macro lens.

➤ When you want larger-than-life images of small objects, invest in a bellows to use with your macro lens.

➤ Lenses that are advertised with close-focus ability are not always macro lenses. If you want the best close-ups possible, buy a true macro lens.

➤ Wind, even the slightest bit, can ruin your chances for sharp close-up images. Be prepared to block wind from your subjects.

➤ Learn to use fill flash to bring out the detail in your close-ups. A ring light is a wonderful accessory for serious close-up work.

Animal Instinct

Wildlife photography is my passion. Of all the types of photography I do, wildlife work tops my list of enjoyment. I hunted with a gun when I was a teenager and young adult. It didn't take long for me to put the guns on their rack and pick up my cameras in their place. The skill and thrill is the same, but the animals live to be seen again another day. Many photographers love putting wild animals on film. If you are interested in hanging pictures of deer, turkeys, moose, or squirrels on your wall, this chapter is for you.

Hocking Your House for a Long Lens

Do you need a long lens as a wildlife photographer? Yes, you do. Does it have to cost you an arm and a leg? No, it doesn't.

Telephoto lenses with fast apertures can cost a fortune. I was talking with a fellow photographer a few days ago about this subject. The man with whom I spoke had just spent

Watch Out

A 500mm mirror lens is relatively inexpensive, and it gives you distance. Unfortunately, this lens also gives you poor picture quality, as a rule. Mirror lenses pack a long focal length into a short package. This is done by using mirrors as well as lens elements. The short length and large diameter of a mirror lens is distinctive. Most mirror lenses have fixed apertures, frequently at f-8. One drawback to a mirror lens is that it turns highlights into circles of lights, and this can be quite distracting.

more than $8,000 for a 300mm, auto-focus lens. Its aperture is a blazing f-2.8, but still, eight grand is a lot to pay for a lens. My 300mm lens has an aperture of f-4. It's one stop slower than the fancy one my colleague bought, but it cost less than $700, and it is a top-brand lens. Mine is not an auto-focus model. Still, I have trouble spending four times what I spent on my first new car for a lens.

Long, fast lenses are ideal for wildlife work, but they are not mandatory. If you are willing to use film that is one stop faster, you can get the same pictures with a $700 lens as someone else will get with an $8,000 lens. Your picture will have a little more grain, and it may not be quite as sharp, but it will certainly cost a lot less when you factor in the price of equipment.

Most wildlife photographers require at least a 300mm lens. A 400mm lens is also good. If you can swing, and carry, a 600mm lens, you can find a use for it. If you plan to pursue wildlife, work toward getting the longest lens you can afford. Go for fast ones if you have money burning a hole in your pocket, but slower lenses can get the job done most of the time.

Getting to Know Your Subject—Up Close and Personal

You can reduce the expense of your lens collection if you are willing to become something of a hunter. Getting close to your quarry is the secret to using shorter lenses. As a past bow hunter, I'm quite familiar with getting myself close to wild animals. My skills in the woods often allow me to shoot tight frames of animal portraits with a 200mm, f-2.8 lens. Many photographers would need a 600mm lens or longer to get the same shots I get with a 200mm lens.

The difference is my knowledge and love of animals. I know their habits and traits. This allows me to get in close without being detected. It frequently means sitting alone in the woods for hours to get a few shots, but the pictures are worth the effort, and sitting in the woods can be quite relaxing. I have fallen asleep on more than one occasion while on animal stake-out.

It can take years in the woods to truly understand animals. If your interests lie in wildlife photography, invest some of your money in books on animal behavior. Learn what your subjects do, when they do it, and why they do it. Then, get out in the field and study

them. The more time you spend in the company of animals, the more you will learn about them. You will find that the best wildlife photographers are the ones who know and understand the animals they photograph.

Spot Meters Are a Must

Spot meters are a must for wildlife photographers. It is important for you to accept the fact that no serious wildlife photographer will be caught without a spot meter. As you may recall, spot meters allow you to take light readings from very small portions of subjects that may be a great distance away. Since many forms of wildlife are difficult or even dangerous to approach, a spot meter should be used to calculate accurate exposures.

Calling All Animals

Learning to call wild animals in for close shots is a wonderful way to avoid paying big bucks for long lenses. You can master mouth-blown calls, learn to shake certain hand-held calls, or simply use a special tape recorder to call in your subjects. An electronic game caller is the easiest type of call to use, and it often works best. Some states prohibit the use of electronic callers, so check your local laws before you buy or use one.

The electronic caller I use has a large, external speaker. It uses cassette tapes and will run off of internal batteries or by the cigarette lighter housing in a vehicle. Many types of tapes are available for calling anything from crows and coyotes to foxes and skunks. Bird photographers can capture some fascinating shots when using an electronic call, and animal photographers often get similar results.

Bet You Didn't Know Hawks and owls are attracted to the calls of crows. If you play a cassette tape of a crow fight, your odds of seeing a hawk are very good.

Zoo Safaris: The Sensible Way to Get Super Wildlife Photos

Getting great wildlife photos can be a tough job. The need for long, fast lenses and a lot of time to invest in finding animals can be more than what you may want to commit to. This doesn't mean that you can't go out and get some dynamite animal portraits to hang on your wall. Go to a local zoo or wildlife preserve.

I have taken countless photographs of animals in the wild, but many of my best shots have been taken under controlled conditions. You would probably be surprised by the number of cover photos for magazines that are taken in zoos and game reserves. Professional photographers know well that they can reduce their time investment considerably by working with animals that are in some type of captivity. I'm not suggesting that a deer, for instance, will be standing in a small pen for these photographers. But, a herd of deer will probably be found roaming the grounds on only a few acres of an enclosed compound. This allows you to take natural-looking shots without spending days tracking down a herd.

Zoo photography can yield some very nice pictures. Don't worry about fences. If you can get close to the fence, put a telephoto lens up to the fence until the lens hood is touching the wire mesh. Shoot at an open aperture, and the fence will never show up in your shot. The open aperture and telephoto lens not only eliminate the fence in front of you, but they blur out distracting backgrounds, as well.

There are many places where photographers can go to take pictures of semi-captive animals. Game farms that allow hunters to shoot animals for a fee are one place where photographers can go for photos of exotic animals. Many states have some type of animal rehabilitation area where injured animals are nursed back to health. These facilities offer good photo opportunities. The reward of stalking wild animals in a forest may not be equaled with game-farm and zoo shooting, but you will get faster results and probably better pictures.

Eye-to-Eye Contact

When you are shooting animal portraits, focus on the eyes of your subject. The eyes of an animal are often a drawing point to a photograph. If the eyes are out of focus, the whole picture is tainted. People viewing your photographs should be able to make clear, quick eye contact with your subjects. With a tight shot, the eyes and eyelashes should be focal points of the picture.

Wonderful wildlife photos are possible with patience, persistence, and the right equipment. This white-tailed deer fawn was an easy target for a 300mm lens.

Stalking Elusive Wildlife in the Local Park

The local park may seem like an unusual place to go on a photo safari, but don't overlook the possibilities that exist. Many parks have duck ponds. Some of the ducks should be wild and colorful. These birds make tremendous photo subjects. Since people frequently feed the ducks, you should be able to get close to them and work with a medium telephoto lens.

Squirrels are usually abundant in parks. Taking a tight shot of a gray squirrel who is sitting on a branch eating a nut can be a lot of fun. Most park squirrels are not too timid, so super-long lenses are not needed. Common songbirds are another popular photo subject in parks. Depending on where you live, there may be a number of other animal inhabitants for you to work with.

Watch Out
Don't leave camera gear or an open camera bag alone around a duck pond. Ducks will often venture to a camera bag in search of food, and they have been known to peck away at expensive equipment and film.

Setting Photo-Traps for Wildlife in Your Backyard

If you are willing to invest a little time and money in outdoor attractions, you can get some terrific wildlife shots right in your own backyard. You don't have to live on a farm

to pull in photogenic birds and animals. As long as you have some green space, woods, or fields, you can entice your subjects to come to you. This has many advantages. You can take pictures without ever leaving your house. There is no wasted time traveling. Setting the stage for backyard photos isn't difficult, and it can be quite enjoyable.

I spent one winter shooting roll after roll of film from my living room couch. My lenses were 200mm and 300mm units. The subjects included blue jays, squirrels, raccoons, hawks, crows, deer, and other wildlife. With various types of feeders and baits, I was able to turn my backyard into a wildlife photographer's paradise. Salt blocks brought in the deer. Bird feeders produced a variety of birds and squirrels. Cans of sardines brought the raccoons running. An electronic game call pulled hawks and crows in close. I didn't go to much trouble in setting up my wildlife reserve, but I did get hundreds of good pictures that were suitable for professional use. You can do the same thing.

I know of a few professional photographers who go to great lengths to create their own private wildlife habitat. You can take the idea as far as you care to. Whether you simply hang a bird feeder and keep it full of seeds or plant your lawn in good game-bird cover, you can bring animals in close by providing food and habitat. It's hard to beat sitting in the comfort of your home while getting cover-quality wildlife shots.

Do Pets Count as Wildlife?

Pet photography may not qualify as wildlife photography, but the subjects can be just as difficult to work with. Taking pictures of dogs, cats, birds, and other pets can be quite challenging. Pets are frequently the subject of photographs, but they are rarely captured on film in the most appealing manner. Like people portraits, many pet portraits look posed and stiff. This doesn't have to be the case.

Techniques for pet photography vary from pet to pet. It's one thing to get a head shot of a Saint Bernard and quite another thing to bring out the personality of a rat snake. When you want to take memorable pictures of your pets, you should spend enough time at it to get shots that are more than simple snapshots.

Dogs that are well trained are easy to photograph. They can be told to sit and stay. If the training works, your subject is cooperative and easy to work with. You should pay attention to the background that fills your viewfinder. It should not be distracting. Use a portable backdrop or a plain, painted wall for the best-looking formal portraits. Outdoor shots can be done with natural backgrounds that are diffused with an open aperture.

When you are taking pictures of pets, get your camera at the pet's eye level. Never stand up and shoot down on a pet. Sit down, kneel down, or even lay down, but get your camera at eye level. Once you are in position, focus on the animal's eyes. Do your standard portrait shots, and then try to get some personality shots.

My wife had a cat many years ago that loved to lay on its back. It was a big, gray, fluffy cat. I got a wild idea one day that led to a cat picture that to this day still gets a lot of attention. The cat was in its favorite position on our couch. I took an empty beverage can and put some juice from a can of sardines around the rim of the empty drink container. When I laid the can on the cat's belly, he gripped the can with both front paws and began to lick the oil from its top. My motor drive was spinning frame after frame of film through my camera. The resulting pictures were great. I could see the advertising copy under the pictures that would read, "good to the last drop." My creative cat picture is just one example of how you can set your pets up for pictures that are sure to produce comments and conversation.

When you photograph your pets, try to get some shots of them in action. If your dog is a swimmer and retriever, throw a stick into a pond and shoot frames of the dog in various stages of the retrieval process. Put your cat in a tree to get a different type of pet portrait. Hopefully, you won't need the local fire department to get the cat down. Let your animals act naturally and get as many candid shots as you can.

If your pets need to be photographed through glass, such as with fish, snakes, and other container-type pets, you should put a polarizing filter on your lens before shooting. Get the lens very close to the glass. If you have to use a flash, be careful not to allow it to bounce back at you from the back side of the tank. Put the flash above your subject and at an angle that will not cause bad reflections. Pet shops sell all sorts of background paper for aquariums, and this is a cheap, easy way to keep your tank pet looking good.

Wildlife and pet photography can be more difficult than basic photography, but the rewards are worth the extra effort for people who love animals. Focus on the fundamentals of photography at all times. Get to know your subject well, and use plenty of patience. Before you know it, you'll be taking first-class photos of all kinds of critters.

The Least You Need to Know

➤ Buy the longest, fastest lenses you can afford for wildlife photography.

➤ If you are going to take good wildlife pictures, you should invest in a spot meter. Taking light readings of wild animals is very difficult to do without one.

➤ You can get good pictures of birds and animals in your local parks and zoos. Even your backyard can provide photo opportunities.

➤ Always focus on the eyes of your subject. If the eyes are in tight focus, you have the makings of a great photograph.

➤ When taking pictures of your pets, make the shots as natural as possible. Candids are almost always better than posed portraits.

Getting Creative

In This Chapter

➤ Manipulating Mother Nature

➤ Landscape lenses

➤ A monochrome approach

➤ Texture techniques

➤ Making satin with slow shutter speeds

➤ Getting in over your head

Landscape and scenic photography is a passion of many photographers. This type of work requires some wide-angle lenses and an eye for detail. Composition and lighting are the two most critical concerns of landscape photographers. Finding the right angle to shoot from can be difficult. Getting rid of distracting electrical lines can be a real pain in the neck. Dealing with heat flare, sun flare, changing lighting conditions, and biting bugs are all part of a landscape photographer's life. Are the results worth the test of patience and skill? Yes, they are. Once you are outfitted for scenic photography, the trophies you hang on your wall will be a rich reward.

Use Filters to Enhance the Mood of Your Scene

A key element to any landscape photo is the lighting. You can use filters to manipulate Mother Nature and come home with some unique photographs. For example, you can turn an average day into a foggy one by putting a filter in front of your lens. If you don't like the color of the sky, you can change it with a graduated filter. Red filters can put a lot of contrast in your black-and-white shots. There are filters available for every occasion, and you should experiment with some of them.

Some photographers feel that filters are a form of cheating. I don't use filters often, but when I do, the results are often pleasing. You will have to decide if you are a purist who will not tolerate filters or a creative soul who will. My wife is a filter freak. She filters everything. I must admit, she comes home with some pretty snazzy shots. Filters are not for everyone, but they do offer you a variety of options in the creative arena of photography.

Filters can be used for special effects or to correct colors. They can also be employed to bring out precise contrast with black-and-white film. Few landscape photographers work with black-and-white film these days, but this may be a mistake. Ansel Adams did some fine work in black-and-white. You have to choose between color and black-and-white film. Likewise, you must decide when to use filters and which ones to use.

One of the best ways to become acquainted with your filter options is to request catalogs from filter manufacturers. Be prepared to see a wide variety of options. We don't have the space here to go into all of the various types of specialty filters, but rest assured, there is a filter available for just about any effect you wish to create. You can screw on a filter that will make your picture appear to be several shots in one. Fog can be created with a filter, and soft-focusing filters are also available. Graduated filters let you change colors in portions of your scene without affecting other areas. Split-field filters allow you to focus on a close-up subject and a distant subject simultaneously. Since our focus here is basic, bread-and-butter photography, let's concentrate on corrective filters. You can experiment on your own with special effects.

Jargon Alert
Split-Field Filter: This is a filter that contains clear glass in the top half and a plus-diopter lens in the lower half. When you use this type of filter, you can focus on a close foreground and a distant background evenly. The special glass in the lower half of the filter magnifies close-up subjects without distortion.

Strong sunlight can create a bluish tint on film. You can avoid this by using a filter rated as a 1A/B. Filters in the 81 series can also be used to cut down on blue tones. Filters in the low-end of the series make the least correction, and those at the upper-end provide the most. An 86B filter will take the blue out of shots taken in dense shade. All of these filters (1A/B, the 81 series, and 86B) are warming filters.

Filters in the 82 series are used to cool down the red tones of daylight shots. They are just the opposite of the filters in the 81 series. A polarizing filter stops reflection problems and eliminates ghosts.

Jargon Alert
Ghost: A photographic ghost is a flare spot on an image that is caused by reflection of intense light. A polarizing filter will aid in avoiding ghosts.

When you work with black-and-white film, you can really see some strong changes in contrast when you use filters. A red filter, number 25, produces strong contrast between clouds and sky. It can darken blue, green, and purple tones while lightening red, yellow, and orange tones. A deep red filter, number 29, gives dramatic contrast between clouds and sky and can produce simulated moonlight when underexposed. A yellow filter, number 8, is used to give more natural exposures. Other black-and-white filters include yellow-green (number 11), orange (number 16), blue (number 47), and green (number 58). If you own each of these filters, you are well-prepared for any type of black-and-white film manipulations.

The simple use of various filters will create effects that make a specific subject look different in each exposure. The best way to decide which filters to use is experimentation. Choose a subject and take multiple exposures of it. Change filters with each new photograph. Log your filter use in a notebook. Keep track of your experiments by recording your filter use with the frame numbers on your film. For example, filter number one was used with frames one, two, and three. Filter number two was used with frame number four, and so on. When your shots are developed, compare the prints with your log. You will see instantly how each filter affected the shot.

From Fisheye to Compacted Telephoto Images

Choosing a lens for landscape work isn't difficult. Almost any lens will do, but some are better than others. My personal landscape lens is a 24mm. Some people use fisheye lenses for unusual perspectives. You don't have to be a scuba diver to use a fisheye. While fisheye shots do stand out, they are not the type of picture that most photographers want to create in bulk. If you use a fisheye lens, use it sparingly. Lenses in the 24mm to 35mm category work very well for most landscape work. There are times when a shorter lens is appropriate, and there are occasions when longer lenses are best.

An 85mm lens is a good all-around choice for landscapes and portraits. However, this lens will not give you the wide angle of view that you might want for some landscape work. You may want to use short-to-medium telephoto lenses for your scenics. Telephoto lenses compress a picture, which can be a positive effect. By compressing a picture, you bring all of the subject matter closer together. This occurs naturally when a strong telephoto lens is used. Two objects that are a reasonable distance apart will appear to be closer together.

Zoom lens are very handy for landscape work. A lens with a range of 35mm to 70mm will cover a lot of ground as a versatile lens. Personally, I would keep at least one wide-angle lens in my vest for landscapes, but you may find that this is not necessary for the types of shots you take. Outfitting your camera bag is something that will take time, experimentation, and personal choices.

Use Black-and-White Film for Dramatic Landscapes

In this age of color film, many photographers have never taken a black-and-white photograph. This is a shame. Colorless, black-and-white film is capable of producing powerful pictures, especially in the field of landscape photography. Some shots scream out to be recorded on black-and-white film.

When you work with high-contrast film, you must learn to see a little differently. The dark and light tones you have in black-and-white film require you to see in terms of contrast rather than color. Learning to do this is difficult for some people. If you don't work on contrast with black-and-white film, your shots will be gray and dull. This is one good reason to use filters. They bring out the contrast.

Jargon Alert
Contrast: This is the difference between the densities or degrees of light present in an image.

Why would anyone load a camera with black-and-white film when they could load up with color film? There are many good reasons for doing this. If you want to develop your own prints, black-and-white is a perfect film to start with. It's easy to process and you don't need a lot of expensive equipment, like color analyzers. A more important reason is that some landscapes look better in black-and-white. The stark contrast that can be brought out on black-and-white film can't be touched by color film. No, you won't see the beautiful colors of autumn foliage with black-and-white film, but you can derive a lot of pleasure from looking at high-contrast photos. By mixing high contrast with low-key features, you get outstanding black-and-white photos.

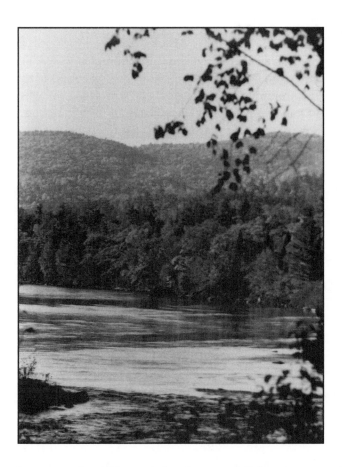

This landscape photograph is a typical composition. The tree limb in the right corner adds depth to the picture, while the river winds through the frame and leads your eyes to the mountains.

Go to your local library or book store and thumb through some photo books that feature black-and-white photographs. Try to imagine what the scenes would look like in color. Many of the shots would lose their powerful statement if they were clogged up with color. Sometimes less is more, and this is often the case with black-and-white film. If you keep it simple, you are more likely to see success. You may never fall in love with colorless photographs, but you should at least explore the medium.

Jargon Alert
Low-Key: This is a scene that is comprised mostly of dark tones.

193

Those Confounded Electric Lines

Nearly all landscape photographers have experienced the frustration of electrical lines ruining the composition of an otherwise fantastic photo. How can you get rid of the lines? You can't; you have to work around them with telephoto lenses and changes in position. Eliminating a fence in a zoo is easy; erasing electrical lines from your composition is not. Of course, you could carry a chainsaw around and cut the poles down, but this would be hazardous to your health.

When electrical and phone lines get in your way, you have to compromise. Look for a shooting position that is higher or lower in elevation. Try some telephoto lenses to see if you can crop the lines out of your composition. Can you shoot from a different angle? Of all the obstacles you encounter as a landscape photographer, electrical lines are sure to be one of the most consistent and difficult to deal with.

Lay on Your Back for a New Perspective—But Beware of Birds!

How many times have you seen photographers laying on their backs and aiming their lenses skyward? I would guess the answer has to be not often. One of the ways to make your photographs special is to shoot them in a creative manner. Most photographers see landscapes from an upright position. If you get on your back and look up, you will see an entirely different scene. It is this type of individual effort and creativity that will make your photographs win prizes and stand out. Let me tell you a quick story about this type of thing.

I was shooting stock photography for a New York agency several years ago. My agent requested pictures of fall foliage. This seemed strange to me, since so many photographers are ravenous on this subject. My agent said that the client wanted something special, but didn't know what. I went to work.

When I started my assignment, I took typical foliage shots. Some had covered bridges in the foreground, and others had churches. All of the shots looked good, but they didn't have the special quality I wanted. Then I got an idea. I laid down on my back and shot straight up into the canopy of fall leaves. Becoming infatuated with my new angle, I switched to a zoom lens. I zoomed the lens during a slow exposure to create a collage of color. I probably stayed on my back for close to an hour, experimenting with different lenses. The results of my up-in-the-air shoot were gorgeous. The agent and customer were delighted. By looking at the world from a different angle, I found success.

For an unusual perspective, lie on your back and shoot straight up with your camera. You will see the world around you in a very different way.

Have you ever seen a photograph of a playground that was taken from the ground up? Can you imagine what the Eiffel Tower would look like if you laid under it and looked up? There are many landmarks and tourist locations that have been photographed so often that there is nothing fresh about them. Get on your back and shoot toward the sky to create a noteworthy print. This type of approach is not always sensible, but it can produce some eye-catching prints.

Use Side Lighting to Bring Out Texture

If you ever take a course in photography, one of your subjects will likely be texture. This is a favorite topic among photography instructors. To get strong texture in a picture, you need side lighting. Sunlight shining on tree bark from behind a camera will not give you nearly as much texture as light coming from one side. This is easy to prove. Bring a piece of bark into your home and shine a light directly on it. Look at the bark through your camera lens. Move the light to one side and peek through your viewfinder. You will find that side lighting enhances the texture tremendously.

When you are shooting landscapes, texture can be an important element. This is particularly true of your foreground subjects, but it can also pertain to your primary subject.

Let's say that you are photographing an old barn covered in wood siding. If the barn is lit by light from behind your camera, the siding will be flat. Wait until the sun moves to the side of the barn, and all the grooves and texture of the siding will then jump out at your film.

As with most types of photography, landscape photography is often done best when the light is not shining from directly above or behind your lens. Angled lighting produces the most pleasing photographs. For texture, insist on side lighting.

Warm Up Your Images with Afternoon Light

The time of day you choose to work with your camera will affect the outcome of your pictures. Morning light tends to be cold, while afternoon light is warm. A sprawling hay field will almost always photograph better in the golden glow of late afternoon lighting. Sand dunes also photograph best in warm afternoon sun.

You can use filters, as we have discussed, to warm morning light. Sometimes you may want the cool tint of morning light, but most scenics look better in warm light. In general, concentrate on your landscape photography in the afternoons or use warming filters to change the mood of morning light.

Turn Flowing Water into Satin

You have probably seen pictures of streams and cascading waterfalls where the water had a satin-like quality to it. This effect is created by using a slow shutter speed. To stop flowing water in its tracks, you have to shoot at a faster speed. However, most waterscapes look best when the water is slowed down and turned to satin. The shutter speed that works best will depend on the speed of the water. In some cases, a shutter speed of 1/60th of a second will work fine. Other occasions call for a slower speed. To be on the safe side, start with 1/60th of a second and take several exposures at increasingly slower speeds.

To capitalize on the satin effect, you should have your camera mounted on a tripod. Your goal is to get everything except the water in crisp focus. Since the water is the only part of your scene that is moving, a slow shutter speed will not affect other elements of the photograph. To make sure you get what you want, bracket your exposures in a downward trend. Start with an exposure around 1/60th of a second and make additional exposures with slower speeds. I think you will like the results.

Fishermen's Float Tubes Can Give You a Frog's View of the World

Perspective is everything in a scenic picture. Just as you must have your camera at eye level for portraits, you should have it at subject level for most landscapes. Depending upon your personal preferences, landscapes that interest you might involve water. When this is the case, you need a boat, canoe, or float tube to take advantage of unique composition.

I've done a lot of aquatic photography over the years. Not underwater photography, but water-surface work. Much of this work has involved close-ups of reptiles, birds, and plants. One of my favorite modes of transportation is a wide-body canoe. However, there are times when sitting in a canoe puts me too high above my subjects.

When I was asked to bring back pictures of pink water lilies, I decided to use a float tube. If you are not familiar with these tubes, they are similar to the old inner tubes that kids used to float around on. Modern versions are covered in canvas and equipped with seats and pockets. They are intended for use as a fishing vessel, but they work great for photographers. However, don't use them in alligator-infested water!

When I went out into a pond with my float tube, I was at eye level with the lilies I wanted to photograph. My low angle of approach gave the pictures a unique quality. If I had taken the shots from the bank with a telephoto lens, they would not have been nearly as good. Even using my canoe would have resulted in a downward composition. By being low in the water, I got picture-perfect shots.

Your float tube or canoe will probably see more action with wildlife or nature photography, but don't overlook this mode of transportation for landscapes and scenics. You can bet that few photographers go to the trouble of getting at water level for interesting shots. This is just one more trick that will turn your shots into wall-hangers instead of album dust-catchers.

The Least You Need to Know

➤ Filters can be used to correct difficult lighting, and they can produce awesome special effects. Polarizing filters are sunglasses for your camera. UV-haze filters are cheap protection for expensive lenses. You should have UV-haze filters on all lenses.

➤ A 24mm lens is a good choice for landscape photography. Short telephoto lenses, such as an 85mm lens, are also good for scenics. A zoom lens with a wide range of focal lengths is a good lens to start your hobby with.

➤ Shoot a few rolls of black-and-white film to see how much fun it can be. Experiment with filters, such as a red one, to alter the contrast in scenes. Some pictures look better in contrast than they do in color.

➤ Side lighting brings out texture in a scene. Shoot your scenics from different angles and with angled lighting to get the best pictures possible.

➤ Most scenics photograph better in afternoon light. The warm tones in afternoon light make color film come to life.

Artistic Photography: Creative or Just Plain Crazy?

Cameras and film are most often used to make accurate records of images. This, however, is not always the case. Creative photographers often push their equipment to limits well beyond standard photography. You might think that photographers who spend hours with macro lenses and bellows aimed at the seedy insides of watermelons are weird. The idea of going out with your camera after dark may seem unthinkable to you. Yet, many photographers have the most fun with their gear when they break the rules of traditional photography. If you are willing to take a walk on the wild side, you will find some direction in this chapter.

Ice Cubes, Watermelon Seeds, and Other Unusual Subjects

I must admit that I sometimes go over the edge with my photography. While I don't consider myself artistic, some of my work has to be looked upon with creative eyes to be appreciated. During one of my photographic phases, I concentrated on strange and unusual photo subjects. My theme was to make pictures that would be hard to identify for what they really were. Some of the shots were pretty bizarre. Oddly enough, people often liked the curious images that I put on photographic paper. The phase passed, and I moved on with nature and wildlife photography as my personal passion. However, there are still times when I just have to take what-is-it pictures.

If you are interested in what-is-it pictures, you will never be without subjects to shoot. Almost anything will allow you to play the game. What you will need is quality close-up gear. At the very least, get a macro lens and extension tube. It's better if you also have a bellows. The skills needed for this type of photography are the same as those used on typical close-up work. Since we have already covered close-up fundamentals, let's spend our time here generating ideas.

What should your first wild and crazy subject be? An ice cube is a good subject to start with. Light the ice from either side. I prefer to use a quartz-halogen light for this particular shot. However, the hot light will melt the ice quickly, so work fast. Shoot the ice cube at maximum magnification. The finished print will be difficult to identify. The air pockets and streaks in the ice make an interesting pattern on film.

If you have a cooperative cat or dog, you can take a most unusual pet portrait. Position your animal so that its fur is standing up. Light the fur from behind and, in different shots, from the side. At high magnification, the forest of fur will keep viewers guessing for quite a while. Of course, you might get some flea or tick portraits by mistake.

If you look around your house and lawn, you will find hundreds of potential subjects. The cork in a bulletin board makes a good shot. Cut an orange in half and shoot the inner section. Zoom in on some watermelon seeds. An oak leaf photographed at high magnification is interesting. Texture in wood works well. Essentially, you are unlimited in your ability to find fascinating subjects for what-is-it photography.

Plastic Rabbits Come to Life on Film

Another little game I like to play involves taking inanimate objects and bringing them to life on film. It's always fun to see if viewers of my work can tell that the subjects are fakes. Let me give you a quick example.

My wife has a small figurine of a mother and baby bunny. The figure is painted in realistic colors, but it stands only about three inches high. One night when I was looking for something to do, I took the figure and put it in my studio. After arranging some pine trimmings to resemble a low-hanging tree branch, I started lighting the subject. I took probably a full roll of film at different exposures and with different lighting. The end result could have fooled me. Plastic or not, the rabbits look real on film. This fueled my fire for turning statues into wildlife.

Since my first experience with the fake rabbits, I've done a lot of fooled-you photography. A brass wild turkey statue that I own has made great silhouettes of the stately bird. The key to success with this type of trickery is usually the lighting. A porcelain pheasant that sits in my window sill looks as real on film as the live pheasants roaming the woods around my home. I find studio photography fun under many conditions, but playing tricks with film is one of my most enjoyable studio techniques.

When the Lights Go Out

Night photography is something most photographers never consider doing. This is a shame. Some excellent photography can be accomplished after the sun goes down. Cities come to life in colorful light after dark. Shooting cityscapes can be a lot of fun. Timed exposures of the sky produce some astonishing photographs, and creative flash photography keeps night shooting fast and furious.

Walking the streets of a city at night can be dangerous, especially if you're carrying thousands of dollars worth of camera equipment with you. But, if you live in a safe town or city, venture into the night and test your skills. You'll need a tripod, but no other special equipment is required. With practice, you can make night shots come out as well as day shots.

Timed exposures produce unexpected results. Set your camera up on a tripod. Put a long lens on it and aim it at the sky on a clear night. Do a timed exposure of about 15 minutes. Try another one at about 20 minutes. Keep resetting the camera for longer times after each exposure. When you review the images you capture, you'll be in for a surprise. I could tell you what to expect, but that would take all the excitement out of the experiment, so just do it.

Would you ever consider doing a model shoot in complete darkness? I doubt it, but maybe you should. What can you possibly hope for on a dark night? A lot, if you learn to paint with your electronic flash. I'll give you an example.

I once had a female model dress in a white bodysuit and wear a white lace cape. Her face was made stark white with makeup. Once it was very dark, we went into a private

cemetery, with permission. We placed the model among many large, granite monuments that were quite old. A rusted, metal fence with sharp points surrounded the scene. Everything was ready for the shoot.

On my signal, the model began to move her arms and the cape. I used a flashlight to get my focus right and then put the scene into total darkness. As the model swung the cape, I fired my shutter on a timed-exposure mode. Every few seconds I would fire my flash from different angles and at different objects. Sometimes the light would hit the model, and other times it would light other portions of the scene. By using a telephoto lens adapter on the flash, I was able to concentrate the beam of light tightly. When I got the film back from my ghostly photo session, the slides were terrific.

You can do things at night like I've just described, but don't feel limited to that style of photography. Take your camera out to a busy highway after dark. Get in a safe place and focus your lens on the road. Your camera should be at an angle of about 45 degrees to the passing cars. Set yourself up in a timed-exposure mode and fire. The lights from the moving cars will make interesting patterns and colors on your film. Instead of putting your camera away at sunset, keep it out and active. You will be surprised how productive and fulfilling night photography can be.

Zooming to Conclusions

Almost any photographer who buys a 35mm component system winds up with a zoom lens at one time or another. Dual lenses, which allow multiple focal lengths, are also very handy to have around. They can also be used for some creative special effects. If you have a zoom lens, don't limit its use to standard photography. Use your lens as a creative tool.

There are several ways in which you can take unusual pictures with a zoom lens. One way is to zoom the lens at the time an exposure is being taken. Another way is to set your camera in a timed-exposure mode and zoom the lens a little at a time for several seconds or minutes. You will never be sure what your images will look like until they are processed, but this is half the fun of it.

To get started in creative zoom photography, you should mount your camera on a tripod. Set the zoom at one end or the other of its scale. In other words, if you have a 100mm to 300mm lens, set it at either 100mm or 300mm. Focus on your subject and take your meter readings. When you are ready to take a picture, start moving the zoom through its range. Snap a picture while you are moving the zoom. You can zoom in or out in terms of magnification.

Using a zoom with a timed exposure is really interesting. Follow the same instructions as given above, but with your camera in a timed-exposure mode. Move the zoom slowly through its range. You may even want to stop for a moment or two between movements.

It's hard to tell what you will wind up with, but it should be different from what other photographers are doing.

I use zoom lenses to create backgrounds for other pictures or advertisements. For instance, I would focus on a tree full of colorful leaves at maximum focal length and zoom to a lower magnification as the shutter is fired in a continuous mode with my motor drive. The results are absolutely gorgeous, and they make good background material for advertisers to lay copy over.

Underwater Photography in Your Den

You don't need scuba gear to take good underwater photos. In fact, you don't even have to know how to swim. Aquariums provide excellent underwater photo opportunities. Whether you are capturing an elusive goldfish at home or tackling a large shark at a commercial aquarium, you can do it easily and never get wet. Snorkels are optional.

To shoot underwater aquarium photos, you need a camera and a handheld flash. Your lens must be capable of focusing on your subject. In a commercial aquarium, a normal lens should work. At home, working with a small fish tank, a macro lens is in order. The flash you use must be in a remote location, triggered by a PC cord or a hot shoe. It is helpful to have a polarizing filter on your lens. You should also keep a small container of glass cleaner and a rag or towel on hand. If the glass of the aquarium is dirty, you must clean it to get great shots.

When you are ready for your aquatic photo session, make sure that your lens is touching the glass of the aquarium. The head of your flash should also touch the glass. Focus and fire. That's all there is to it. The key is getting your lens and flash both pressed tightly to the glass. When you are working with a small home aquarium, you may have to light your subjects from the side to avoid bounce-back flash. One other solution to this problem is to install a non-reflective background on the inside, back glass of the aquarium.

The neat thing about aquarium photography is that you have your own little contained studio. If you want pictures of crabs, you simply put crabs in the aquarium. With a little landscaping, you can make the tank look like natural habitat. Trips to commercial aquariums will allow you to take pictures of a variety of fish and sea life. This is a lot of fun on a rainy day.

Using Museums to Create Conversational Wall Hangings

Taking your camera gear with you to museums is a good way to get some uncommon pictures. Would you like to have a portrait of Abe Lincoln hanging on your wall? Take the

shot yourself. No you don't have to go beyond the pearly gates to get it. Go to a wax museum. Have you always wanted to take a picture of a dinosaur? A trip to a museum of natural history will give you the opportunity.

Museums offer more photo opportunities per square foot than you might imagine. Wonderful wildlife pictures can be taken of realistic exhibits in museums. Whatever your interest, it is sure to be represented in some type of museum. The problem is, how do you get the pictures to look like something other than tourist snapshots of museum exhibits? It's really pretty easy.

When you want to shoot in museums, you may have to do without your electronic flash. Some facilities prohibit their use. This calls for a faster film and some corrective filters to make the existing lighting look natural. You also need some type of camera support, but setting up a tripod could make you not only a center of attention among other visitors, but a target for complaints. Carry a monopod instead.

Long lenses in the 200mm range are often ideal for museum photography. Their focal length and compaction qualities allow you to eliminate telltale background with an open aperture. My favorite museum lens is a 200mm, f-2.8. With a lens like this, you can often isolate subjects so that they don't appear to be sitting on a stand in a museum. Another good lens to have along is a 100mm macro lens. The extension tube is not needed for this type of photography. The close-focusing macro lens will allow you to get highly detailed photographs with diffused backgrounds.

If flash photography is allowed, use your flash like you would at an aquarium for subjects that are behind glass enclosures. When you take a flash exposure, take the first one under normal ratings. Then, reduce the flash power. By having the flash produce a weaker beam, you can darken backgrounds and eliminate incriminating evidence of your location. You will have to experiment with your flash to come up with ideal settings, but you can get terrific photos that don't look like tourist brochures if you work at it.

Mastering the Art of Illusion

To master the art of illusion with photography, you have to experiment and practice. Don't expect to set up some scenes and get pro-quality pictures right away. Creative photography breaks the rules of traditional photo work. When you break the rules, you can no longer use auto-exposures, recommended exposures, and rule-of-thumb guidelines. You must blaze your own trail. Coon-tail hats are optional.

Practice makes perfect, or so the saying goes. In many cases, it really does. The more you use your camera, the more you will get to know about it. There is no substitute for shooting roll after roll of film when it comes to learning photography. Ideally, you should combine tips and techniques that you read about with your hands-on

experiments. It is equally important that you keep records of your exposures. Otherwise, you may not be able to repeat the process that gave you what you wanted.

Buy a notebook and keep records of what you are doing. Log in the frame numbers of your exposures so that you can study and identify what you have done right and wrong. With this type of organized approach, you can grow to become a fabulous photographer who makes prints that others are in awe of.

The Least You Need to Know

➤ There are no rules in artistic photography. Anything goes. You can photograph subjects of all types in ways which will make them artsy.

➤ Night photography is not only fun, it extends the time that you can spend using your camera. Don't hang your camera strap over a peg when the sun goes down. Get out in the night and shoot for the moon.

➤ Underwater photography, at home or at commercial aquariums, is easy to do, and you don't have to get wet. The key is keeping your lens and flash tight against the aquarium glass.

➤ Museums offer creative photographers a host of intriguing subject matter. The next time you don't want to shoot in the rain but can't find something to do, go to a museum.

➤ Illusion is easy in photography. You can use your bedroom or dining room as a temporary studio to create all sorts of pictures. With the right props and lighting, you can make almost anything appear real on film.

Part 4
The Red-Light District

Want to take a walk on the wild side and do it in the dark? Hey, don't tell me you're from the vice squad. Come on, let's go into the dark and see what develops. Since you haven't slapped me yet, I guess I can tell you a secret—this section is going to show you how to set up and use a darkroom of your own.

We will start by doing an inventory of all the reasons you should consider developing your own film and prints. Equipment will, of course, be on our agenda. Not only will you find out the stuff you need for a home darkroom, I'll even tell you how to use it.

Black-and-white darkrooms are not too expensive to create. You can process your own color slide film without even owning an enlarger. Since the cost of doing your own developing is manageable, this is a great way to expand your hobby and enjoy having something to do when you don't feel like taking pictures.

Photo Developing: Doing It in the Dark

Many photographers grow to a point where they wish to develop their own film and make their own prints or slides. Doing this can add a new dimension to your hobby. A black-and-white darkroom doesn't cost a lot to create, and you can turn a bathroom into a temporary darkroom. Color processing is more expensive, but it too can be done in small spaces. You can even process and mount your own slides with certain types of film. Having a darkroom of your own can bring you closer to your photography, enhance your enjoyment, and even save you some money if you do a lot of shooting.

In this chapter, you'll learn a bit about darkrooms in general and get a feel for what it might take to get started in the developing field. Then in the three chapters that follow, we'll look separately at black-and-white and color developing.

The Advantages of Developing Your Own Pictures

When I got started in photography, it was difficult to find a one-hour photo-processing store. To get my pictures developed, I had to go down to the local drug store, fill out a shipping envelope, drop my film off, and wait for days to see the results of my shoot. This was okay with some rolls of film, but there were times when I wanted pictures fast. Driven by that desire, I got a non-paying job as an apprentice with a local professional photographer. I would work as an assistant in both the studio and the darkroom for a few hours a day in exchange for the use of his darkroom. Not only did I get to use a professional darkroom, but I learned a lot from the photographer. My photography career was off to a roaring start, and I didn't even realize it.

Ever since my first experiences in a darkroom, I've been enthralled with the idea of going into a room with little light and coming out with finished photo prints. There is a certain magic to the whole process. You don't have to work as an unpaid apprentice to enjoy darkroom work. In fact, if you are willing to work with black-and-white film or color slide film, you can do your own processing with a minimal equipment expense.

Instant Gratification

In this modern age, you can get color prints back in about an hour from any number of facilities. However, getting slide film and black-and-white film processed can take much longer because few quickie labs are set up to process slides and black-and-white film on a production level. Therefore, they either do this work only on certain days of the week or send it out to other labs for processing. You can overcome this problem by setting up your own darkroom. It won't cost a lot, and you will have total control over when and how your film is processed. Never again will you have to worry about your film being lost in the mail. Take control of your processing and build your own darkroom. Even a makeshift, temporary darkroom in your walk-in closet or bathroom will allow you to produce premium photos.

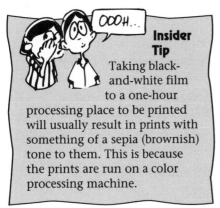

OOOH...

Insider Tip

Taking black-and-white film to a one-hour processing place to be printed will usually result in prints with something of a sepia (brownish) tone to them. This is because the prints are run on a color processing machine.

The Dark Can Be an Exciting Place...

If you have never processed your own film and prints, you can't possibly appreciate how exciting the activity can be. I still remember some of the first prints I ever watched come to life in a developing tray. As you stand there, moving your print around in the developer, you begin to see a ghost image. As time in the developer increases, so does the detail of the image. This is a feeling that is hard to duplicate. Knowing that you took the picture, developed the film, and are now making your own print can send a

wave of self-satisfaction through you. It's not just watching the image appear, but knowing that you are making it happen.

Processing your own film is a hobby in itself. It adds a great deal to a passion for photography. Some photographers develop their own stuff to save money, but most do it for creative control and enjoyment. If the weather outside is too bad for shutterbugging, you can retreat to the comfort of your darkroom and enjoy a good day in the dark.

Should you set up your own darkroom? Only you can answer this question, but you will miss out on a lot of fun if you don't. Is it expensive to outfit a darkroom? Not in terms of what photographers frequently spend on cameras and lenses. Used darkroom equipment is abundant and affordable. Even new gear isn't too expensive, until you get into color prints.

How hard is it to develop and print film? An average person can use a darkroom guide and be processing and printing black-and-white photos in one day. The same holds true for some color slide film. Color prints are a little more difficult to work with, but even they can be done by a novice without formal training. If you were to set up a black-and-white darkroom tomorrow morning, you could have custom prints hanging out to dry before noon. It's that simple.

Crop It, Enlarge It, Burn It In, or Sandwich It

When you choose to become your own darkroom technician, you are in control of your own success. There is no one else to blame for bad exposures. If something goes wrong, it's your fault. But hey, you can always blame it on the chemicals. You control the camera and the processing, so it is all your ball game. This new freedom can add a lot to the results of your photo sessions.

If you are a real rookie in photography, you may not have experienced a need to crop an image. However, anyone with even a modest level of experience knows that there are times when unwanted objects appear in a photograph. You can try to screen out these obstacles by checking your viewfinder, but some may sneak in at the last minute. If this happens and you send your film out to a commercial processor, your finished print will bear the burden of a distracting image. Once you own your own darkroom, you can crop out the bad part of a negative. Your enlarger will give you the ability to clean up your negatives before you print them. Bad elements are not really removed from the negatives, but they are prevented from showing up on a finished print. This advantage alone can make custom printing a worthwhile venture.

Enlargements are a source of enjoyment for many photographers. Hanging a snapshot on your wall is not nearly as impressive as displaying a nice enlargement. When you have your own darkroom, enlargements are easy to make and are not very expensive. When

you make an enlargement, some elements of the negative you are working with will be eliminated from the print. This is to be expected. Another factor to consider is that when a print is made larger, more imperfections will show up. Depth of field and focus are two elements that may look okay in a small print but terrible in a large one. Even with the drawbacks, enlargements are a prime interest for darkroom owners.

Did you know that you can alter the exposure of an image when you work with it in a darkroom? You can. If you want a background to be darker, you can burn it in. Burn it in? Yes, this is a process where you protect some of the photographic paper from full exposure. For example, you can use a piece of wire with a strip of cardboard on it to block enlarger light from the middle of the print, while the borders of the print get full light. This dodging, as it is called, allows you to burn in the edges of the print. A creative person can use this to come up with numerous ways to make interesting prints.

Have you ever heard of a photo sandwich? This is when two images are combined to make one. For example, you might take a slide that has a bright full moon in it to be your background slide. You could then put another slide in front of it, say one with an airplane as a subject. When you worked this magic, you would have a finished image that shows an airplane flying under moonlight. All sorts of outrageous special effects can be done when you make sandwich prints.

The Ultimate in Control

To gain the ultimate control over your photography, you must process and print your own film. Statistically, few amateur photographers do this. It is easier to take your film to the local processing lab and wait to pick it up in an hour or so.

Don't try to justify the cost of darkroom equipment by thinking about how much money you will save processing your own film. The numbers don't work. By the time you factor in equipment, labor, paper, and chemical costs, you will probably find that it costs more to do your own processing. Setting up a darkroom is fun if you enjoy what you are doing. Taking on processing work without having a serious interest in it is a mistake.

Darkroom work is similar, in some ways, to photography. If you don't want to invest much time or money in either hobby, you don't have to. You can buy an all-automatic camera and never have to learn strong photography skills to get reasonable pictures. By the same token, you can buy a few darkroom guides and never worry about learning the intricacies of film developing and printing. If you follow the instructions supplied with film or in darkroom guides, you can make good prints most of the time.

There is no better way to control all of your photography than by having a personal darkroom. Once your private processing lab is in operation, you can correct mistakes that were made when a picture was taken. Your enlarger and developing trays will become

your safety net when an in-field exposure is off or some unwanted object jumps into your viewfinder.

Much of your control will not be obvious to viewers of your work. But if you shoot a roll of film and want nearly instant gratification, you can get it with your own darkroom. Once you start processing your own film, you don't have to worry about it being lost or damaged, unless you are at fault. One of the most interesting aspects of making your own prints is the amount of manipulation you have with a frame of film.

Magnificent Manipulations

You've read how filters allow you to alter the appearance of a subject when a picture is taken. They can also be used in your darkroom to change exposures. In other words, a picture that you take without a filter can be filtered in the darkroom. This, however, is only the beginning of what you can do with your film once you get the hang of darkroom work. There is almost no limit to the creative steps you can take in your darkroom.

When you make color or black-and-white prints from negative film, you can manipulate many aspects of the negative. Exposures that were incorrect when pictures were taken can be corrected with your enlarger. A wide range of special effects exists for darkroom owners. Let's talk briefly about some of them.

Have you ever heard of the Sabattier effect? This is when film in a developer solution is exposed to light during the development process. The film becomes fogged or darkened. Other changes can be accomplished using this process to give your work a very unique appearance.

If you load a screen filter in your enlarger, you can make a photograph that is reduced to only black-and-white. Not like black-and-white film with gray tones, but a true black-and-white only print. The high contrast achieved with this method can be quite desirable.

Other effects that can be realized involve the use of bleach to change color tone. You can take a normal picture and make it appear to have been side lighted, even though it wasn't. Montages can be made in the darkroom, and masks can be used for a variety of effects. A mask is a cutout that blocks enlarger light from one part of a print during exposure so that the spot can be filled with some type of special effect in another exposure.

The Least You Need to Know

I won't twist your arm to get you into darkroom work, but I will tell you that it adds handsomely to a photography hobby. When you consider the fact that you can buy enough darkroom equipment to develop your own black-and-white prints and color slides for less than what you might pay for a good lens, it's worth some thought.

So, what do you think? Are you intrigued with the idea of processing your own film and making your own prints? If you want to know more about setting up a home darkroom, all you have to do is turn the page. We are about to build a black-and-white darkroom. Go on, turn the page and find out how easy setting up a darkroom can be.

➤ Developing your own pictures is fun and rewarding. It's possible to save some money on your processing costs, but don't set up a darkroom for only financial reasons. Learning to work in a darkroom will go hand in hand with your development as a photographer.

➤ Start your darkroom work with black-and-white prints or color slides. Getting into color prints is a little more complicated and a lot more expensive.

➤ Mistakes made with film in a camera can often be corrected in a darkroom. In other words, if you exposed your film at the wrong speed, you can correct the problem in your darkroom.

➤ Owning your own darkroom gives you complete control over your photography. You are in charge from the moment film is loaded in your camera until the final print or slide is processed.

Black-and-White Developing Made Easy

In This Chapter

➤ Choosing an enlarger

➤ Timers that do it in the dark

➤ Reels and tanks that aren't for fish

➤ Dr. Do-It-Right's chemical choices

➤ Picking photo paper

➤ Entering the red-light district

If you are interested in setting up a darkroom, start with one that is designed to do black-and-white developing. You can use it to process some color slide film too. The only thing you won't be able to do is make color prints, but you can grow into that phase of the process later. Black-and-white darkrooms can be set up in almost any room or enclosed space. Walk-in closets make good darkrooms, and bathrooms are an ideal temporary location. Laundry rooms are another part of the home where weekend darkrooms often pop up. You don't need much space or money to get yourself started in processing and

Bet You Didn't Know
A standard bathroom makes an excellent temporary darkroom. You have hot and cold running water, drainage, and a bathtub that can be converted to a good work space with the addition of a piece of plywood.

printing film. You do, however, need some specialized equipment, and you are about to find out what it all is.

Equipment You'll Need

Equipment needs for a basic darkroom are not complicated or expensive in terms of photographic gear. You will need a film tank and reels to develop your film in. I recommend buying a Paterson tank and reels that will allow you to do up to three rolls of film at one time. This saves time and chemicals. A thermometer is needed to monitor the temperature of chemicals. If you roll your film completely into the film canister after exposing the film, you will also need a bottle opener to get the film out.

Scissors are needed to cut film, and clothespins and string are needed to hang negatives and prints. You need at least one graduate for measuring chemicals. A funnel will be used for transferring liquid chemicals. Brown or black plastic storage bottles will be needed for your chemicals. Some should have a one-gallon capacity, and others should hold one quart. You will want a photo sponge or squeegee to dry your film and prints. Some sort of a timer will be needed. Your wristwatch will do, but a darkroom timer that glows in the dark is better.

When you are ready to make prints, you will need an easel. This is a device that holds your photo paper in place during exposures. A focusing magnifier is handy when you are trying to get your negatives focused just right. Three processing trays are necessary for chemicals, and you will need a set of tongs for each tray. You may wish to add other odds and ends, such as rubber gloves, as you get along in your processing. Before you can make prints, you will also need an enlarger.

An Enlarger, If You Want Prints

One piece of equipment that you *must* have to make prints is an enlarger. Enlargers are used to expose photo paper to processed photo negatives. You might say that the enlarger burns the image on a negative into the photo paper.

An enlarger allows you to zoom in on a negative to make images larger than they appear on film. Most inexpensive enlargers will let you go to 8 × 10 size on enlargements that are made on the enlarger board. While enlargers can appear difficult to use, they're not. You put a negative in the negative holder, turn off the lights in your darkroom, and focus the negative by turning a knob on the enlarger. That's about all there is to it. We will, however, get into more details in the next chapter.

If you are only interested in processing and mounting slide film, you can do very well without an enlarger, but let's assume that you want the versatility to work with both

black-and-white print film and color slides. This means that you need an enlarger, but you don't have to hock your house to get one. An enlarger can cost just over $100 and still do a fine job with black-and-white prints.

Insider Tip

OOOH...

Used photography equipment is often priced at half of what it would cost new. You can likely buy the entire contents of a working darkroom for what a good enlarger might cost if you bought it new. People get into hobbies and then lose interest in them. They also lose money when they sell out, but this is to your advantage. Check your local classified ads for used equipment. The savings could be substantial.

When you venture out to buy an enlarger, you don't need a Gold Card. Black-and-white enlargers are quite affordable. How cheap are they? A name-brand, quality enlarger (for black-and-white work only), including a 50mm lens can be bought for less than $115, based on current mail-order advertisements. I own this particular model of enlarger, and it works flawlessly. The system comes complete with a filter holder, lens, focus rail, and baseboard. You really can't beat the deal.

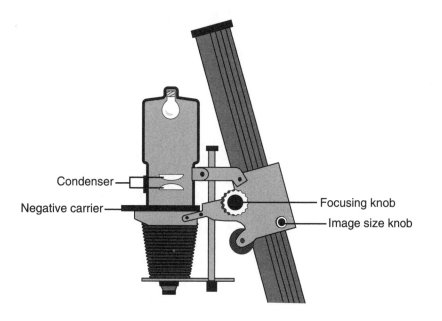

Enlargers may appear intimidating at first glance, but they are really quite simple to use.

Condenser

Negative carrier

Focusing knob

Image size knob

Insider Tip

While we are on the subject of unbeatable deals, let me stray from our specific talk on enlargers for a moment. The same manufacturer offers a complete kit, which includes an enlarger and lens plus 23 other items. Order this kit, and you're in business. How much will it set you back? Would you believe it only costs about $240? See, you can get into a darkroom on a budget, even with new equipment. Deals like this are abundant in the advertising pages of *Shutterbug* magazine. Now, back to enlargers.

Some black-and-white enlargers can be upgraded to work with color film. If you think that you may want to step up to color, you can consider this option. Personally, I would buy an inexpensive black-and-white enlarger and not worry about upgrade features. If you want to start doing color work, buy a color enlarger. Then you have two specialized enlargers, and your color unit will probably do a better job. Plus, you're not paying for a feature that you don't know if you will ever use. I do recommend getting an enlarger that has a filter tray, but most of them do anyway. This tray allows you to alter prints with filters in much the same way that you can with a camera and filters.

Choosing an enlarger is similar to choosing a camera body. Some people prefer one style or brand over another. Look around at local camera shops and become familiar with what's available. Then, I would give some serious thought to cruising the classified ads for a deal on a complete darkroom. Who knows, you might get everything you want for less than $100. I've seen deals like that before.

Something to Keep Track of the Time

Sun dials don't work well in darkrooms, so you need some other type of timing device. A simple stopwatch will do, and so will a wristwatch that has a second hand or counter. Ideally, you should have a darkroom timer. These timers glow in the dark, so you can keep an eye on the progress of your work. They are also rigged so that your enlarger plugs into them. When time is up, the enlarger shuts off automatically. This may not seem like a big advantage, but a few stray seconds can make a difference in how well a picture turns out. By the time you realize time is up and get the enlarger turned off, you have missed a few seconds. Start off with an inexpensive timer if you want to, but plan on graduating to a full-size darkroom timer as soon as you can. How much do they cost? One like mine runs about $75, and it's worth every penny.

Jargon Alert
Stop Bath: This is a weak solution of acetic acid that neutralizes the developing action on film and prints. Many photographers use ordinary tap water as a stop bath.

Three, Count 'Em, Three Processing Trays

You will need three processing trays. One will hold your developing chemicals, a second will hold a stop bath (water), and the third will hold a fixer chemical. The size of the trays needed depends on how large your prints will be. A set of three trays for 8×10 prints will cost you about $8. No big expense here.

Tanks and Reels

You must have a developing tank and reel to process your film. There are different types of tanks and reels available. I have a personal favorite that is pretty much the industry standard. It is a three-reel black tank with plastic reels. I've been using this type of tank for as long as I can remember, and it's never failed me yet. Must be expensive, huh? Wrong! It's less than nineteen bucks, complete. Am I showing you how to set up on a budget, or what? If you process a lot of film at one time, you can get a five-reel tank.

Jargon Alert
Fixer: This is a chemical that is used in film and print processing to remove unexposed silver and make the image safe to view under normal lighting conditions.

Watch Out
Many rookies make a mistake by buying a tank that holds only one reel. Spend a few more dollars and get a tank that will allow you to process three reels of film at one time. You don't have to load the tank to capacity, but being able to do more than one reel at a time saves a lot of time.

A developing tank, such as the one pictured, allows you to process film in normal room light after the film is loaded into the tank in total darkness.

Before film is put into a developing tank, it is loaded onto a film reel, such as one of the reels shown here.

Chemicals of the Mad Scientist, Dr. Do-It-Right

You don't have to be a chemist to develop pictures, but you *do* have to work with chemicals. The chemicals used in black-and-white photography last longer on your darkroom shelf than the ones used for color work. A full, stoppered bottle of black-and-white chemicals, in stock solution, could easily last for six months. Bottles that are not full may last only two months. Temperature, containers, and storage procedure all play a role in how long chemicals will remain useful. They should be stored in brown or black plastic bottles. These bottles are less than $2 each and are readily available from most photo suppliers.

Jargon Alert
Stock Solution:
This is the liquid form in which chemicals are stored.

What about the chemicals themselves? If you are going to process color slides, you can buy a kit that has all the chemicals you need. These kits aren't cheap, but they won't break your bank either. Depending on what the manufacturer includes in the kits, they generally run around $25–$45. Prices vary greatly on kits like these, and so do the amounts of chemicals you receive. Shop around before you commit to one particular kit.

If you are into black-and-white work, your chemicals will probably be purchased individually. You must have a developer and a fixer. You may choose to use a chemical stop bath, but you can use water. In fact, if you are using a resin-coated (RC) paper, you should use only water. Since RC paper is very popular, you should only need to buy developer and fixer for your print-making work. Ah, but what about the film processing? Almost forgot about that, but here's the skinny on film development.

Jargon Alert
Fixer Remover:
This is a solution used in negative and print processing before the final wash to shorten the final wash time.

When you develop film, you need a developing chemical. A stop bath requires you to use either acetic acid or plain water. I usually use water. Then you need a fixer chemical. After the film has been fixed, you should use a fixer remover. This is an optional step, but it considerably reduces the amount of time that the film must be washed. The last solution you should use is a wetting agent. This too is optional, but a wetting agent reduces spotting and streaking on your negatives. In addition to chemicals, you will need photo paper to print your work.

Jargon Alert
Wetting Agent:
This is the last solution used in negative processing. It is used to reduce surface tension on film and promotes faster, more even drying.

Paper to Print Your Prints On

When you shop for photo paper, there are five qualities you must consider. They are base type, weight, tone, surface, and contrast. Since this may not mean much to you, allow me to expand on the various qualities. By the way, you won't need paper if you are processing slides.

Your first decision will be whether to use resin-coated (RC) paper or a fiber paper. As a beginner, you will probably have better luck with RC paper. This is the paper of choice for most photographers under most conditions. RC paper is coated on both sides with a thin layer of clear plastic. It is faster and easier to work with than fiber-based papers. There are some artistic values associated with fiber papers, but on the whole, RC paper is the way to go.

The weight of photo paper is rated as either single, medium, or double weight. RC paper is usually a medium weight. Heavier papers, such as some fiber-based materials, dry flatter and don't wrinkle, crease, or curl as much as lighter weight materials. This advantage comes at a price. Double-weight paper is expensive and slow to work with.

When you talk about the tone of a paper, you are discussing whether it is cold or warm. Warm tones lean toward a brown tint, while cold tones are a more neutral black. For general use, tone doesn't make much difference. The surface of photo paper can be glossy, lustre, semi-matte, or matte. If you want sharp images, go with a glossy surface.

Insider Tip

Resin-coated (RC) paper is the best paper for novices to use in a darkroom. It is both easy and fast to work with.

The last aspect of paper to consider is contrast. A low-contrast paper produces prints that are gray, with only a few bright or dark areas. High-contrast paper gives you light and dark images with less gray tones. You can also get papers that offer variable contrast. This means that with the use of filters for your enlarger, you can use one paper to produce different levels of contrast. For basic darkroom work, a high-contrast paper will be the most appropriate. As your skills develop, experiment with variable-contrast paper for more artsy effects.

Play It Safe with a Safelight

When you set up your darkroom, you will need a safelight. This is a light that will not affect your photo paper under proper conditions. Common safelights have wattage ratings of either 15 watts or 25 watts. The bulbs are either red or amber, or a regular light bulb may be housed in a receptacle that is covered with a colored filter of red or amber. For a typical home darkroom, you only need one safelight. It should be positioned at least three feet away from your enlarger and your developer tray.

Easels that You Don't Paint On

Easels are what hold your photo paper during your work with an enlarger. The easel must hold the paper flat and securely. There are many types of easels available. Most of them

Jargon Alert

Safelight: This is a colored light, usually red or amber, that is used to provide illumination for darkrooms during various phases of work.

are made to leave a border around all edges of the paper, but some don't. You can get adjustable easels to use with papers of different sizes or you can buy individual easels for each paper size you plan to use. I prefer individual easels for each paper size. This allows me to work faster in the darkroom. Instead of setting easel adjustments, I just grab the one that I need and get to work. Some easels are easier than others to work with. I recommend that you buy special easels for each paper size.

An easel, such as this one, is used to hold photo paper in place during the time it is exposed to light from an enlarger.

Water, Water, Give Me Water

To have a working darkroom, you need a water source. Your water will have to be available at various temperatures, so an ideal situation requires the presence of both hot and cold water. If you do your weekend darkroom work in a bathroom, water is not a problem. People who use closets as darkrooms do have a problem. They don't have any water readily available. It is possible to use a dry room as a darkroom; you can collect water in advance and take it with you. Maintaining the water temperature can be tricky, especially if you are working with color film and prints.

Temperature variations are more critical with color film and prints than with black-and-white work. For example, black-and-white film can be processed in water with a temperature of anywhere from 65 degrees to 75 degrees Fahrenheit. The warmer the water is, the shorter the processing time is. Since you have about a 10-degree latitude in water temperature for black-and-white film processing, you can start your water off at the upper end and continue to use

Jargon Alert
Working Solution: This is a chemical solution that has been diluted and is ready for use.

it as it cools. However, you must use a thermometer to monitor the water temperature so you can make adjustments in your time factors. I should add that the thermometer you use should be a photographic thermometer. Photo thermometers tend to be longer than standard thermometers, which is helpful when taking the temperature of chemicals in bottles.

Hauling water into a darkroom and changing it as its temperature changes is okay for occasional work, but it gets old fast if you are doing much darkroom work. The simplest solution is to use a bathroom as a darkroom until you can commit to setting up a permanent darkroom. By putting pieces of plywood over a bathtub and vanity or lavatory, you can create a fairly comfortable work area.

If you have to work in a dry area, you can reduce the number of trips you have to make in and out of the darkroom by carrying quantities of water in at different temperatures. Take in one batch at a working temperature. Draw another batch at a higher temperature. When your first water supply cools to a point of being unusable, the second batch should be cool enough to use right away as a replacement. By staggering the temperatures of your water supplies, you can process for hours without having to make new trips to a faucet.

Other Goofy Gadgets

There are all sorts of goofy gadgets you can buy to customize your darkroom. Some are needed, some are nice, and some are just dust-catchers. In addition to the main items that we have already discussed, you will need some smaller items. Scissors should be readily available in your darkroom. You will need a bottle-opener to open a film canister if you accidentally wind your film too tightly after a shooting session. Clothespins and string will be needed to dry your prints and negatives. If you can hang these items over a bathtub, you don't have to worry about drips. Otherwise, you will need plastic or towels to place under your drying work.

Negative hangers should be used to suspend your film during its drying process. A photo sponge is handy to have, and a funnel is very helpful. Stirring rods make it easier to keep chemicals mixed up. Rubber gloves are a good idea since you are working with chemicals. Some type of eye protection is also a wise investment. You don't want chemicals splashing you in the face and ruining your eyesight.

Photo tongs, which are usually made of wood with rubber tips, should be used when moving prints from one tray to another. A blower-brush or a can of compressed air is good for removing dust. An anti-static brush is also a good tool to keep on hand. An enlarger magnifier is almost essential. This device allows you to focus the lens of your enlarger with precision. A print squeegee works well for getting excess water off prints before they are hung to dry. A paper trimmer makes it much easier to cut prints evenly.

A piece of glass that is the same size as the baseboard of your enlarger will allow you to make contact sheets. This is not only fun, it will help you avoid wasting a lot of photo paper on bad negatives. A contact sheet is a piece of photo paper that holds a number of negative strips. You print all negatives simultaneously to check for focus, contrast, and exposure. In doing this, you can see many negatives in print with the use of only one piece of paper.

When you are ready to spend more money, you can step up to more advanced equipment. Some such items include a film-drying storage cabinet, a voltage stabilizer, a paper safe, a refrigerator, a tempering box (this keeps water at a constant temperature and is desirable for color work), and a dry mounter. The list of potential items could go on and on.

Before you get too carried away with equipment purchases, buy only what you need and work with it. See if you like working in a darkroom. Like a camera system, you can always add to your darkroom equipment. Hey, that's part of the fun. When you are addicted to the darkroom, you may want to expand into doing color prints. To find out what's involved with this type of upgrade, check out Chapter 25.

The Least You Need to Know

➤ Setting up a black-and-white darkroom is simple and relatively inexpensive. You can create a temporary darkroom in a standard bathroom.

➤ An enlarger is the only big-ticket item required for a black-and-white darkroom. If you will be processing only color slides, you don't even need an enlarger.

➤ When you buy film tanks and related equipment, invest in the best. Good tools are essential to having fun in your darkroom, and they don't cost much more than cheap imitations.

➤ Resin-coated (RC) paper is the best type of photographic paper to use for most darkroom requirements. It is both fast and easy to work with.

➤ You can process and print black-and-white film even if you don't have running water available in your darkroom. Since temperature variations are not extremely critical with black-and-white processing, you can take water into your darkroom in jugs.

Do-It-Yourself Developing

In This Chapter

➤ Buying and mixing chemicals

➤ Developing film

➤ Making prints

➤ Processing color slides

➤ The finishing touches

The fun ends for many photographers when the last frame of film is filled and rewound. But, if you develop your own film and prints, the fun is just starting. You can save rolls of exposed film for a rainy day, or you can rush home and develop them right away. The choice is yours. As your own darkroom technician, you are in control. Contrast in a picture can be altered in your darkroom. If you exposed your film at a setting that would normally make the picture too dark or too light, you can fix it in the darkroom. Most of all, though, developing your own work is relaxing and rewarding.

In this chapter, I'll lead you through the steps of how to print some black-and-white prints and color slides using the darkroom you set up in Chapter 23.

Black-and-White Chemicals

After your darkroom is set up, you need some chemicals to work with. While plumbing codes don't consider home photo chemicals to be a hazardous waste, you must respect the chemicals you use. They can burn your skin and eyes. You should have good ventilation in your darkroom. It's okay to pour spent chemicals down your sink drain, but don't underestimate the hazards of your solutions. Photo chemicals can cause skin irritations, and they are particularly dangerous when splashed into your eyes. Developer tends to stain items with a dark brown, so avoid spills. Dumping occasional photo chemicals into a septic system is okay, but heavy dumping can disrupt the natural chemical reactions that occur in a septic tank.

Insider Tip

You can buy a replenisher chemical to add to used developer. This extends the useful life of the developer by replacing the chemical components of the developer that are used during processing.

Developer

The first chemical you need is a film developer. There are many brand names of developer for you to choose from. I use Kodak D-76. Enough of this chemical to make a full gallon of working solution costs less than five dollars.

Stop Bath

After the developer is used, you need a stop bath. This is what stops the developer from working beyond the recommended developing time. Regular tap water is commonly used as a stop bath, but some darkroom technicians prefer to use acetic acid. I use plain old water in my darkroom. I don't see any real advantage to using acetic acid as a stop bath. A 16-ounce container of it costs less than five dollars, but I've never seen a reason to use it. Tap water has worked for me over the last two decades.

Fixer

Fixer is the next chemical you will need. It removes the unexposed silver from the film and allows the film to be viewed in normal lighting conditions. If you don't use a fixer, the film will darken to a point where the image is ruined. A standard Kodak fixer costs less than five dollars for a full gallon. Rapid fixer, which requires about half the amount of time that standard fixer requires, is nearly twice as expensive. I normally use a rapid fixer to reduce my time in the darkroom.

Fixer Remover

As necessary as the fixer is, it must be removed once it has done its job. Leaving fixer on the film will cause the film to deteriorate over time.

Fixer remover, also known as hypo remover, should be used to speed up the removal of your fixer. A long, plain-water rinse will remove fixer, but using a fixer remover reduces the rinse time dramatically. Fixer remover, or hypo, sells for less than three dollars a gallon.

With all of my chemicals, I mix a full gallon and then put the stock that I'm using into quart bottles. This allows me to keep the chemicals fresh by discarding the used chemicals periodically and refilling the small bottles from the gallon jugs.

Wetting Agent

The last chemical, which is optional but highly recommended, is a wetting agent. If you don't put your film through a wetting agent, water may cling to the film as it is drying. This can cause spots and streaks on the negatives. A wetting agent reduces surface tension on film, thereby reducing the risk of spots and streaks.

Insider Tip
Fixer remover, like most other chemicals, can be used over and over again. Eventually all chemicals have to be replaced, but don't pour them down the drain after just one use.

What Form Should I Buy?

The chemicals you buy may come in powdered or liquid forms. Powdered chemicals will need to be mixed with clean water. It's a good idea to use distilled water, but you don't have to. Liquid chemicals are sometimes ready to use, but most of them have to be diluted with water. Read the instructions that come with your chemicals to achieve the proper mixing ratio.

Chemical solutions last longer when they are not exposed to light. For this reason, you should use either brown or black chemical bottles to store your mixed solutions. Clear containers will not protect the contents from light. Label each of your bottles so there is no risk of confusing the containers or their contents.

How Much Should I Use?

Make sure that you mix enough of each solution to meet your processing needs. For example, a one-roll film tank will hold about 8 ounces of liquid. A two-roll tank uses closer to 16 ounces. I use a three-roll tank, so I need more liquid. Don't mix more stock

solution than you need, but mix enough to fill your film tank and still have some left over. There will be some spills and losses, so mix about 15 percent more than you expect to use.

Developing Film

Chemicals for film development should be stored in brown or black plastic bottles. Once film is loaded into a developer tank, the room lights of a darkroom can be turned on safely. This allows you to work with your chemicals in full light. Make sure each container is labeled clearly, so that you don't put your chemicals into the developing tank out of sequence.

Watch Out

Avoid breathing fumes when you are mixing your chemicals. A simple dust mask, like painters use, provides some protection from powdered chemicals. Rubber gloves can protect your hands from chemicals. While you are not likely to receive serious burns from photo chemicals, you could develop a rash or some other skin irritation. It's best to minimize contact with the chemicals.

The first chemical in the tank will be your developer. Depending on the type of film you are using and the temperature of your chemicals, the developer will stay in the tank for 8 to 10 minutes. Let's say that you are developing a roll of Kodak Tri-X film with D-76 developer. If the chemical temperature is 65 degrees, the developing time will be 11 minutes. But, if the chemical is at 75 degrees, you will leave your film in the developer for only 8 minutes. This type of specific instruction can be found on the inside portion of Kodak film boxes.

Film immersed in developer should be agitated by stirring or inverting—preferably both—for the first 30 seconds of development. After this, agitate it 5 seconds for every 30 seconds of developing time.

When the developer time has elapsed, you must put your stop bath into the film tank. It should be at the same temperature as the developer. Agitate the film constantly for 30 seconds in the stop bath.

The next step is your fixer. A standard fixer will take between 5 and 10 minutes. Rapid fixers take only half this amount of time. Film should be agitated for half of the total fixer time. In other words, agitate for 30 seconds, and then let it sit for 30 seconds. Continue this routine until your fixer time is done. I'd allow about 7 minutes for a standard fixer.

You don't have to use a fixer remover, but it will speed up your processing time. Once you are done with your fixer, put fixer remover, also known as hypo, in the tank. Maintain the same chemical temperature that your developer was at. Agitate your film for half of the fixer-remover time, which is 2 minutes.

With the fixer remover gone, put your film tank into a wash cycle. You might set it under a faucet, but special film-tank washers are available at low costs. Film that has been treated with fixer remover requires about 5 minutes of washing. If you don't use a fixer remover, let the film wash for 25 minutes.

The last step, which is optional but highly recommended, is the wetting agent. Pour the wetting agent into the tank and let it sit, undisturbed, for 30 seconds. When this is done, you can remove your developed film and dry it.

Getting the Film into the Tank

Developing film is a pretty simple procedure. The hard part is getting the exposed film from its canister into the film tank. This is a procedure that most people have to practice awhile before they get the hang of it.

Exposed film cannot be exposed to any light without some damage to the images on the film. This means you have to work in total darkness. Even a safelight cannot be used when working with exposed film that has not yet been developed. Now, imagine this scenario. I hand you a film canister, a bottle opener, and a film tank with reels, and I lock you in a dark closet. Can you get the film out of the canister, onto the reel, and into the lighttight tank without messing it up? You can, but you probably won't on your first few attempts. Getting the film into the tank is, in my opinion, the hardest part of darkroom work for an inexperienced person.

Insider Tip
Don't attempt to load exposed film into a film tank until you have done some dry runs for experience. Fumbling around in the dark with film that contains important images is not a good way to learn how to load film reels. Buy a cheap roll of film, or two, to experiment with. When you become proficient with the loading process, you can start to load film that you actually plan to develop.

Insider Tip
Many photographers wind their used film tightly into its canister when all frames have been exposed. This helps to keep dust and stuff out. But, if you plan to develop your own film, leave a little of the film leader sticking out when you rewind your film. This makes the work in your darkroom much easier. Having the leader to grab hold of is a lot easier than using a bottle opener to pry off the top of the film canister to remove the film.

You will need a pair of scissors to cut the film from its roll. The scissors will be used to trim back the film leader so that you have a square cut on the film. This is necessary to load the film on a reel properly. Once all the film has been transferred to a reel, you must cut the end of the film to free it from its canister.

To get ready for a real run at developing, you should do a dress rehearsal. Take a roll of film into the darkroom with you. Turn off all the lights and get the film on the development reels and into the tank. Sounds simple, but it's not. There are different types of tanks and reels to choose from. I'm biased, but I would not use anything other than a Paterson tank and reel. In my opinion, this is the best system available, and it's easy to work with.

To load film on a reel, you must first cut the end of the film leader to square it up. Feed the end of the film onto your film reel. If you are using a Paterson reel, you will use back-and-forth hand motion to advance the film around the tank reel. Don't pull all of the film out of the canister to start with. Let the film wind from the canister onto the tank reel. When you reach the end of the film roll, cut the film and wind the remainder of it onto the tank reel.

Getting film on a developing reel requires some practice, but it's easy to do once you get a feel for it.

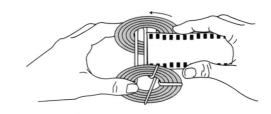

The loading procedure is not really difficult, but it does take a little getting used to. If the film has been rewound entirely into the film canister, you will have to use a bottle opener to pry off the top of the canister. Then you can lift the film out and load it on the tank reel. However, this is more difficult, since you don't have the film contained in the canister during the loading process. Practice loading film in the dark several times before you attempt the process with exposed film that is important to you.

Once you have your film loaded on a reel, it can be placed in your film tank. The reel is held in the center of the tank when it is positioned over an inner spindle. Not all film tanks are alike, so follow the loading instructions for the type you are using. With my Paterson tank, there is a plastic spindle that mounts in the center of the tank and holds up to three film reels. When you have your film safely in the film tank, with the light-tight cover installed, you can turn on the lights in your darkroom. The rest of your film processing can be done in full light.

Putting the Film Through Its Chemicals

To develop your film, you must follow instructions for development times and temperatures. This information can be found in or on film boxes. For instance, as I'm writing this, I'm looking at a box for a roll of Kodak T-MAX, 400-speed, black-and-white film. Developing instructions are printed on the inner portion of the box. According to Kodak, I should develop this type of film for 7 minutes at a temperature of 68 degrees Fahrenheit. If the developer temperature were 75 degrees, the developing time would be 5 minutes.

The remaining steps can be done at temperatures ranging from 65 to 75 degrees. The box recommends that you rinse the film in Kodak indicator stop bath, or running water, for 30 seconds. Kodak also recommends using their rapid fixer for 3 to 5 minutes. Then you are to wash the film for about 30 minutes. The film box doesn't mention this, but if a fixer remover is used for about 2 minutes beforehand, the wash time can be reduced to about 5 minutes. This saves time and water.

You can buy darkroom manuals that will give a wide variety of developing criteria for various types of film. The manuals are handy and usually accurate. However, all you really need is the information provided in or on your film boxes.

Hanging It Out to Dry

When your film is done, it must be removed from its reel and hung out to dry. It is wise to get as much water off the film as possible before leaving it to dry. This can be done with a photo sponge or with a set of squeegee tongs. Film should be dried in an area free of dust. Ideally, a drying cabinet should be used, but a piece of string and some clothespins are all that are absolutely necessary. When you hang up the film, weight the bottom of the film, so that is will not twist and curl. If you have film hangers, which are inexpensive, use one to hang the negatives and another to weight them. Don't cut the film until after it has dried.

When developed film has dried, you can cut the negatives into strips. Don't cut each image out individually. Invest in some negative holders, such as clear sheets that fit three-ring binders. These sheets hold several strips of negatives and protect them from scratches and dust. When you cut your film into strips, make sure that they will fit in your holders. Expect to get about five frames per strip. When this is done, you are ready to make your own prints.

Making Prints

Developing film can be a little boring, but making prints will keep your interest high. This is when you can see the fruits of your labor, and it's a lot of fun. You can select an individual negative to enlarge and print, but it's wise to make a contact sheet of an entire page of negatives that were taken and processed together. This allows you to see what your exposures are like, and you won't waste as much time or photographic paper.

First, you must prepare your developing trays. You will need three of them. The first tray will contain developer. I use Kodak Dektol. This is a paper developer. Don't use D-76 developer for prints, it is intended only for film. Your second tray will be the stop bath, which can be plain water. The third tray is your fixer, and this can be the same fixer used to develop film. You will also need some way of washing your prints. Ideally, you will buy a print washer. Paterson makes a great one for less than 15 dollars.

To make a contact sheet, you need a piece of clear glass that is large enough to cover the photo paper you are using. Most contact sheets are done on 8 × 10 paper, so the glass should be about 10 inches by 12 inches.

Making a contact sheet is not difficult. Position the head of your enlarger near the top of its post. You want the beam of the enlarger to cover the entire piece of glass you will be using on the enlarger board. With the room lights out and a safelight on that is at least 3 feet from your enlarger and photo paper, place a piece of photo paper on the enlarger board. Do not use an easel. Place strips of negatives in rows on the paper. Make sure the emulsion side (this is the dull side) is facing down. Next, put your piece of glass over the negatives. This will hold them flat and tight against each other.

Making a contact sheet is easy. A piece of photo paper is placed emulsion side up on the enlarger board. Negatives are placed emulsion side down on the paper. A piece of glass is laid over the negatives to hold them flat. Then, the enlarger is turned on and the print is processed. This work is done with only safelight illumination.

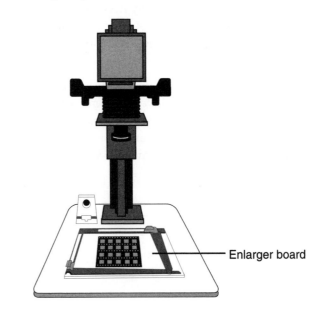

Enlarger board

When you are ready to make your contact sheet, turn on your enlarger for about 5 seconds, with the aperture set at f-8. You can experiment with the amount of time and aperture you want to use. After turning the enlarger on and off, you can treat the photo paper like you would treat any other print in the developing process, which we will cover in just a moment. After making a contact sheet, you can see how the exposure looks on several images at once. This allows you to adjust exposures for individual negatives without wasting a lot of time and paper.

To make an individual print, you must put your negative into the negative holder on your enlarger. Position the strip of negatives so that the frame you want to enlarge is in the negative holder's view window. Put an easel on the enlarger board, and do your focusing work with the enlarger. A darkroom magnifier is helpful when refining the sharp focus needed for good prints. When you can see that the easel is in proper position and that your focus is good, shut off the enlarger.

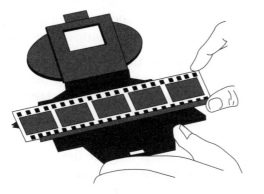

When you put a negative in the negative holder of your enlarger, the emulsion (dull) side of the negative must be on the bottom.

Remove a sheet of photo paper (with the room lights off—a safelight a few feet away is okay) and slide the paper into your easel. I prefer Speed Easels, but you can use any type you like. Set your aperture ring on the enlarger and turn on the enlarger for the desired amount of exposure.

Bet You Didn't Know
If you see brown streaks on your prints, the paper was probably fogged by exposure to light. Keep your photo paper shielded from light to avoid this.

After exposing the paper, put it in the developing tray. If you are using RC paper, a 1-minute bath in the developer should be adequate. You must agitate the paper constantly, with tongs, for the full minute. Fiber-based papers can require up to 3 minutes in the developer. Development times vary with the temperature of chemicals and the contrast of prints. The suggestions I've just given you will normally produce desirable results. However, you may have to use some trial-and-error techniques to pinpoint a perfect development time.

When your timer goes off, move the paper into the stop bath tray. When moving paper from tray to tray, it's a good idea to shake off the chemicals before putting it in the next tray. This will extend the life of your chemicals. However, don't take a lot of time to clean the prints between trays. Give them a couple of quick shakes and move on. If you leave the paper out too long, you could ruin your prints. For example, when you take paper out of the developer tray, the developer will continue to develop your paper until it is neutralized in the stop bath. In the stop bath, agitate the paper constantly for 5 to 10 seconds with RC paper and for 15 to 20 seconds when you use fiber paper.

Then move the paper, with tongs, into the fixer tray. Agitate the print constantly. RC paper requires about 2 minutes whereas fiber paper may take anywhere from 5 to 10 minutes. Some rapid fixers take less time, so consult the instructions on your chemicals. Once your prints come out of the fixer, you can expose the paper to normal room lighting.

The next step is a water rinse of about 2 minutes. This is often considered an optional step, but I highly recommend it. If you are using fiber paper, consider giving your print a bath in fixer remover for 2 to 4 minutes. Agitate constantly during the dunking. Don't use a fixer remover with RC paper.

The final step is a long water rinse. RC paper takes about 4 minutes. Fiber paper should be washed for up to 15 minutes when a fixer remover has been used, and up to an hour if the fixer remover is not used. A Paterson print washer works extremely well for this. It consists of a tray that has a hose attached to a faucet spout and a second hose that acts as a drain. With the faucet turned on, water moves through the tray, cleaning your prints perfectly.

When your prints come out of the wash, use a photo squeegee to remove excess water. Hang the prints up to dry. Again, string and clothespins are all you need. Once dried, you have your own, homemade photographs to view and be proud of.

Processing Color Slides

Processing color slides does not require an enlarger. If you have a film tank, reels, and basic film-processing equipment, such as beakers and a thermometer, you can process your own slides. However, not all slide film can be processed at home, so make sure that the film you buy can be developed in your darkroom. The type of slide developing you can do at home is called E-6 processing. Kits are sold that include everything in terms of chemicals you need to develop your slides.

Color film is more sensitive to temperature than black-and-white film. Keeping your liquids at the proper temperature is a critical concern when working with color film. If you plan to do much color processing, you should invest in a tempering box. Having a piece of equipment like this will help you maintain your liquids at a steady temperature. Many people feel that color slide film is more difficult to process than color negative film. There are more steps involved, but they are not, in my opinion, particularly difficult.

Insider Tip
Kodak Koda-Chrome film cannot be processed in a home lab. It must be sent to a commercial lab for special processing. E-6 films, however, can be processed at home.

Since color slides produce a positive image, rather than a negative one, there is no printing process involved. This is both good and bad. Once you are done with the processing, you have a finished slide. The bad side is that there is no way to correct mistakes made during a shoot or during development. You must follow development instructions closely to avoid problems. Read and heed the instructions provided with your development kits.

To give you an idea of how the color processing of slides works, I will give you a step-by-step example. Keep in mind, however, that you should always follow the instructions packed with your developing kit.

Your first step is to pour Kodak E-6 solution into your film tank. We are assuming, of course, that you have put your film on a tank reel and enclosed it in a lighttight tank, as I explained how to do in the black-and-white section earlier in the chapter. Take about 10 seconds to pour the solution. Read your instructions to determine how long the E-6 should stay in the tank. Agitate the film as requested on your kit instructions. Start to pour out the E-6 solution about 10 seconds before the complete time for developing has elapsed.

Wash your film with running water for 2 minutes. If you don't have running water, fill your film tank and agitate it. Drain and refill the water at least twice if you do not have the luxury of running water.

Next, you will pour the reversal bath into your developing tank. Remove and rebottle it according to your instructions. Since color slides are first processed with black-and-white chemicals, the reversal bath is needed to create the positive images formed on color slides.

Next, pour your color developer into the tank. Wait the prescribed amount of time and pour it out. Then put the conditioner that comes with your kit into the tank. After the

conditioner has had time to work (see your instructions), you must add bleach and fix the film. Then you wash and soak the film in stabilizer. This is done before you remove the film reel from its tank. Color processing kits vary in terms of their contents. You must read the instructions supplied with each individual kit to determine exactly what your role as a darkroom technician will involve. Quantities, time frames, and frequency of reuse will all be explained in the paperwork packed with your color kit.

The last step is hanging your film out to dry. This can be done in normal lighting conditions. Once dry, you can cut out film frames and mount them in slide mounts, which are available from all major photo suppliers.

Finishing Touches

There is not much that you can do with slide film to dress up an image. What you see is what you get. This is not the case when working with negative film, either color or black-and-white. As you become more accustomed to working in your darkroom, there are many things you can do to alter the finished print of a negative. We don't have room in this chapter to cover all that is possible, but I can hit some of the highlights for you.

Underexposing the Print

If you have a black-and-white picture that you would like to increase in contrast, you can underexpose the paper during your enlargement time and increase your development time. You underexpose by one f-stop and increase the development time by about 50 percent. To reduce contrast, you can overexpose at your enlarger by one f-stop and reduce the developing time by about 20 percent. If you make a contact sheet or develop a test print, you will be able to see what your existing contrast level is. Expect some mistakes as you experiment.

There are some rules-of-thumb for contrast developing. Expose for shadows in the negative and develop for the highlights. When you expose for shadows, you set up your print for easier developing. You can leave your photo paper in the developer for a longer period of time to bring out highlights. Shadows will become darker when you do this, but they are dark to begin with. The longer you develop your paper, the denser the highlights will become. This will also increase contrast. Shorter development times reduce contrast.

Pushing the Film Speed

Pushing the speed of film is also possible in your darkroom. If you have film with a speed rating of 400, you can expose it in your camera as if it had an ASA rating of 800 or 1600. This allows you to shoot at faster shutter speeds in low-light conditions. Even though you are cheating in film speed, you can correct the exposures in your darkroom.

When you push film, you are, in effect, underexposing it. This means that you must leave the film in its developer for a longer period of time to compensate for the underexposure. The result will be higher contrast and a usable photograph. If you push a film by one stop, such as shooting 400 film as if it were 800 film, you must increase the development time by 50 percent. Making your camera think that 400 film is 1600 film requires additional developing time of between 100 and 150 percent.

There are some disadvantages when pushing film speeds. You will likely lose shadow detail, due to the underexposure. Contrast is increased, but this usually isn't a problem. One of the biggest problems that you might expect is a grainier picture as you enlarge the negative into prints.

Darkroom Dodging

If you have a negative where some of the image is too dark or too light, you can adjust for the problem by *dodging*. A cut-out piece of a file folder taped to a wire coat hanger is all that you need. You can buy pre-made dodging instruments for special effects, but I've never owned one.

The concept behind dodging is very simple. Assume that you have a negative where a person's face is overexposed if the rest of the picture is developed properly. All you have to do in order to correct this is to hold the dodging material over the facial features for a period of time during the enlarger exposure. Blocking the enlarger light from a portion of the photo paper will allow you to balance out the overall exposure. This takes a little trial-and-error experimentation, but it works very well. The use of a dodging tool allows you to provide prints with the amount of exposure you feel is necessary.

I really wish we could go on about other creative and corrective exposure techniques, but we simply don't have the space. When you decide to develop your own pictures, buy several books on the subject. You will discover a wealth of opportunities within them. Having and using your own darkroom is an experience that every photographer should take advantage of. Not only will you save some money on processing, you will also gain a better understanding of how photography works. A photographer who is familiar with all aspects and elements of the photographic process is usually a better photographer.

The Least You Need to Know

> ➤ Treat photo chemicals with respect. Work with them only in well-ventilated areas. Avoid contact with your skin. Don't breathe the fumes from chemicals.

> ➤ Protect your chemicals from light by storing them in either brown or black plastic bottles. Light will shorten the life of mixed chemicals.

➤ Practice loading film on your film reels in the dark before you attempt to load film that has been exposed with meaningful images.

➤ Never subject exposed film or photo paper to room light. A safelight can be used when working with paper, but the paper should be kept several feet from the safelight. No light is safe when working with exposed, but undeveloped, film.

➤ The temperature of photo chemicals is crucial when developing color film, slides, and prints. A tempering box is a good investment if you plan to do much color work.

➤ Buying or creating a dodging kit will give you much more control in your darkroom. Pieces of cardboard that are cut into various shapes and attached to wire coat hangers that have been straightened out will work wonders on prints with difficult exposures. Whether you buy a complete dodging kit or make your own as you need it, dodging can be a lifesaver in the darkroom.

Moving On Up to Color Print Processing

In This Chapter

➤ Moving into color work

➤ Expensive enlargers

➤ Better than your own eyes

➤ Time bombs in bottles

➤ Money to burn

➤ When it's right, you'll know it

If you advance into a color darkroom, you're going to have to spend some serious money to set up a good system. Processing your own film and making your own prints can be a lot of fun, but when you get into color prints, it's a costly hobby. Most amateur photographers who shoot color film just drop it off at a processing facility to have prints made. Considering the cost of color darkroom equipment and the time and skill involved with doing color work, commercial labs are a good alternative. Still, some photographers are not happy until they have complete control over their work. To get this, you have to do your own processing and printing. So, let's see what a color darkroom entails.

Upgrading a Black-and-White Enlarger

If you start off with a black-and-white enlarger, you may be able to upgrade it to do color work. Don't think for a moment that this means you won't be spending much to get into color printing. A color head for a black-and-white enlarger will usually cost more than the enlarger did. Sometimes it can cost a lot more.

The quality of color prints made with a converted black-and-white enlarger may not be top-notch. If you are serious about doing color work, I think you should buy an enlarger that is meant to do color work from the start. I own an enlarger that could be converted to color, but I have chosen not to buy the conversion package for it. For my money, buying a color enlarger makes more sense.

Bet You Didn't Know
Some enlargers produce color prints simply by accepting color filters. Most color enlargers, however, have a tri-filter color head. If you're serious about doing color work, get an enlarger that will grow with you instead of being outgrown by you.

If you want to buy a black-and-white enlarger that can be converted to a color unit in the future, go over all of the details and costs with your photo supplier before making a buying decision. I've never had first-hand experience with a converted enlarger, so my thoughts on the subject are based on the comments of other photographers. To date, I've never talked to a photographer who was pleased with a converted enlarger. However, the enlargers might work fine. I just can't say definitively.

Buy a Color Enlarger, and I'll Throw in the Golden Gate Bridge

Color enlargers are much more expensive than their black-and-white cousins. How much do they cost? I would expect to shell out at least $500 for a basic color enlarger. You can find some for less and many for a lot more. The cost goes up as the size of your negative increases. Depending on the format of your camera, you could be looking at a cost of several thousand dollars. The 35mm enlargers are the least expensive, but they still aren't cheap. One catalog that I researched had just the color head, not a complete enlarger, priced at almost $800. Moving up to color prints will cost you more than it's worth unless you are truly dedicated to darkroom work.

There are many features and options available with color enlargers. Black-and-white enlargers are pretty simple and easy to understand. Their cost is low, so a mistake is not too hard to take. When you are getting ready to buy a color enlarger, however, you owe it to yourself to do a lot of product research. Find out exactly what each model you are looking at is capable of. For example, how large of an enlargement can you make? Many low-end black-and-white enlargers allow you to make prints only as large as an 8 × 10. If

you're looking for an enlarger to make bigger prints, make sure the unit you are considering can do it.

Not all color enlargers cost a fortune. One catalog I looked in sells a name-brand, color enlarger for just over $300. This is an enlarger for 35mm film. It can make baseboard prints up to 11 × 14. Larger enlargements can be made by reversing the enlarger column and projecting your image on the floor. All in all, this is a good starter unit for photographers who want to branch out into color darkroom work. Check advertisements in *Shutterbug* magazine for a wide array of quality equipment at affordable prices.

Insider Tip

Here are some mail-order suppliers and their phone numbers that I've had successful dealings with in the past. I can't promise that you will have a good experience dealing with them, but I've never had a problem:

➤ Adorama 212-741-0052

➤ B & H Photo 212-807-7479

➤ Tri State Camera & Video 212-633-2290

Before you invest in a color darkroom, you have to look at more than just the cost of an enlarger. When you are doing black-and-white work, the enlarger is your only major expense, and it's not too costly. This is not the case with a color darkroom. Not only do color enlargers cost more than twice what a black-and-white one does, you've still got other equipment and expenses to factor in.

Color Analyzers Add to Your Cost

Color analyzers add to your cost when setting up a color darkroom. Technically, you don't have to have one. But few darkroom junkies who do color photos would be without one. Since the human eye is not perfect, you may need a little help when choosing filters for coloration. Color analyzers give you this help, but at a hefty price.

Color analyzers take the guesswork out of color filtration. To get the proper colors in a print, such as skin tone, you must make adjustments in the color filtration. This is part of getting a successful color balance. A color analyzer tells you which colors will work best. Without an analyzer, you have to look at color charts and play a game of trial-and-error to achieve optimum colors.

Jargon Alert
Color Balance:
This is an adjustment in color processing, at the print stage, that ensures accurate color reproduction.

Before I tell you how much you might spend on a good color analyzer, you had better sit down. Take a few deep breaths and prepare yourself. A name-brand analyzer could easily cost you over $1,000. A cheaper, less automated version will go for over $500. Are you starting to see why a color darkroom is a questionable investment for a hobbyist? And hey, I'm not even pitching you on the really expensive stuff. Professionals may pay more than $4,000 for a color analyzer. Of course, these are the guys who pay $8,000 for one lens.

You can take your color darkroom to many different levels of equipment, assuming that you have enough money. The problem is, even on the low-end of the scale, your costs are going to be sizable. Is it really worth it? In my opinion, nonprofessionals have a difficult time justifying the expense of a color darkroom.

Color Chemicals

Most color chemicals are sold in sets. It's common to buy black-and-white chemicals and supplies individually, but this is not the case with color.

Insider Tip
If you want to maximize the life of your photo chemicals, buy brown bottles that will collapse a little at a time as chemicals are depleted. By reducing the amount of air in the bottles, your chemicals will last longer. These collapsible bottles are available from most photo suppliers, and they're not terribly expensive.

The chemicals used with color work don't last as long as the ones used for black-and-white work. If you only get around to processing a few rolls of film each month, you could be paying a high price for your chemicals. They are expensive enough to begin with, and if you don't get a lot of use from them quickly, their cost soars. Pouring expensive chemicals down the drain is something like flushing $20 bills down your toilet.

If you are thinking about doing color work, investigate the chemicals. Ask your supplier to provide information on their shelf life once they have been activated. How long the chemicals last will depend on many factors, such as the type of chemicals and how they are stored. Even under ideal conditions, a casual photographer will not use them often enough to make them cost-effective. I'm not trying to talk you out of doing color work, but you deserve to be informed of the drawbacks before you lay out a lot of cash for equipment.

Marching to a Different Drum Processor

When you work in a black-and-white darkroom, you can do so with trays that are filled with chemicals and a safelight. Color paper is much more sensitive to light than black-and-white paper is. You cannot use a safelight during most of your color work. While a tray system can be utilized with color, it is not recommended. Instead, you should use a drum processor. This allows you to develop your color prints without having them exposed to any light. Once the paper is inserted in the drum, normal lighting can be turned on. These processors are sold as both manual and automatic units. A high-tech, professional version that I know of costs considerably more than $5,000.

An economical, manually operated processor sells for just under $500 in the catalogs I've reviewed. While this piece of equipment is not mandatory, it is recommended. This is not the only piece of added equipment that is recommended when you are moving up from black-and-white to color work.

Next, You Need a Tempering Box...

Temperature ratings are much more critical in color work than with black-and-white prints and processing. To guarantee that you are working with proper temperatures, you should use a tempering box. The one I looked up in my catalog sells for more than $300. If you take a moment to read back through this chapter and add up the expenses we have discussed, you may be dismayed with color darkroom work. At these prices, the corner one-hour photo lab starts to look really good.

Is there any alternative to the high cost of color printing? Yes and no. If you simply want to make your own color prints, up to an 8 × 10 size, and are not concerned with all of the control you gain from a full darkroom, there is an option. One manufacturer makes a sort of desktop darkroom that will produce color prints from snapshot size to 8 × 10 enlargements. The stripped-down version sells for $400. A deluxe version goes for about $600. These prices aren't cheap, but they are a lot less than a full-blown color darkroom.

The Few, The Proud, The Brave

There are some photographers who can (or will) justify the expense of a full color darkroom. Most of them are professionals, but some amateurs can get in on the act. What are the requirements for justification? If you have plenty of money and want a color darkroom, that's all the justification you need. Since most people don't have money to burn, however, some other form of approval is usually needed. Let's talk about when and if you should move up to a color darkroom.

Should you set up your own color darkroom? This is a question with a lot of implications. Money, of course, is one of the considerations. There is also the fact that color darkroom work is more difficult to master than black-and-white work is. When you can take a roll of film to a lab and have finished prints back in an hour for a reasonable price, it becomes difficult to justify the expense of making your own color prints. How, then, can you decide if a color darkroom is right for you?

If you are a casual photographer who likes to dabble in a darkroom, the cost of a color darkroom is probably too great. Stick with a black-and-white setup and spend the money you save on more film. Owning your own black-and-white darkroom is not a big expense. It does, however, give you the opportunity to develop your own film and prints. Remember, you can even process some types of color slide film in your simple, black-and-white darkroom. Even if you have a substantial color darkroom, there will still be some types of color slide film that you must send out to commercial facilities for processing.

How important is it to you to have complete control over your photography? If you are a neophyte to photography, you have plenty to learn by just taking pictures without worrying about how to process them. Before you spend much money on any type of darkroom, you should establish that you do enjoy photography as a hobby.

Are you contemplating using your photography as a source of potential income? Many amateur photographers find financial success with part-time photo work. You could make $500 in one day shooting a wedding. Taking pictures of your friend's pets could pay for your film, and then some. For most part-time professionals, weddings offer the most lucrative income. However, there is money to be made with a camera in many areas of photography.

Have you always wanted to have your own portrait studio? If so, invest first in cameras, lenses, lights, and props. Good portrait photographers normally do their own darkroom work, so a darkroom may be in your future. However, see if you are going to have enough business to justify the cost of a color darkroom. You can always have your film developed and printed by other professionals until you are sure you should take the dive into a color darkroom.

Personal pleasure is an intangible element. How much is it worth to you? If owning your own color darkroom will make you a better, happier person, the cost is justified. However, this is not true for most casual photographers. Darkrooms don't develop pictures by themselves. You are going to have to invest more than money to get great prints. It will be necessary for you to learn darkroom techniques. You will also have to spend time in the darkroom. For some photographers, this is fun and rewarding. Other photographers resent spending time in a darkroom when they could be out shooting more film. You have to make the call.

If money is on your mind, you have to look at both sides of the coin. You might make money with your darkroom, but you will definitely spend money in acquiring the capability to do so. Is the investment worth the risk? You never know until you try, but you can test the waters.

Having your own color darkroom is very advantageous if you are doing commercial work. You can airbrush images, retouch shots, and change exposures, all after a photo session is done. This ability makes it easier for you to overcome mistakes and problems that occur during a shooting session. If you are gearing up for a photography business, a color darkroom might be in the cards.

Having a darkroom can help you learn how to use your camera and lenses better. By understanding the principles employed in developing film and prints, you have a better knowledge of what you want and need out of your camera. There are two schools of thought pertaining to this situation. Some people will tell you that you should master photography before you start to learn darkroom procedures. Others will tell you that the only way to master your camera is to understand your darkroom.

I think it is best for a person to become very familiar with all photographic equipment needed to record good images before investing in a darkroom. Darkroom work, when kept on a basic level, is pretty simple. If you can follow instructions, you can create developed film and prints. This is not the case with your camera. Reading the owner's manual will tell you how the equipment functions, but you have to learn how to see photographically.

If I were you, I'd spend several months using my camera gear before investing in any type of darkroom. Once I was familiar with my camera equipment, I would buy a black-and-white darkroom. If I saw that I was using it and enjoying it, then I'd consider stepping up to a color darkroom. This is a logical progression.

In the end, you are the only person who can decide how much a color darkroom is worth to you. If I did photography as a hobby, I would not spend the money on a color darkroom. Assuming that I had money to spend, I would use it to buy film and new equipment for taking pictures. A black-and-white darkroom would be a part of my arsenal, but a color darkroom would not. Your decision to invest in expensive color equipment requires more than just the flip of a coin. If you do go after a color darkroom, research all the equipment and shop for good prices and reliable customer service.

Well, we're at the end of our film leader. That's photo talk for "this book is done." I've enjoyed writing it, and I hope you have enjoyed reading it. Good luck in all of your endeavors, and remember to keep your film loaded and your camera cocked. See ya next time!

The Least You Need to Know

➤ Moving up to a color darkroom is an expensive step to take. Experiment with black-and-white developing and color slides before you spend a bundle on color darkroom equipment.

➤ Color processing is more complicated than black-and-white work. Water temperature is critical in color processing, so you have to be prepared to create and maintain stable temperatures. Don't attempt color processing until you have become comfortable in a darkroom setting.

➤ Chemicals used for color processing are expensive and don't last very long. If you think you can save money by doing your own color prints, you're probably wrong.

➤ There is almost no end to the amount of money you can spend on a color darkroom. The money spent is difficult to justify unless you are a professional photographer.

➤ Set up a color darkroom only when you are willing to gain satisfaction from making your own prints. Don't look upon this type of opportunity with dollar signs in your eyes. The cash flow you hope to save on processing costs will be going downstream.

Glossary

Aberration A lens fault where light rays are scattered and degrade a photographic image.

Abrasion marks Marks made on the emulsion of film that resemble scratches. They can result from dirt or dust on the film while worked with either in your camera or in your darkroom.

Acutance The objective measurement of how well an edge is recorded in a photograph.

Adapter ring A device that mounts on a lens to allow you to install further accessories, such as a gelatin filter holder.

Additive process When lights of different colors are combined you have an additive process. If a set of three primary colors are combined equally, the result will be white.

Aerial perspective You might think that this relates to aerial photography, but it doesn't. It is the impression of depth shown in a scene that is conveyed with the use of haze.

Angle of view A measurement that has to do with the widest angle of light rays seen by a lens that forms a suitably sharp image at the film plane. To determine this measurement, a lens must be set at a focus level of infinity. In lay terms, the angle of view is what you can see when looking through your viewfinder. Or, in some cases, what the camera sees that you don't. Not all cameras offer a what-you-see-is-what-you-get view.

Aperture A part of a lens that opens and closes to allow light to get to the film. You can see the aperture work if you look in a lens that is not mounted on a camera body and rotate the aperture ring.

Aperture priority When an in-camera meter takes its reading based on the aperture setting you have chosen, the camera is in aperture-priority mode. For example, if you want a diffused background, you would set an open aperture, say f-2.8, and your camera would choose the proper shutter speed to produce a good exposure.

ASA American Standards Association. It is a measurement of film speed and relates to the sensitivity of a particular film.

Available light Light that is on a photographic subject naturally, such as sunlight in an outdoor setting.

Back lighting Lighting that is placed behind a photographic subject.

Barn doors Hinged metal flaps found on photographic studio lights that allow you to control the volume and direction of lighting produced by the lights.

Base A term applied to the support material on an emulsion, which is usually plastic or paper.

Bellows A device used for close-up photography. It is a lighttight, extendable sleeve that is infinitely adjustable between its shortest and longest extent. Extreme magnification is possible when a bellows is used.

Bounce flash A procedure in which light from an electronic flash is flashed onto a reflective surface and then lights a subject. As an example, you might bounce your flash off a wall in your home to light the face of a subject in a portrait.

Bracketing A method in which you take more than one picture of the same scene using different exposures. Typically, the first picture is taken at what is believed to be the ideal exposure. Subsequent exposures are taken one stop faster and one stop slower to ensure a successful exposure.

Bulb setting A setting on a camera that allows the shutter to remain open for as long as the shutter release is depressed. By using this feature, you can produce timed exposures.

Bulk film Film that is purchased in a long roll and cut and loaded into canisters or other containers for standard use. Bulk film is cheaper than pre-packaged film containers, but it can be difficult to load. If the film is exposed to light during the loading process, it will be fogged and ruined.

Burning in A darkroom term that means you are increasing the exposure on a portion of a photograph by leaving it exposed to enlarger light while the rest of the picture is shaded or masked.

Cable release A device that allows you to depress the shutter button of your camera without touching the camera body. A cable release should be used when you are shooting at slow shutter speeds. By not touching the camera, you reduce the risk of camera shake and distorted images.

Cassette A container that 35mm film is loaded into when it is prepared for use in a camera. Another name for this container is magazine.

Changing bag A lighttight bag equipped with openings for your hands and arms. A changing bag can be used to load film into film tanks or cassettes without the need for a darkroom.

Coating A thin layer of material placed on the surface of a lens to reduce flare.

Color compensating filter A filter used to alter the color of light under various circumstances. Many ranges of compensating filters are available for all types of occasions.

Color contrast The subjective impression of the difference in the intensity between two close colors.

Color head A darkroom device used as part of an enlarger. It is an illumination system that has built-in, adjustable filters or light sources that are used when making color prints.

Complementary colors Colors that when combined produce white light.

Composite image An image that is made from more than one image source. For example, a multiple exposure is a composite image; so is a sandwiched image.

Compound lens A lens that is made with more than one element, allowing for optical corrections to be made.

Contact sheet A sheet of exposed, developed photo paper that contains images from all negatives produced from one roll of film. Contact sheets are used to preview exposures in a darkroom and to allow evaluation of various darkroom exposures.

Critical aperture The point of aperture opening where a lens produces the best image quality. The setting is usually somewhere around the middle of the range of settings.

Cropping A procedure where unwanted items are deleted from a picture. Cropping can be done before a picture is taken by using a zoom lens, switching to a longer lens, or by moving closer to the subject. It can be done after a photo is taken by enlarging the image in a darkroom.

Dedicated flash An electronic flash designed to work with one particular camera. The flash is connected to the camera with a sensor that allows for automatic flash exposures.

Depth of field The distance at which subject matter remains in sharp focus during the picture-taking process. Open aperture settings reduce depth of field. Closed-down apertures extend depth of field.

Diffuser A material that breaks up and diffuses incoming light.

DIN Deutsche Industrie Norm. It is a method of identifying film speed and sensitivity.

Diopter Refers to the light-bending power of a lens.

Dodging A term used in connection with darkroom work. It is when a portion of photo paper is shaded during an enlarger exposure. This allows the unshaded areas to be exposed longer, giving a different type of contrast and look.

Electronic flash A portable, artificial light source used to illuminate photographic subjects. The light output from an electronic flash is perceived as daylight by film, so no corrective filters are needed when using daylight film.

Emulsion A light-sensitive material composed of halides that are suspended in gelatin. It is used in the making of both film and photographic paper.

Exposure This word relates to the amount of time that film or photographic paper is exposed to light.

F-stop Aperture settings are rated in f-stops. A low numbered f-stop, such as f-2.8, is an open aperture, and a high f-stop, such as f-16, is a closed-down aperture.

Film speed rating A measurement of a film's sensitivity to light. It is most often referred to as either an ASA or ISO rating, each of which will be the same. A film with an ASA rating of 200 will have an ISO rating of 200. Another scale used for rating film speed is the DIN rating.

Filters Devices that are placed over lenses on both cameras and enlargers to alter light and images. They can be used for corrective purposes or to create special effects.

Flare Light that is scattered or reflected and that does not form an image. It can be reduced with lens coating and lens hoods.

Flash guide number A unit of measurement that allows you to determine the proper aperture setting for your camera when electronic flash is being used as a light source.

Focal length The distance between the center of a lens and its focal point.

Focal plane The point at which a lens forms a sharp, crisp image.

Focal point The point on either side of a lens where light enters parallel to the axis of coverage.

Focus The point where light is converged by a lens.

Gelatin filters Filters that are made from dyed gelatin. They are inexpensive, but scratch easily.

Grain A light-sensitive crystal that is normally made of silver bromide. The faster a film is, the more grain it has. For the clearest pictures, a slow film speed should be used to reduce the effect of grain in photo enlargements.

Haze A vapor of fog, smog, or smoke in the air. Photographically speaking, haze can be created by harsh light falling on the glass element of a lens.

Hyperfocal distance The minimum distance at which a lens can record an image clearly while the lens is set on a focus range of infinity.

Incident light Light that is falling on a subject, rather than light being reflected off of a subject.

Incident light reading A light reading taken with a light meter that shows the amount of light illuminating a subject.

Infinity A point in distance when light rays from objects are parallel.

Internegative A negative that is made on special color film for making copies of prints or for making prints from slides.

ISO International Standards Organization. A standard rating for film speed and sensitivity.

Joule A unit of measurement for the output of an electronic flash. It is equal to one watt-second. By using this form of measurement, you can compare the power of various electronic flash units effectively.

Kelvin When you see temperature ratings given in Kelvin degrees, you are seeing the standard unit of thermodynamic temperature. It is arrived at by adding 273 degrees to a centigrade temperature reading.

Latent image An invisible image that exists on exposed emulsion. Once the emulsion is developed, the image becomes visible.

Lens flare The result of scattered or reflected light that is non-image forming that reaches an emulsion. It can be reduced with lens coating and lens hoods.

Lens hood A device on the front of a lens that protects the lens surface from unwanted, non-image forming light that can cause flare. Some lens hoods are built-in on lenses, and others are accessories screwed into the filter threads of a lens.

Luminance The amount of light emitted by or reflected from a surface.

Macro lens A lens that gives high-quality performance when shooting close-ups. Some manufacturers call them micro lenses.

Masking A technique where a mask is used to block light from part of an emulsion. Masks can be used in filter holders for special effects when taking a picture. They can also be used in a darkroom when making prints with an enlarger.

Negative A photographic image that is comprised of reversed tones. In other words, light objects are dark and dark objects are light when looked at on a negative. When a negative is printed, the colors become positive and appear normal.

Negative carrier A holder that works in conjunction with a darkroom enlarger to hold a negative or slide.

Normal lens A normal lens is one with a focal length equal to the diagonal of the film format. What this amounts to is that a normal lens produces a picture that has a normal or everyday perspective and angle of view. Wide-angle lenses and telephoto lenses distort these qualities and are therefore not normal.

Open flash When a camera shutter is held open with a timed-exposure and flash is fired periodically on a subject, the process is known as open flash.

Panning Moving your camera in a smooth arc to follow the motion of a moving subject while keeping the subject in the same position in your viewfinder.

Photo lamp A tungsten lamp used to light photographic subjects that gives a color temperature of 3400 degrees Kelvin.

Primary colors Red, green, and blue are primary colors, so are cyan, magenta, and yellow. Primary colors are colors that when grouped in threes can be used to make any other color. When mixed together in equal proportions by the additive process, they make white. If the subtractive process is used, they make black.

Pulling film A process where the development time for film is shortened.

Pushing film A process where the development time for film is extended.

Reciprocity failure Light-sensitivity lost during exposures that are either very short or extremely long is known as reciprocity failure.

Resolution The capability of a lens to distinguish between items placed closely together. The higher the resolution of a lens, the better the lens is.

Ring flash An electronic flash that is shaped like a doughnut and attaches to the end of a lens.

Safelight A light that can be left on in a darkroom without affecting light-sensitive materials. Most safelights are either red or amber in color.

Sandwiching When two or more images are combined to make a single image. This process is usually done in a darkroom with an enlarger, but accessories can be purchased that allow you to sandwich slides and shoot the composite picture with your camera.

Scrim A screen placed in front of lights to reduce their output.

Shutter priority One form of an automatic camera. When an in-camera meter takes its reading based on the shutter-speed setting that you have chosen, your camera is in shutter-priority mode. For example, if you want to stop the motion of a Ferris wheel, you would set a shutter speed of 1/250th of a second and your camera will choose the proper aperture setting to produce a good exposure.

Single-lens reflex camera A camera that uses a mirror to allow photographers to see exactly what is focused on their film.

Slave unit A device used with multiple flash setups that allows independent flashes to fire in unison with the primary flash that is serving a camera.

Snoot A device that is fitted to the head of a photo lamp to narrow its beam of light. Snoots are often used when lights are intended to highlight a model's hair.

Spot meter A handheld, independent light meter that takes reflective light readings from very small portions of a subject. It is the most accurate reflective light meter you can own.

Stepping down This means that you are reducing the aperture size or the shutter speed for your exposure.

Subtractive process When the combination of primary colors, dyes, or filters that absorb light are used to produce a black image.

Thick negative A negative that is dark or that has a dense image.

Thin negative A negative that has a thin density and is pale.

Transparency Another name for a photographic slide. It is a positive image meant to be viewed by transmitted light, such as that from a light table or slide projector.

Tungsten light Light that is created by heating a filament of tungsten to a temperature where it emits artificial light.

Vignetting The gradual fading of the edges of an image to either black or white.

Index

cloudy days
 lighting, 130
 meter readings, 166
coatings, 251
cocking the shutter, 143
color
 analyzers, 243-244
 balance, 244
 chemicals, 244
 compensating filters, 251
 complementary, 251
 contrast, 251
 darkrooms, 245-247
 head, 251
 primary, 254
 print films, 98-99
 prints (darkrooms),
 241-248
 slides
 developing, 227-240
 processing, 236-238
color-negative films, 90
comas, 43
composite images, 251
composition, 113-123
 angles, finding, 119-120
 backgrounds, 118
 eye level shots, 116
 framing shots, 121-122
 horizontal shots, 114
 landscape photography,
 197
 outdoor photography,
 170-171
 vertical shots, 115-116
compound lenses, 36, 251
contact sheets, 251
contrast, 192
controlling backgrounds, 163

costs
 cameras, 15-16
 automatic, 19
 large- and medium-
 format, 31
 chemicals for darkrooms,
 220
 close-up rings, 74
 color enlargers, 242-243
 darkroom equipment, 218
 drum processors, 245
 enlargers (for prints), 217
 equipment packages, 30
 flashes, 48
 lens filters, 73
 lenses, 41
 lighting kits, 52
 quartz-halogen lights, 53
 strobes, battery-powered,
 55
 telephoto lenses, 39-40
 tempering boxes, 245
coverage area of flashes, 49
covering power (lenses), 31
cranks, rewinding, 143
creative photography,
 200-205
critical apertures, 251
cropping photographs,
 211-213, 251

D

darkrooms, 209-214
 black-and-white films, 96
 color, advantages, 245-247
 color prints, 241-248
 equipment, 216-219
 chemicals, 220-221
 color analyzers, 243-244

 color chemicals, 244
 color enlargers, 242-243
 drum processors, 245
 easels, 222
 enlargers for prints,
 216-218
 gadgets, 224-225
 paper for prints,
 221-222
 processing trays, 219
 safelights, 222
 tanks and reels, 219
 tempering boxes, 245
 timers, 218
 water sources, 223-224
safety, 230
setting up, 215-225
techniques
 burning it in, 212
 cropping photographs,
 211
 dodging, 239-240
 enlarging photographs,
 211
 filtering, 213
 photo sandwiching, 212
 pushing film speeds,
 238-239
 Sabattier effect, 213
 special effects, 213
 underexposing
 prints, 238
ventilation, 228
daylight film, 50
dedicated flashes, 251
depth, creating with lighting,
 127-128
depth of field, 105-106, 118,
 163, 175, 251
 outdoor photography,
 170-171

259

Q-R

When You're Smart Enough to Know That You Don't Know It All

For all the ups and downs you're sure to encounter in life, The Complete Idiot's Guides give you down-to-earth answers and practical solutions.

Lifestyle

The Complete Idiot's Guide to Learning French on Your Own
ISBN: 0-02-861043-1 ▪ $16.95

The Complete Idiot's Guide to Learning Spanish on Your Own
ISBN: 0-02-861040-7 ▪ $16.95

The Complete Idiot's Guide to Successful Gambling
ISBN: 0-02-861102-0 ▪ $16.95

The Complete Idiot's Guide to Hiking and Camping
ISBN: 0-02-861100-4 ▪ $16.95

The Complete Idiot's Guide to Choosing, Training, and Raising a Dog
ISBN: 0-02-861098-9 ▪ $16.95

The Complete Idiot's Guide to Trouble-Free Car Care
ISBN: 0-02-861041-5 ▪ $16.95

The Complete Idiot's Guide to Trouble-Free Home Repair
ISBN: 0-02-861042-3 ▪ $16.95

The Complete Idiot's Guide to Dating
ISBN: 0-02-861052-0 ▪ $14.95

The Complete Idiot's Guide to Cooking Basics
ISBN: 1-56761-523-6 ▪ $16.99

The Complete Idiot's Guide to the Perfect Wedding
ISBN: 1-56761-532-5 ▪ $16.99

The Complete Idiot's Guide to the Perfect Vacation
ISBN: 1-56761-531-7 ▪ $14.99

The Complete Idiot's Guide to Getting and Keeping Your Perfect Body
ISBN: 0-02-861051-2 ▪ $14.95

The Complete Idiot's Guide to First Aid Basics
ISBN: 0-02-861099-7 ▪ $16.95

Personal Business

The Complete Idiot's Guide to Getting Into College
ISBN: 1-56761-508-2 ▪ $14.95

The Complete Idiot's Guide to Terrific Business Writing
ISBN: 0-02-861097-0 ▪ $16.95

The Complete Idiot's Guide to Surviving Divorce
ISBN: 0-02-861101-2 ▪ $16.95

The Complete Idiot's Guide to Managing Your Time
ISBN: 0-02-861039-3 ▪ $14.95

The Complete Idiot's Guide to Speaking in Public with Confidence
ISBN: 0-02-861038-5 ▪ $16.95

The Complete Idiot's Guide to Winning Through Negotiation
ISBN: 0-02-861037-7 ▪ $16.95

The Complete Idiot's Guide to Managing People
ISBN: 0-02-861036-9 ▪ $18.95

The Complete Idiot's Guide to Starting Your Own Business
ISBN: 1-56761-529-5 ▪ $16.99

The Complete Idiot's Guide to a Great Retirement
ISBN: 1-56761-601-1 ▪ $16.95

The Complete Idiot's Guide to Protecting Yourself From Everyday Legal Hassles
ISBN: 1-56761-602-X ▪ $16.99

The Complete Idiot's Guide to Getting the Job You Want
ISBN: 1-56761-608-9 ▪ $24.95

Personal Finance

The Complete Idiot's Guide to Buying Insurance and Annuities
ISBN: 0-02-861113-6 ▪ $16.95

The Complete Idiot's Guide to Doing Your Income Taxes 1996
ISBN: 1-56761-586-4 ▪ $14.99

The Complete Idiot's Guide to Getting Rich
ISBN: 1-56761-509-0 ▪ $16.95

The Complete Idiot's Guide to Making Money with Mutual Funds
ISBN: 1-56761-637-2 ▪ $16.95

The Complete Idiot's Guide to Managing Your Money
ISBN: 1-56761-530-9 ▪ $16.95

The Complete Idiot's Guide to Buying and Selling a Home
ISBN: 1-56761-510-4 ▪ $16.95

You can handle it!

Look for The Complete Idiot's Guides at your favorite bookstore, or call 1-800-428-5331 for more information.